THE SOUTHWESTERN UNITED STATES and northwestern Mexico exist in a rain shadow cast by mountain ranges to the west. Rain clouds sweep from the Pacific Ocean across coastal land, shedding rain as they rise into the mountains, where they drop most of their moisture. The arid and semiarid lands of the Southwest begin on the east side of these mountains. Here rainfall is light and undependable. Summer rains are often brief and highly localized, as clouds suddenly boil up from the south in the afternoon. Winter storms from the Pacific may arrive in waves, soaking the ground. At higher elevations, the rain becomes snow. Between these two seasons are dry periods, when great care must be taken to ensure life's continuance.

Indigenous people of the Southwest summon rain through song, prayer, and dance, and they celebrate its blessing through myriad expressions that form the recurring theme of their lives.

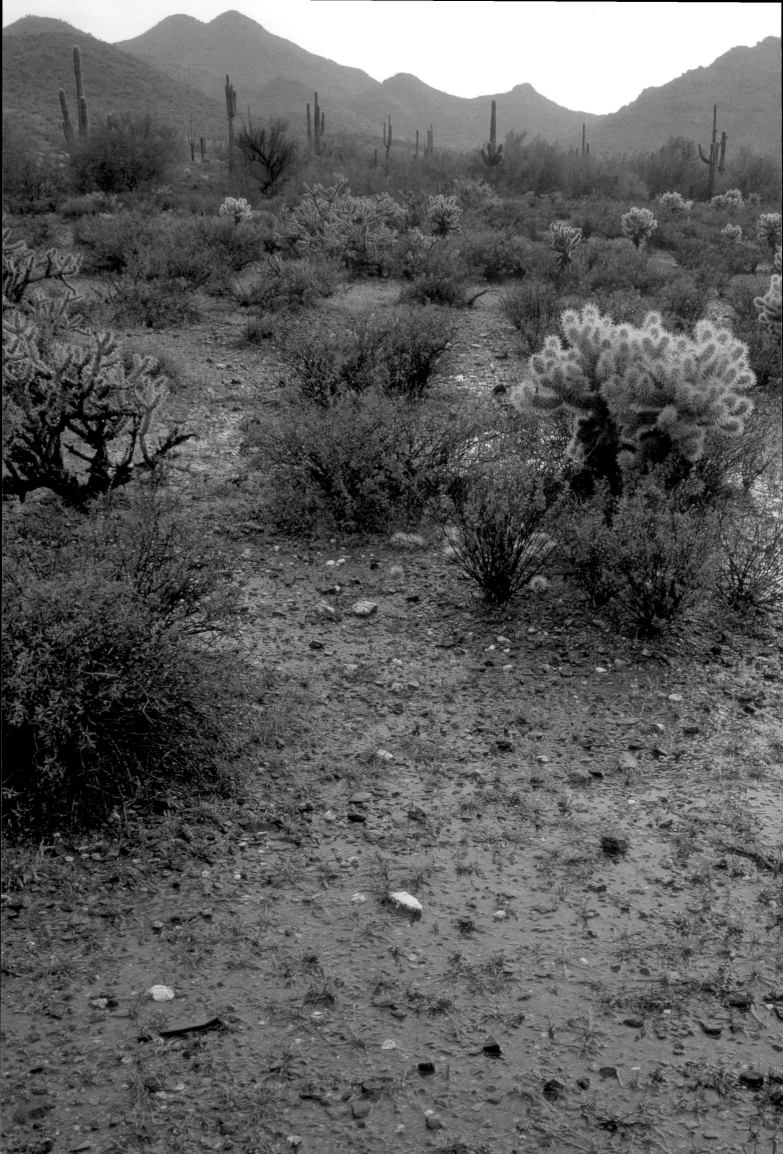

Rain

NATIVE

EXPRESSIONS

FROM THE

AMERICAN

SOUTHWEST

by Ann Marshall

introduction by
Ofelia Zepeda

HEARD MUSEUM PHOENIX
MUSEUM OF NEW MEXICO PRESS SANTA FE

Published by Museum of New Mexico Press in cooperation with the
Heard Museum. Copyright © 2000 Heard Museum. Art, objects, and
photography are subject to copyright restrictions. These rights are held
individually by the artist, maker, or Heard Museum. *All rights reserved.*
No part of this book may be reproduced in any form or by any means
whatsoever without the expressed written consent of the publisher.

Designed by Carol Haralson

Production supervision by David Skolkin
Project management by Mary Wachs
Photography by Craig Smith unless otherwise noted.
Manufactured in Hong Kong
10 9 8 7 6 5 4 3 2 1

Library of Congress Catague Number: 99-63764
ISBN: 0-89013-344-1 (PB)

Photographs
Cover detail and page 4: Cave Creek Arizona, Jerry Jacka;
page 1: Clouds over Hopi Mesa, Arizona, Owen Seumptewa, Hopi:
page 2: Hopi Mesas, Owen Seumptewa, Hopi; page 3: Navajo
Reservation, Arizona, Jerry Jacka; page 8: Hopi Tewa Senom dancers,
Craig Smith, 1997; page 12: Sonoran Desert, Arizona, Kevin Harris; page
15: Sonoran Desert, Arizona, Kevin Harris; page 144: Hopi Tewa Senom
dancer, Craig Smith, 1999.

MUSEUM OF NEW MEXICO PRESS
Post Office Box 2087
Santa Fe, New Mexico 87504

ꛩ Heard Museum
2301 N. Central Avenue
Phoenix, Arizona 85004

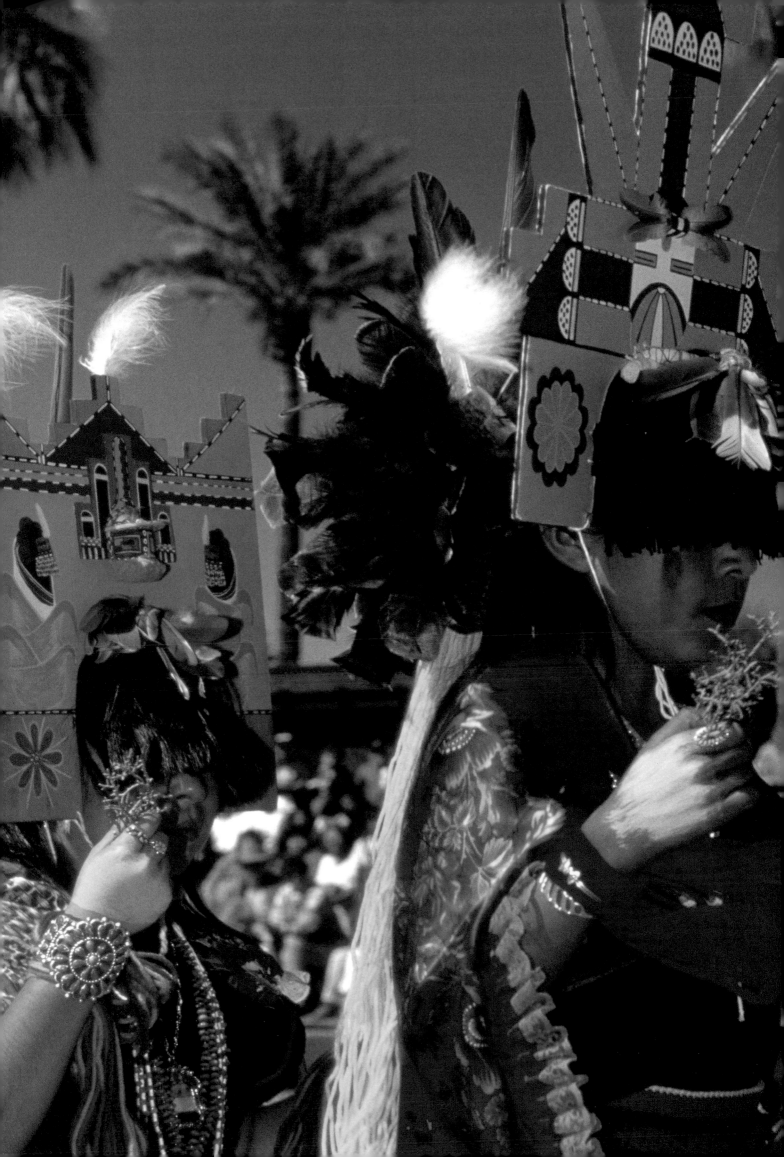

RAIN IS DIFFICULT TO FIND in the Southwest, but easy to find in the artistic creations of Native people who make their home there. Artists use designs and symbols of rain, lightning, clouds, thunder, rainbows, and many kinds of water animals in their work. In this way, the people are surrounded by thoughts, prayers, and wishes for rain and the good life that comes with it. For all of the cultures in this book, rain has deep meanings that reflect their unique experience with the universe. This spiritual relationship is far from the stereotypes and feeble jokes about the "Indian Rain Dance."

When I first mentioned doing an exhibit and book about rain's representations in Native art, some non-Native people said it couldn't be done—that it was too big, too abstract. But none of the Native people I talked to said it couldn't be done; when I suggested the idea, their first response was usually "hmm." They were intrigued with the idea. One person, whose heritage is Indé (Apache), thought a moment about rain-related symbols that had meaning for him and said, "Lightning." When Edgar Perry, who is Indé, began looking at baskets in the museum collection storage area, I asked, "Edgar, what are you looking for on the basket?" He said, "Lightning." The Indé live in the high mountains of eastern Arizona, where fierce summer storms boil up in the afternoon and lightning strikes all around.

Over the course of this project, I worked with seven Native Americans belonging to cultures that are well represented in the Heard Museum collection. The cultural expressions of rain shown in this book were selected by a person of that culture. Through their eyes, we can see the many ways that rain is brought into people's lives. Although all of them are knowledgeable about their respective cultures, none would claim to be a spokesperson for his or her people. They are Clifford Lomahaftewa (Hopi), Eileen Yatsattie (Zuni), Gary Roybal (San Ildefonso), Laura Roybal (San Felipe), Michael Chiago (Tohono O'odham/Pima/Maricopa), Joe Ben, Jr. (Diné), and Edgar Perry (Indé).

While reviewing the museum collection, I also searched the literature for expressions of rain. These include poems, ritual oratory, prayers, and songs. Because, as Gary Roybal says, "rain is life," it has been an inspiration for pleas, petitions, and praise for centuries. Rain is also part of important Native American ceremonies. Information about some of these ceremonies is considered sacred, not to be shared with the uninitiated. In addition, objects used in some ceremonies are not to be shown to outsiders. The people who contributed to this book are knowledgeable, but out of respect for restricted information within a culture, they took care to work only in areas where information may be shared with everyone.

The term "expressions" is used frequently in this book. Why not just call it art? Certainly some of the pieces, such as paintings and carvings, can be described as fine art, but others are referred to as cultural arts, for the people who create them and the purpose for which they were intended have no connection with the European-derived concept of art. As you look at the designs and symbols on these objects, remember that they are part of a whole and have meaning as part of that whole. Expressions of rain span centuries. Some of the forms may change, but the intent of their creators—to bring the blessings of rain into their lives and the world—remains the same.

This project was a great joy and an exciting experience in learning. I will never look at these objects in the same way—and that is a tremendous gift. There is much to learn. If you look for signs of rain, you can gain insights into how people see their worlds.

Lisa MacCollum, exhibits and graphics coordinator at the Heard Museum, provided good advice at all stages of this project. Paige Moriarty, Ann Douden, and Betsy R. Armstrong edited and advised initial work with the manuscript.

Thanks for initial funding of this project go to the Lila Wallace–Reader's Digest Fund. The Heard Museum is grateful to the Dr. and Mrs. Dean Nichols Publication Fund and to Life Trustee Mareen Nichols for funding the development of this publication and for continued support of Heard Museum publications that contribute to knowledge and understanding of Native American cultures and art.

Rain

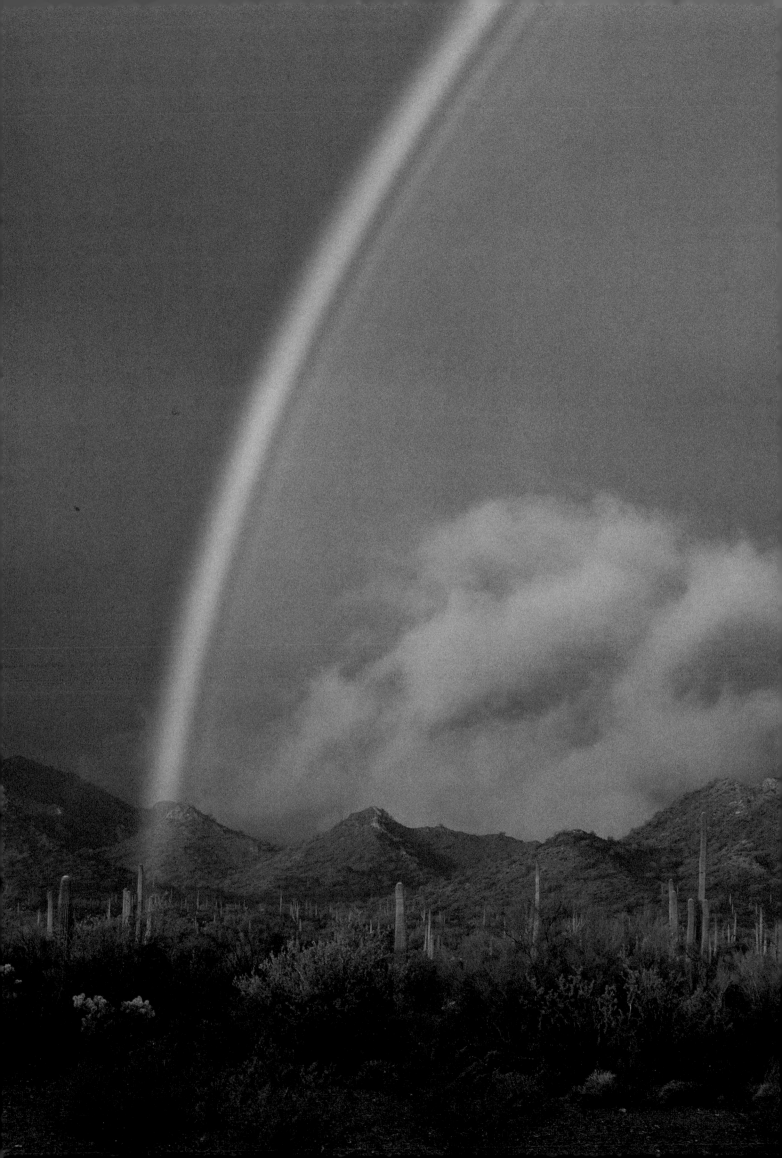

BY OFELIA ZEPEDA

On long hot summer days, the O'odham women's gaze is directed
toward the horizon with anticipation of thunderheads and breezes. By
mid-morning, as the heat of the land and air builds, white clouds
begin to slowly gather. The women seem to quicken their pace.
Laundry is hung quickly, they billow and twist in hard gusts of hot
wind. This wind that comes before the cooled wind of a summer
storm. There is time yet. By late afternoon, more clouds continue to
march up from the horizon. They are darker, blue and black, they
rumble as they ascend. The imagery of these movements is what
inspires the beauty of songs. The Pima Indians sing of this imagery,
likening the black clouds to the image of buzzards, black buzzards
circling, circling slowly in the distance, and suddenly they descend.

Rain

The Sun has move down that way a bit.
And yet it is so hot.
All movement has almost stopped.
A fly goes by so slowly.
Everything has slowed down.
My father is sitting there.
His head is tilted back and he's asleep.
My sister is laying over there, asleep.
The dog passed by, he is looking for shade.
Everything has slowed down.
And yet the clouds have slowly settled in.
It's raining, it's raining!
My father jumps up
"Run and cover my grain!"
"Run and get the clothes off the line!"
Everything is now moving and alive.
My sister is up,
The dog is up,
Everything is now moving and alive.

It is the women who in between their work judge the pace of the clouds. They are the ones often to give the first warning. They call children in, they move vulnerable animals inside. With covered heads and faces, protected from biting sand and debris, and with only a small opening for their eyes, they step lively, but with caution under the low hanging clouds, clouds so low, it would appear they could stretch out an arm and pull down a cloud in a single, swift motion.

Pulling Down the Clouds

N-ku'ibadkaj 'ant 'an o ols g cewagi.
With my harvesting stick I will hook the clouds.
Ant o i-wanno k o i-hudin g cewagi.
With my harvesting stick I will pull down the clouds.
N-ku'ibadkaj 'ant o "i-siho g cewagi.
With my harvesting stick I will stir the clouds.
With dreams of distant noise disturbing his sleep,
the smell of dirt, wet for the first time in what seemed like months
The change in the molecules is sudden,
they enter the nasal cavity.
He contemplates that smell.
What is that smell?
It is rain.
Rain somewhere out in the desert.
Comforted in this knowledge he turns over
and continues his sleep,
dreams of women with harvesting sticks
raised toward the sky.

In their preparation for the rain, they risked walking under the clouds with wisps of preliminary lightning riding just above their heads. These women gathered us all in, and for an unexplained reason make us sit and remain quiet. Our unusual childlike silence made the anticipated storm that much more exciting, that much more dramatic, and certainly that much more fearsome. And as children between the ages of eight and ten, we were certainly afraid. These women, my mother and grandmother, told us to fear these storms. They set examples of how to fear them. And we all learned well.

Like other children, we were not only told not to stand under a tree during a lightning storm, but were told not to be outside at all during a storm. Like many others, our family had elaborate fears that surely must have extended from more logical explanations since forgotten or ignored. My mother, for instance, during a lightning storm would make sure that all of the mirrors and other reflective surfaces were covered so as not to attract lightning. During these storms, we sat in the house without reflections. And it was from distant lines of stories that other explanations came about, some simply to be fantastic stories and others to teach and warn. For instance, some say that when one has naturally curly hair that it is very likely that something fantastic must have

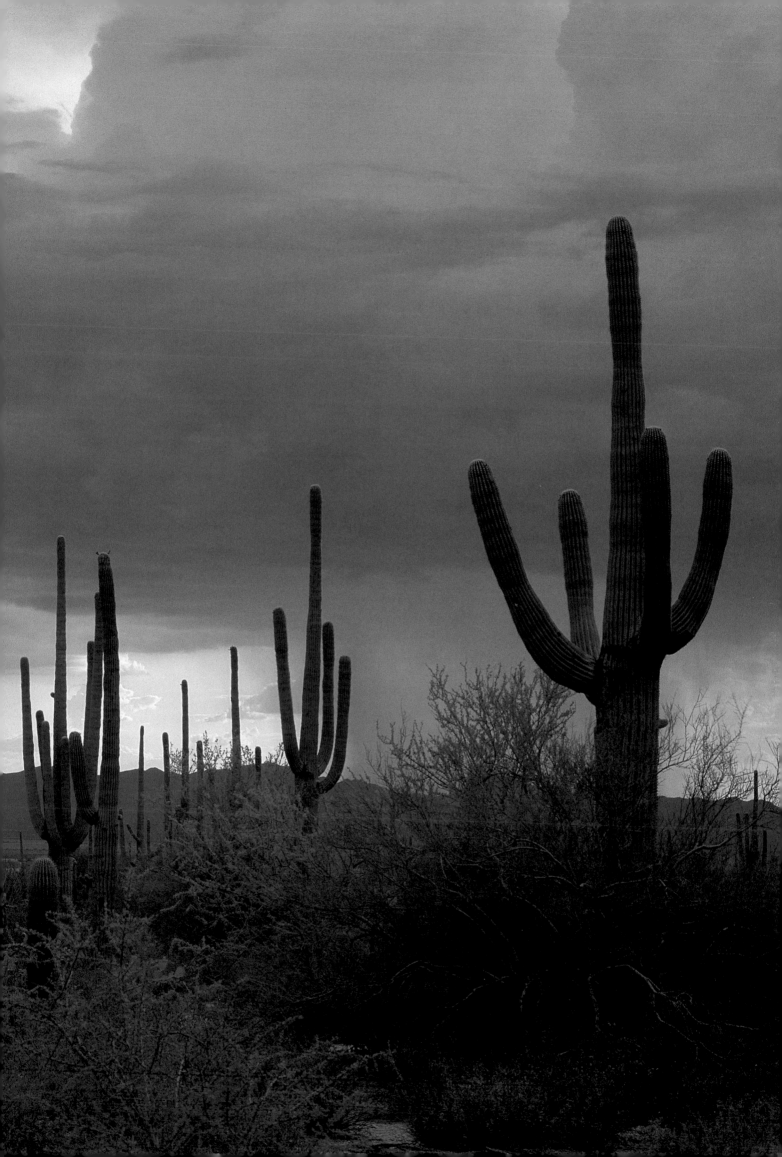

happened to the individual. They say that my grandfather had naturally curly hair as a result of standing beneath a funnel cloud and the cloud touched his head for a split second. "The snake vomited on my head," is what my sister remembers him saying when giving an explanation for why he has curls. Thus, one clearly takes chances when chasing funnel clouds, as surely a funnel cloud can cause death, or curly locks.

Similarly, another admonition concerns rainbows. Rainbows are things of beauty, signs of hope. As children, we were told not to point at a rainbow, amazingly enough, when that is the first impulse for a child or anyone upon seeing a rainbow. We were told if we pointed at it, the consequence was that our mother's breasts would go dry. The interpretation of such a harsh consequence is many-fold, especially for children. Visions of one's mother's breasts shriveled and dry might be the first to occur, when very likely the reference was that her milk would not be suitable for her babies if her child pointed at a rainbow. Such a responsibility held in a child's small hands.

The admonition regarding pointing extends to things beyond rainbows, but what is held in common is beauty and youth. O'odham children are also told, for instance, not to point at newly emerging plants in a garden without risking the young, little plant becoming embarrassed or startled and refusing to grow. Very likely the warning about pointing at rainbows is based on the same premise not to scare them away by literally pointing out their beauty.

However, with the fear there was a balance. These women showed us that balance. The balance came in the form of knowing the beauty of these desert storms. The beauty was in the air. The odor of wet dirt that precedes the rain. People like to breathe deeply of this wet dirt smell, it is the smell not only of dirt but of the dry bark of mesquite and other acacias. It is the smell of the fine dust that must settle on all the needles and spines of saguaro and all manner of cactus, the dust that settles on the fine leaves of ocotillo and other leafed plants. It is all those things that give off an aroma only when mixed by rain.

For many O'odham, the sensory nerves and memory have clinging to them that unique aroma of the creosote bush, the waxy covering when touched with just a small amount of moistness emits a pungent odor that is so strongly identified with the desert. For many, this aroma travels distances from vast desert floors and other small patches of desert, but nonetheless so strong that it is striking when it is inhaled. It is truly like inhaling wetness. It is an aroma so powerful that it does awaken O'odham from deep sleep during midnight summer storms. For many, the scent of the creosote is forever. Some O'odham when buried have stacks of branches from the creosote bush placed in their graves with them. It is medicine, it is a beautiful piece of the desert, it is a part of home.

Rain in any form, with any aroma, is appreciated no matter where an O'odham might reside. O'odham living in the city of Tucson look toward the mountains on those long July days, anticipating afternoon rain clouds. And on winter days when the soft rain of the "gentle rain months," November and December, fall, an O'odham is taken back to the rains of summer.

An unusually cold December day right around Christmas.
The clouds and mist find solace
in the canyons of the Santa Catalinas.
The white moisture lying quietly, moving amid cactus.
Truly, clouds, rain and wind are the few elements
that can touch a saguaro cactus from head to foot,
oblivious of the spines and needles.
Its rubbery hide allowing itself to be surrounded,
soothed, touched by the elements.
The contact triggers the stored heat
of remembered summers.
Moisture beads roll forward, unstoppable.
From the city below we see
mist rising, mist rising.

Ofelia Zepeda (Tohono O'odham) is a professor of linguistics and American Indian Studies at the University of Arizona. In 1999, she was named a MacArthur fellow in recognition of her work writing and teaching the O'odham language. She has published two books of poems, *Ocean Power: Poems from the Desert* and *Earth Movements*. Her work also appears in various anthologies including *Reinventing the Enemy's Language*, edited by Joy Harjo and Gloria Bird.

RAIN IN THE LAND

Over the past five thousand years, the climate and precipitation in the Southwest have not changed appreciably. The undependable aspect of rain that partially defines arid and semiarid lands has meant that drought, and to a lesser extent flood, are always possible. Where annual rainfall is eight to thirteen inches, a decrease of only a few inches in a given year can mean hardship. In the Sonoran desert, despite less than ten inches of rainfall, major river systems such as the Gila and Salt were once year-round streams. They rose in the high eastern mountains that form what is now called the Mogollon Rim. To the north, the Colorado and the Little Colorado were the major rivers, and in New Mexico, the Rio Grande was a focal point of residence. Not until the major water reclamation projects of the twentieth century were rivers dammed and diverted.

FROG EFFIGY
PENDANT,
A.D. 650—1100
Hohokam
Glycymeris shell
1 x 1

FROG EFFIGY BRACELET
FRAGMENT, A.D. 650—1100
Hohokam
Glycymeris shell
7/8 x 2 5/8 x 1

HISTORICALLY, PEOPLE OF SEVERAL NATIVE CULTURES HAVE ASSOCIATED SNAKES AND FROGS WITH RAIN. FOR THE HOPI, SNAKES ARE MESSENGERS CARRYING PRAYERS FOR RAIN TO SPIRITUAL DEITIES. IT IS NOT KNOWN WHETHER ANCESTRAL PUEBLO PEOPLE MADE SIMILAR ASSOCIATIONS. THE HOHOKAM DEPICTED FROGS AND SNAKES, ESPECIALLY RATTLESNAKES, ON JEWELRY AND STONE BOWLS. THEY ALSO CARVED FROGS ON SHELLS OF MARINE ANIMALS. THESE SHELLS WERE TRANSPORTED FROM THE GULF OF CALIFORNIA AND THE PACIFIC OCEAN ALONG TRADE ROUTES AND WERE MADE INTO PENDANTS, BRACELETS, AND RINGS.

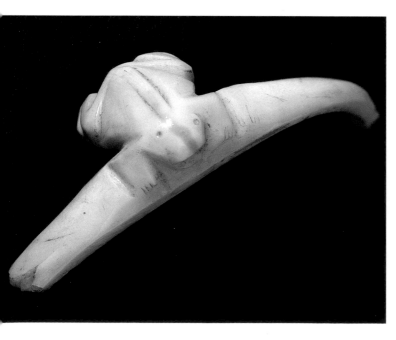

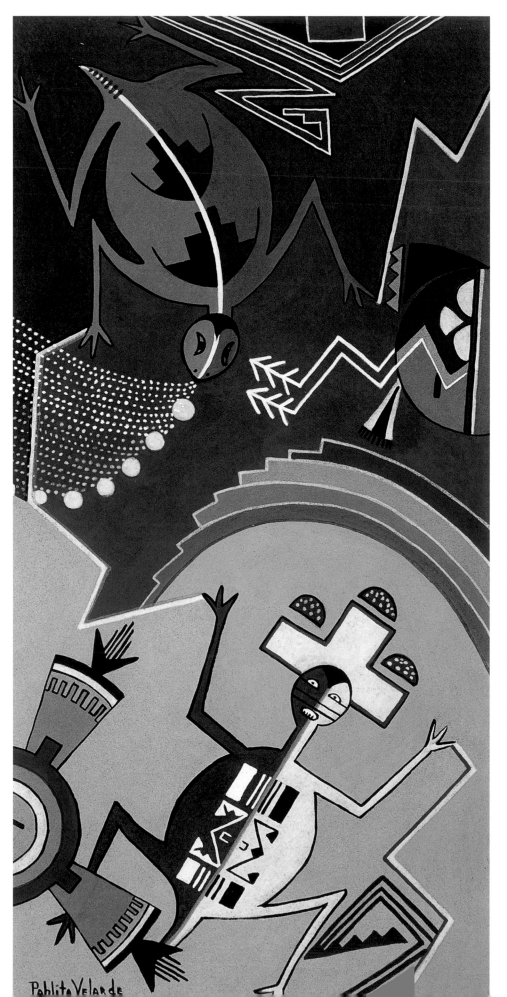

Pablita Velarde

AWATOVI MURAL
OF THEIR
SACRED SPRING,
1967
TseTsan/Pablita Velarde
Santa Clara
Earth pigments on
masonite
38 1/2 x 22 1/4

The kiva murals of the
Hopi village of Awatovi,
painted in the early
fifteenth century, include
images related to rain.
Pablita Velarde selected
some of these images for
her painting. She depicts a
lizard/horned toad figure
with a terraced cloud hat
and a rainbow arching
overhead. Another lizard
is spewing water and seeds
from its mouth. She says,
"I feel that I'm keeping
the old art alive by
painting the ancient way
with my earth pigments
and my traditional
designs. I feel that I'm
keeping them alive, and
they're keeping me alive"
(Mahoney, n.d., 18b).

19

The ancestors of Native people of the Southwest planned the location of their homes and fields to benefit from the rain. Some lived near the few permanent rivers; others relied on springs and wells for water. In the Sonoran Desert, the Hohokam were agriculturalists growing drought-resistant varieties of corn, beans, squash, and cotton. They also collected wild plant foods and hunted and fished. Until the abandonment of many towns around A.D. 1450, the Hohokam canal system grew, stretching over 300 miles in the Salt River Valley alone. Some individual canals were more than twenty miles long, and a large canal might be more than fifteen feet wide and ten feet deep. The Hohokam also grew crops using dry-farming techniques, planting in fields watered by the washes that flowed after summer rains.

THESE ANCESTRAL PUEBLO WATER PITCHERS AND JARS HAVE DESIGNS OF THE TYPE THAT INTRIGUED ARCHAEOLOGIST J. WALTER FEWKES IN 1904. THE SPIRAL DESIGNS ARE SURROUNDED IN MOST CASES BY STEPPED OR TERRACED ELEMENTS THAT RESEMBLE HISTORIC AND CONTEMPORARY CLOUD DESIGNS.

PITCHER, A.D. 1100—1300
Ancestral Pueblo
Tularosa black-on-white
Clay, paint
8 x 6

PITCHER, A.D. 1100—1300
Ancestral Pueblo
Tularosa black-on-white
Clay, paint
7 x 5 3/4

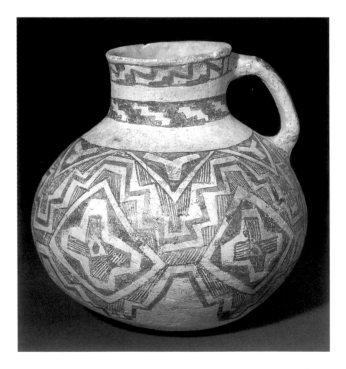

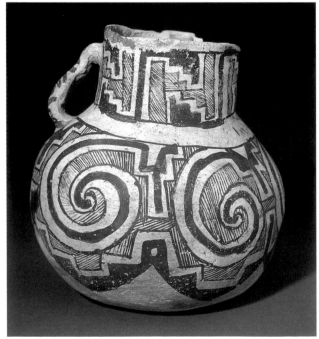

PITCHER, A.D. 1100—1300
Ancestral Pueblo
Tularosa black-on-white
Clay, paint
7 x 7 1/2

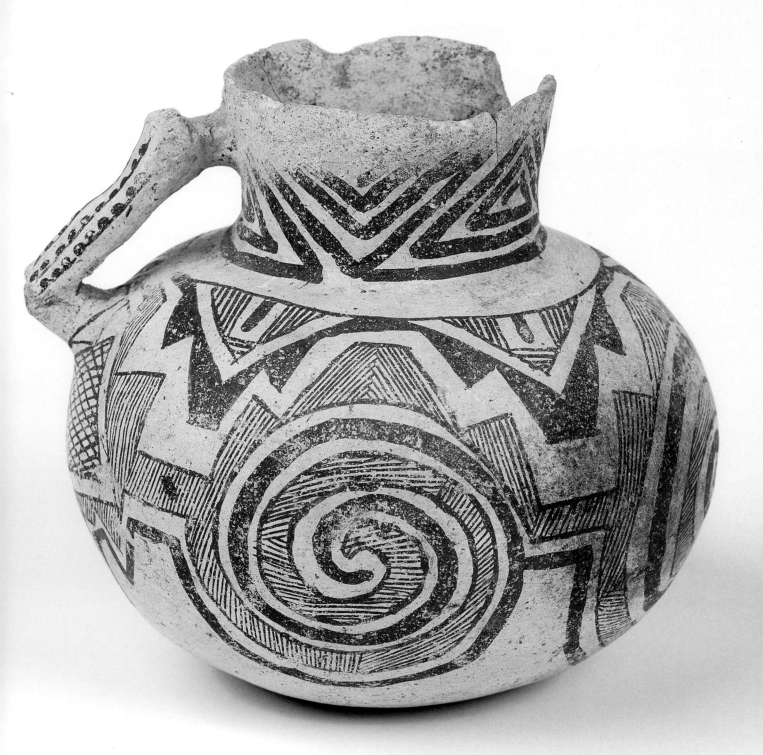

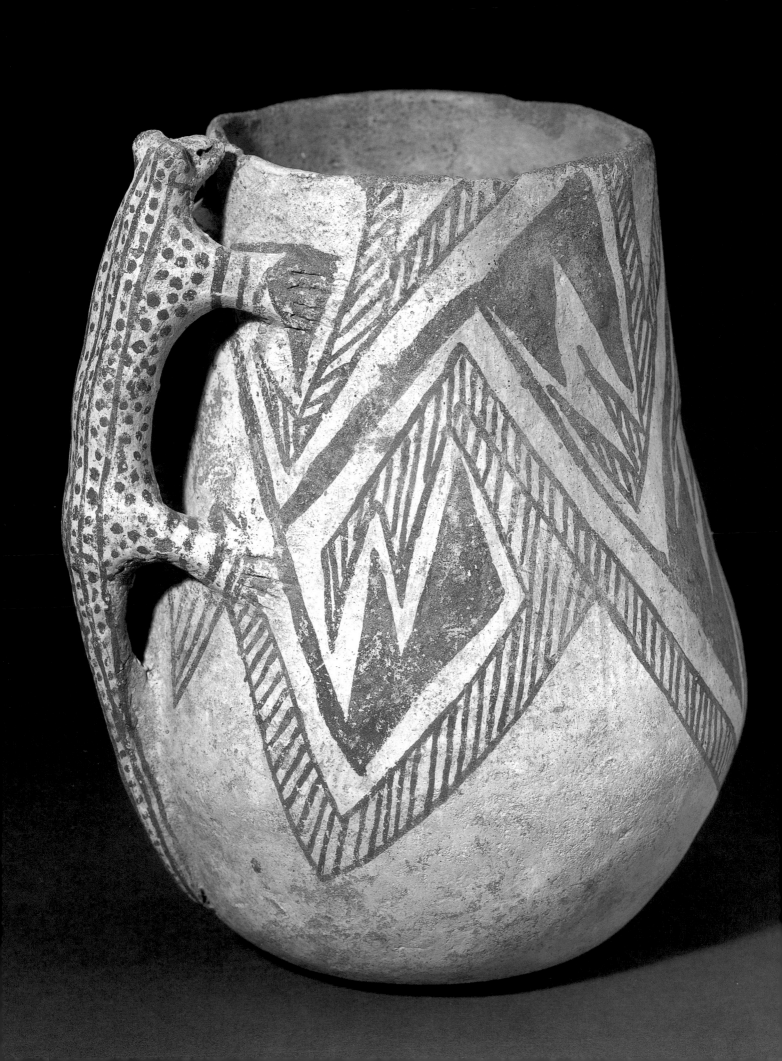

PITCHER
A.D. 950—1100
Ancestral Pueblo
Gallup black-on-white
Clay, paint
7 3/4 × 4 1/2

Animals of all kinds, from lizards to leopards, have been used on ancestral Pueblo, historic, and contemporary water containers. Often the animals are sculpted on the sides or form handles, as if approaching the pitcher rim for a drink of water.

People living at higher elevations received enough rain to practice dry farming but faced the problem of a short growing season. Field terraces and simple check dams made of boulders trapped and slowed the runoff of rainwater. People planted crops that could survive with little water and developed planting strategies to accommodate the sudden, unpredictable summer rains. An early variety of corn was probably first grown in the Southwest in these upland regions sometime between 2000 and 500 B.C. Here, as in the desert, agriculture gradually grew in importance as people moved to areas better suited to growing crops, settling in large numbers in pithouse villages.

Around A.D. 1000, the Pueblo tradition associated with intensive agriculture and fixed villages of the Colorado Plateau was much in evidence. Archaeologists track the ebb and flow of people across the Southwest based in part on correlation of wet years with drought years. Rainfall, as reflected in tree-ring growth and dating, has offered a window into the ways that ancient people coped with life in a dry land.

RAIN IN CEREMONY

What can we know of the rain-related ceremonies of ancestral people in the Southwest? Jemez historian Joe Sando comments: "The systematic raising of corn led to the shaping of Pueblo religion, with rituals and prayers for rain and other conditions favorable to the crops Various dances were held, according to the seasons: prayer dances for rain during the growing season, for snow during the winter season, and thanksgiving dances for a bountiful harvest or a successful hunt. These prayer and thanksgiving dances are the ceremonial dances of today, while the public dances held for entertainment are the social dances of today" (Sando, 1992, 24).

EXPRESSIONS OF RAIN

Did prehistoric people in the Southwest place images and symbols of rain and water on objects they made? The Hohokam carved animals associated with water, especially frogs, in marine shell and stone. Beginning in the fourteenth century in ancestral Pueblo communities, murals painted on the walls of ceremonial rooms depict katsina figures that were important cloud spirits and bringers of rain. (Katsina and the plural katsinam are spellings that more closely approximate the Hopi pronunciation of the word commonly spelled "kachina.") Here again, animals associated with water have a place. The mural painting of this period has inspired the work of contemporary Pueblo artists, including Pablita Velarde.

In 1904, archaeologist J. Walter Fewkes speculated about a possible link between spiral designs known to represent water in sixteenth-century Mexico and similar designs on prehistoric Pueblo pottery: "Although it is possible that the same symbol may have different meanings in the two regions, it is highly improbable that such was the case" (Fewkes, 1904, 535).

Some ancestral Pueblo people painted and carved rain-related subjects. Painted, terraced elements on ancestral Pueblo murals and ceramics resemble the cloud symbols of modern Pueblo cultures.

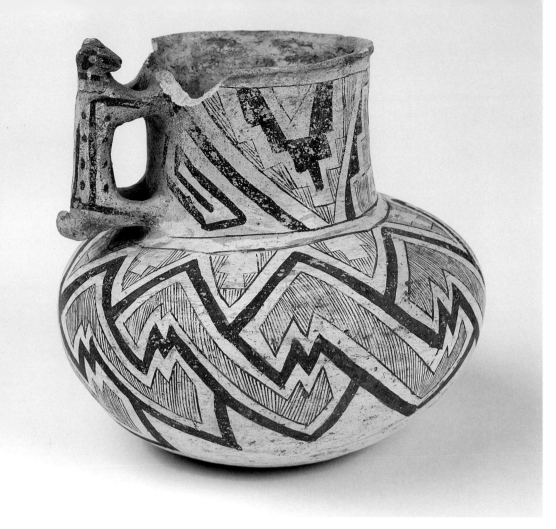

PITCHER
A.D. 1100—1300
Ancestral Pueblo
Tularosa black-on-white
Clay, paint
5 × 5 1/2

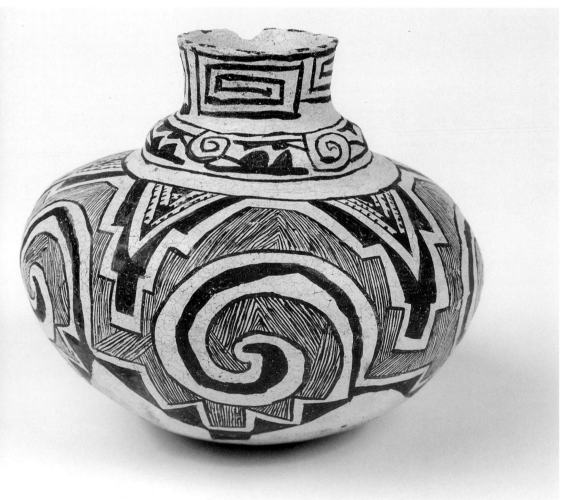

JAR
A.D. 1100—1300
Ancestral Pueblo
Tularosa black-on-white
Clay, paint
5 1/2 × 6 1/2

JAR
A.D. 1275—1325
Ancestral Pueblo
Pinedale polychrome
Clay, paint
4 1/2 × 3 1/4

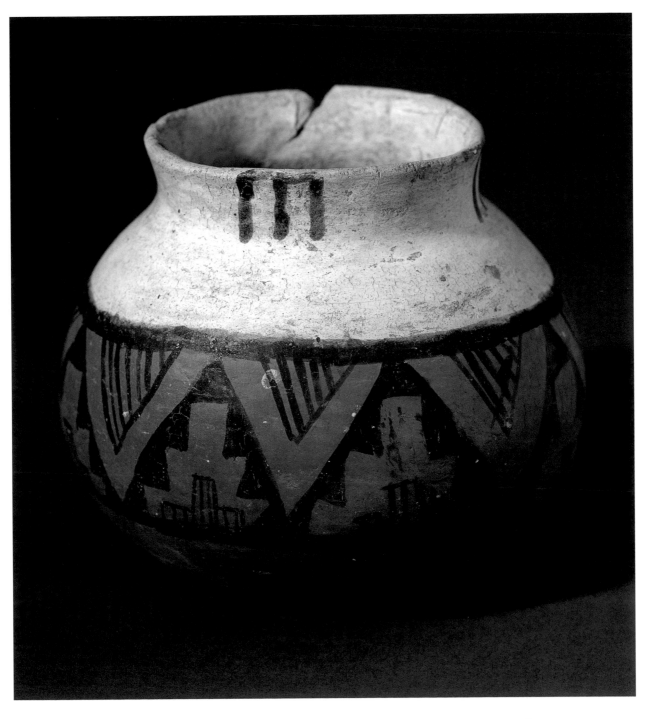

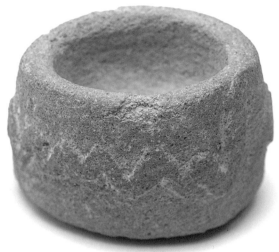

BOWL
A.D. 650—900
Hohokam
Stone
2 x 4 1/4

BOWL
A.D. 650—900
Hohokam
Stone
1 5/8 x 2 1/2

Two rattlesnakes encircle this bowl.

BOWL
A.D. 650—900
Hohokam
Stone
2 x 3 1/2

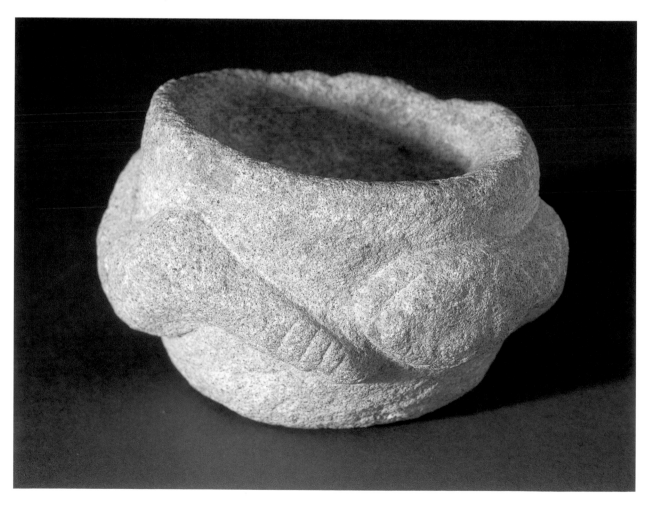

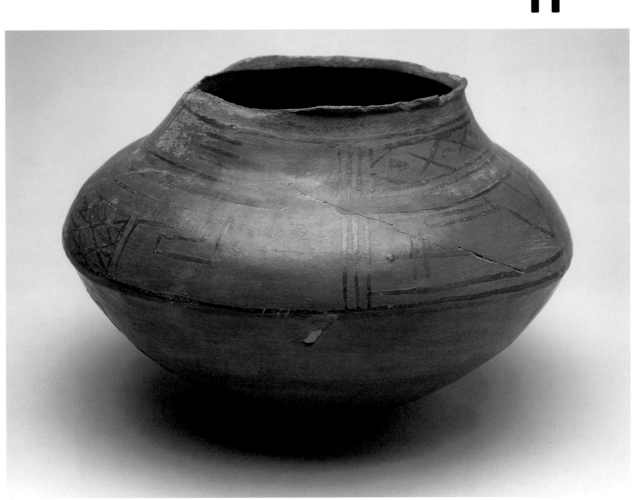

SCOOP
A.D. 900—1100
Hohokam
Clay, paint
3 × 5

Crossed snakes adorn
this ladle.

JAR
A.D. 1490—1550
Early Zuni
San Lazaro Glaze
Polychrome
Clay, paint
9 3/4 × 14

Bridging ancient and
modern, this jar
features a dragonfly, an
old and important water
animal at Zuni.

H O P I

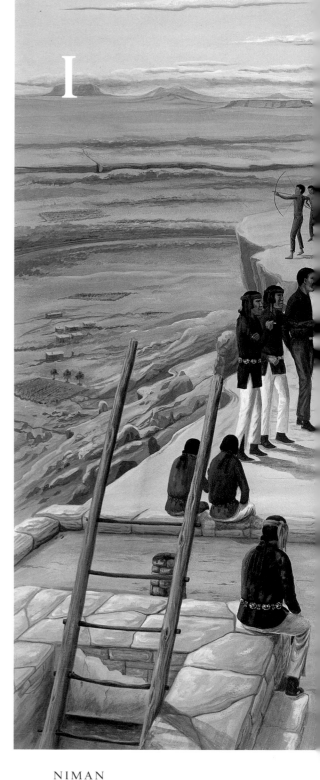

LOOKING FOR RAIN AT HOPI

Clifford Lomahaftewa, Hopi advisor

A Hopi elder of the Sun Clan, Lomahaftewa is from Sungopovi on Second Mesa. A resident of Phoenix, Arizona, he is active in village cere monies and makes katsina dolls, drums, and other cultural art. He had the richest field of objects to choose from because signs of rain and rain related phenomenon permeate many aspects of Hopi life and art. His knowledge of what may be shown to outsiders and his willingness to consult with others at Hopi in questionable areas were invaluable. He serves on the Heard Museum's Native American Advisory Committee.

DURING THE NIMAN CEREMONY, THE HEMIS KATSINAM PRESENT GIFTS AS PRAYERS FOR HEALTH AND PROSPERITY TO HOPI CHILDREN BEFORE RETURNING TO THEIR HOMES IN THE SAN FRANCISCO PEAKS. GIFTS INCLUDE BOWS AND ARROWS FOR BOYS AND KATSINA DOLLS FOR GIRLS. THE GIFTS ARE TIED TO CATTAILS, WHICH ARE WATER PLANTS. THE HEMIS KATSINAM ALSO CARRY CORN AND WATERMELON, SYMBOLIZING SUCCESSFUL PRAYERS FOR RAIN. THE FIGURE IN A KILT WITH HIS HAIR WORN LONG TAKES CARE OF THE KATSINAM. HE IS SHOELESS BECAUSE HE IS PRAYING FOR RAIN. CLIFFORD LOMAHAFTEWA SAYS, "IF HE SEES CLOUDS COMING, HE WILL PUT HIS SHOES ON. OTHERWISE, HE WILL STAY BAREFOOT."

NIMAN
CEREMONY AT
WALPI VILLAGE,
C. 1965
Ray Naha, Hopi
Oil on composition board
41 x 61

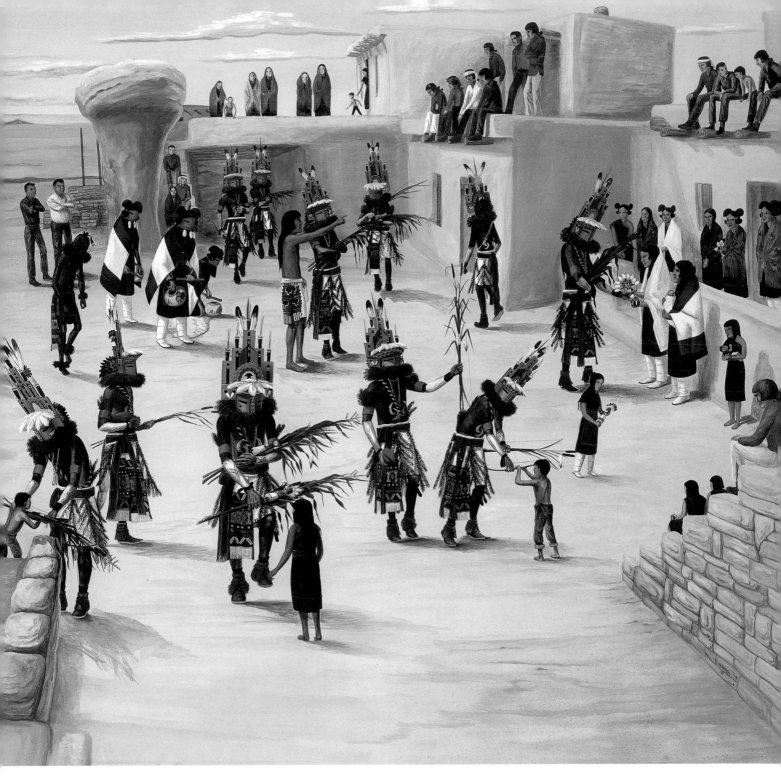

"We may have just a few crops in our fields, but when you bring the rain they will grow up and become strong. Now go back home happily, but do not forget us. Come to visit us as rain."

—Speech to the katsinam at the conclusion
of the July Niman ceremony by the Katsina Father

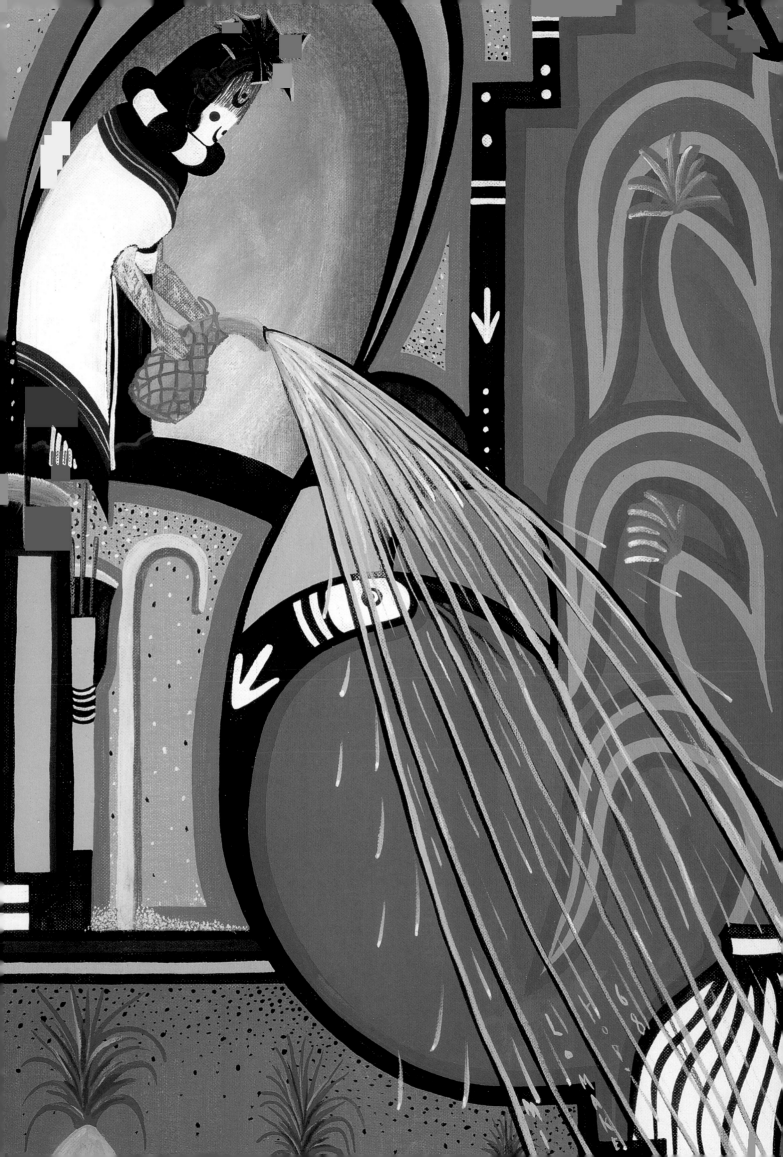

KATSINA
MOTHER
WATERING
CORN, 1968
[DETAIL]
Dawakema/
Milland Lomakema,
Hopi
Acrylic on canvas board
30 × 15

The Katsina Mother
carries a gourd from
which she sprinkles
water during certain
ceremonies. Here she is
shown watering the corn
plant that represents life
for Hopi people. During
the Pachavu ceremony,
she pours water over the
heads of children to
make them grow.

The Hopi people live in northern Arizona at the heart of the Colorado Plateau. Their twelve villages are located on and immediately below three high sandstone mesas that are "fingers" of the larger Black Mesa. From east to west, the mesas are named First, Second, and Third. Ephemeral streams flow down between the mesas to the plains below. The land is celebrated for its beauty and color, which is the colors of sandstone: pink, red, buff, and yellow. Of all the lands on which the Pueblo agriculturalists live, Hopi land is the driest. Every drop of precipitation, rain or snow, is important in a place where the annual average is slightly more than ten inches. Hopi land is high country, around 6,000 feet in elevation, and winters are cold, with nightime temperatures dropping into the 20s. In this arid environment, the vegetation consists mainly of sagebrush, saltbrush, and juniper.

CEREMONIAL
HOES, 1920s—1930s
Hopi
Cottonwood, kaolin, paint
6 1/4 × 7 1/2 × 3 3/4

These hoes are painted
with rain clouds. They are
carried by the Kuwan
Heheya Katsina as part of
the ceremonial dances that
occur in the spring and
summer preceding Niman.
Kuwan Heheya appears in
line dances that take place
in the village plaza. These
ceremonies are held when
crops are beginning to
mature and rain is critical
to their growth.

HAHAY-IWUUTI
KATSINA DOLL,
C. 1974
Richard and Patsy
Carillo,
Laguna and Hopi
Cottonwood root, paint,
fox skin, pigeon feathers,
yarn, commercial cloth,
synthetic fiber
11 1/2 × 7 1/2 × 5

In addition to being
recognized as the Mother
of Katsinam, this doll
represents a katsina
associated with water
spirits. There is a rain
cloud design on the water
gourd in her left hand.

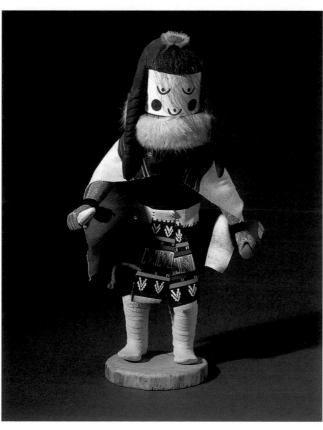

Even in such small quantities, rain and snow are essential for bringing fertility, growth, health, and well-being to the Hopi people. Agriculture, especially the growing of corn, has been important for centuries and today provides income as wage work increases in importance. Crops include corn, beans, squash, melons, peaches, and apricots. They are planted in the spring, usually April, which can be a dry time between winter snow and summer thunderstorms. The growing season at Hopi is short. Combined with aridness, it means that plants must be well adapted to rigorous conditions. By planting crops in a variety of places, Hopi farmers make the best use of available water. Crops are grown at the base of the mesas in several different locations. Some are planted at the mouths of washes, where sand dunes capture runoff from the mesa tops; in a dry summer, the mouths of these washes are the most likely places to find water. Crops are also planted farther from the washes; during a relatively wet summer, crops in the mouths of washes will be swept away, but those a bit more distant will be watered. Windbreaks are needed to retain soil and moisture and to keep sand from covering the crops.

Rain can have a very personal role in a Hopi person's life and identity. It can be part of a name, a clan affiliation, or a personal symbol. For example, potters and jewelers of the Water Clan sign their work with a rain cloud, a practice that began in the 1930s. Names such as Yellow Cloud and Frog Woman are tied to moisture and a good life.

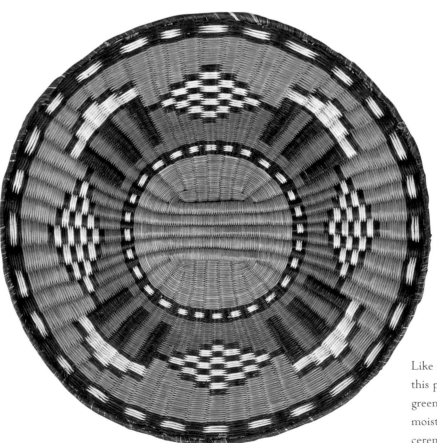

BELT, KILT, SASH, 1983
Mike Gashwazra, Hopi
Wool, cotton
3 1/2 × 87 (BELT)
23 3/4 × 54 1/2 (SASH)
23 3/4 × 57 (KILT)

The belt, sash, and kilt are worn in Hopi ceremonies. The paired vertical lines with hooks on the sash represent a dragonfly, which is associated with water, and the red lozenge shapes are flowers. The red side borders show the sash is from Oraibi Village on Third Mesa.

The terraced designs on the kilt are the clouds; the green part is the earth; and the red lines are the sun's rays.

According to Clifford Lomahaftewa, young Hopi men are given a kilt, belt, and sash by their godfathers when they are initiated into manhood.

The technique used to weave the belt seems to have been developed before the 1600s. A similarly constructed belt may be depicted in kiva murals from the prehistoric Hopi village of Awatovi.

PLAQUE, 1968
Hopi
Rabbitbrush, sumac, dye
14 3/4 × 1 1/2

Like a landscape painting, the design on this plaque depicts snow clouds above the green earth in the center. At Hopi, winter moisture from snow is important, and ceremonies in December may be conducted during snowstorms.

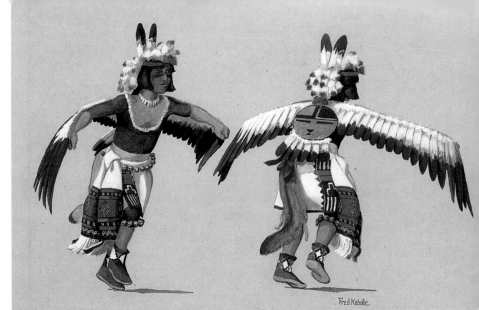

EAGLE DANCERS, 1925
Fred Kabotie, Hopi
Watercolor on paper
9 1/4 × 12 1/2

Kilts with cloud and rain symbols are worn throughout the annual cycle of ceremonies at Hopi.

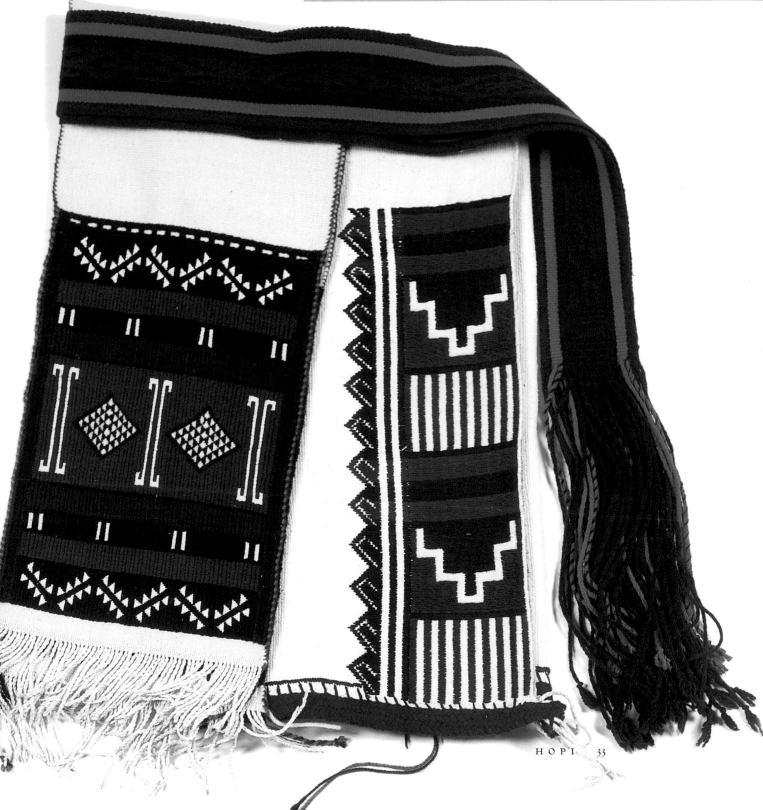

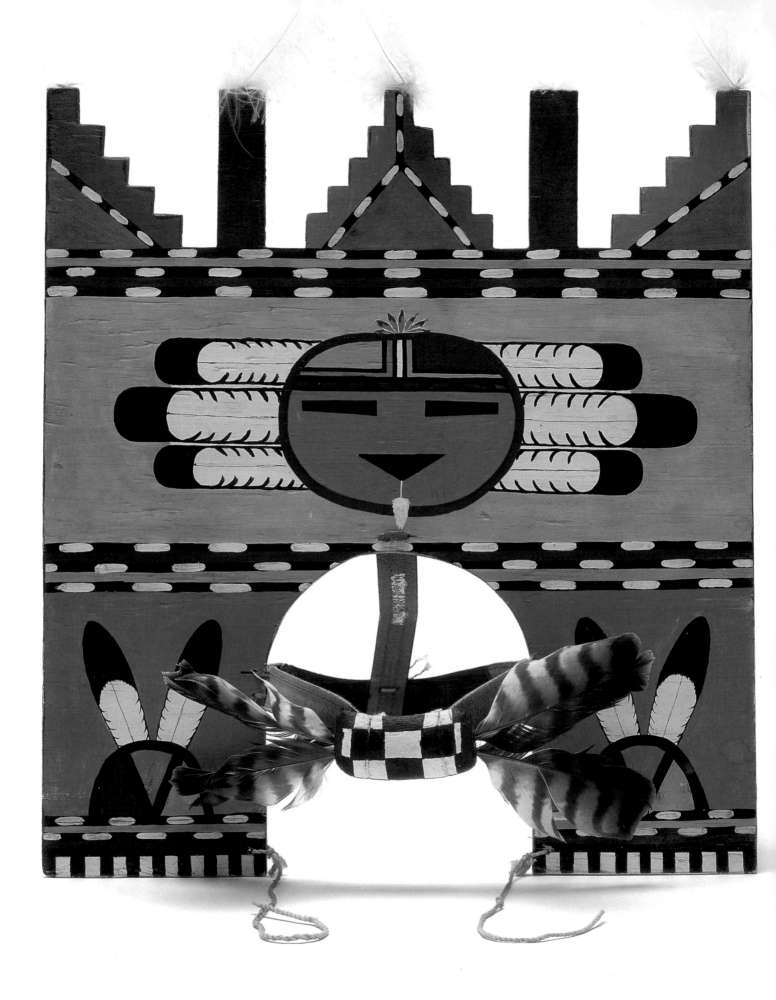

34 Rain

HEADPIECE,
C. 1960
[FRONT SHOWN
AT LEFT, BACK
SHOWN AT
RIGHT]
Hopi
*Plywood, water-based
paint, cowhide, turkey
feathers, gray hawk
feathers*
18 x 16

This headpiece, in Hopi language a kopatsoki, as seen from the front and back, has feather plumes representing clouds and a row of stepped clouds along the top. On the bottom, the black lines represent falling rain. According to Clifford Lomahaftewa, the entire headpiece is a rain cloud. The relationship to growth of crops and vegetation is evident on the back; corn represents life for the Hopi people.

RAIN IN CEREMONY

The katsinam and the carved figures representing katsinam are one of the most widely known elements of Hopi culture. Katsinam are the spirit essences of all things in the natural world and come to Hopi in the form of rain-bringing clouds. After death, a Hopi person continues a spiritual existence as a life-sustaining katsinam. Beginning with Powamuya, usually in February, and ending with Niman in July, a cycle of ceremonies unfolds in the villages with the central purpose of bringing the blessings of rain. As Clifford Lomahaftewa says, "Anything that Hopis do, it's for the rain; in any kind of dances, even your social dances, they still have to pray for the rain or a good summer or good days ahead. . . . it's all connected." He describes another fundamental tenent of Hopi culture: that the ceremonies are for "all the people . . . throughout the world; not just for themselves, but . . . for everybody . . . [to] live in harmony. . . . That's what it's all about."

EXPRESSIONS OF RAIN

Expressions of rain are found everywhere on objects made by Hopi people. A variety of clouds—rain clouds, snow clouds, and blowing clouds—are depicted, as are rain-related phenomena like lightning, rainbows, and animals who dwell in or around water. Birds, as messengers to cloud spirits, are part of many rain-related expressions at Hopi. These representations can be realistic or abstract and are placed on everyday objects, ceremonial objects, and those made expressly for sale. When artists paint groups of clouds, they often use different colors. To Hopi elder Clifford Lomahaftewa, these varied colors represent the idea that Hopi ceremony is for all people, regardless of color.

Emory Sekaquaptewa, Hopi scholar and professor at the University of Arizona, told author Stephen Trimble that "the most creative medium in the Hopi language are the songs of the katsinas. In the songs, we find words that dwell on natural forces at work for the benefit of mankind, language filled with the energy of Hopi thought. One katsina song has cloud maidens grinding rain just as a Hopi maiden grinds corn, to prepare it, to bring this life force to the People" (Trimble, 1993, 109).

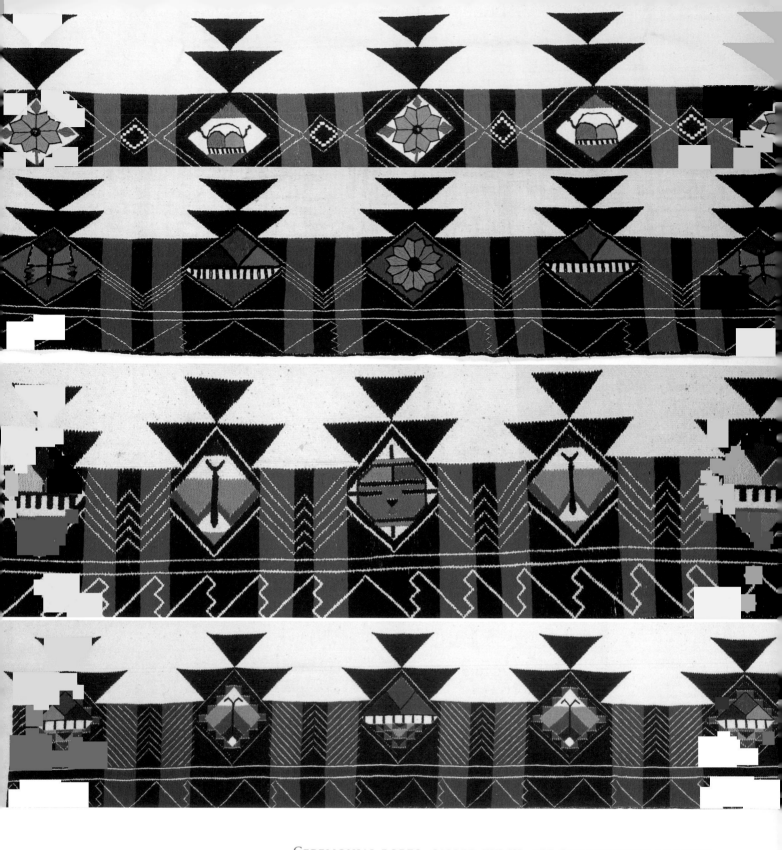

CEREMONIAL ROBES, CALLED TUI.HI, ARE EMBROIDERED AT THEIR

HEMS WITH IMAGES IN LOZENGE SHAPES. THESE IMAGES CONNECT RAIN

WITH THE GROWTH OF ANIMAL AND PLANT LIFE AND FERTILITY.

SOMETIMES THE LOZENGE SHAPES ARE SMALL WINDOWS ONTO

LANDSCAPES OF BLUE SKY, PLANTS OR BUTTERFLIES, AND GREEN EARTH.

FACING, FROM TOP TO BOTTOM [DETAILS]

CEREMONIAL ROBE, EARLY 1900s
Hopi
Wool, cotton, commercial wool yarn
76 × 54

Among the sunflowers on this robe are images of rain clouds and lightning, underscoring the connection between rain and plant growth. Before it was embroidered, it was a wedding robe.

CEREMONIAL ROBE, EARLY 1900s
Hopi
Cotton, commercial wool yarn
66 × 48 1/2

This robe displays a sunflower in its center, bordered on both sides by rain clouds and butterflies. The rain from the clouds falls on the green earth below.

CEREMONIAL ROBE, 1940s—1960s
Hopi
Cotton, commercial wool yarn
47 1/2 × 67

The Sun Katsina face is flanked on both sides by rain clouds and butterflies. The mouth is embroidered in a style distinctive to First Mesa villages at Hopi.

CEREMONIAL ROBE, PRE—1926
Zuni and Hopi
Cotton, commercial wool yarn
77 × 49

The large size of this robe, with butterflies and rain clouds, suggests that it was woven, and probably embroidered, at Hopi but used in a Zuni Shalako ceremony.

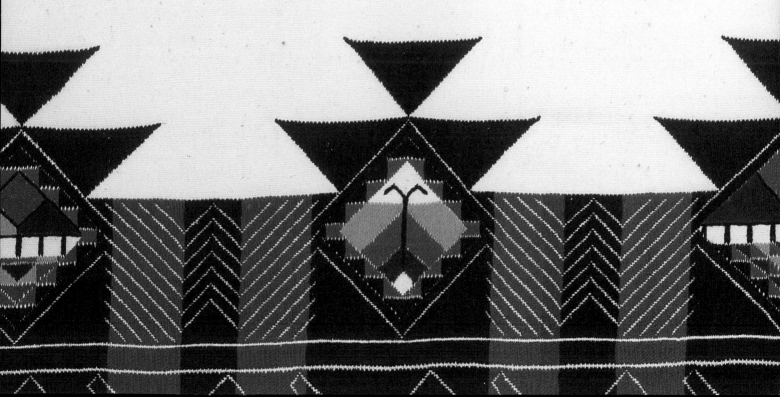

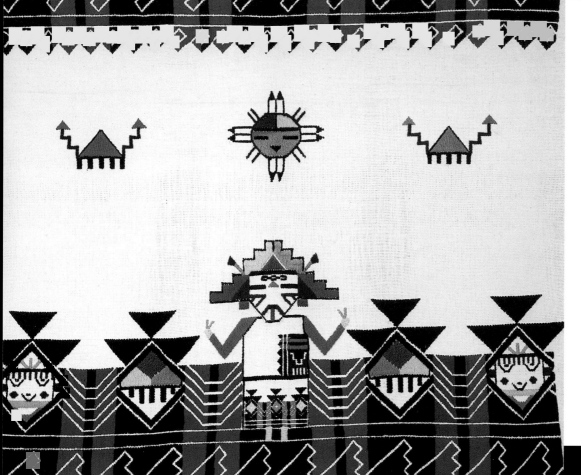

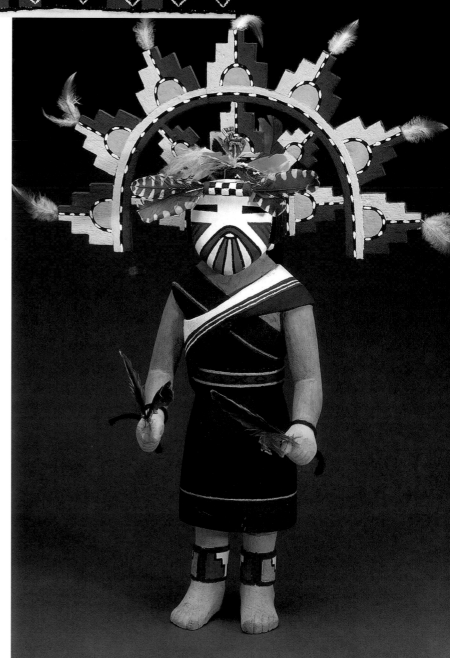

WATER MAIDEN
KATSINA DOLL,
EARLY 1960S
Hopi
*Cottonwood root, latex
paint, red-tailed hawk
feather, pheasant feather,
parrot feather, American
robin feathers*
20 INCHES IN HEIGHT

This doll is crowned with a
headpiece of many rain
clouds, and cloud designs
are also depicted on her
leggings. A rainbow covers
her chin.

CEREMONIAL ROBE,
EARLY 1900S
*Fred Shumia, Hopi
Collected at Walpi, First Mesa
Cotton, commercial wool yarn*
48 × 55

The distinctive full figures and
extensive embroidery on this robe
led curator Nancy Fox (1981, 61) to
identify Fred Shumia as the
maker. Rain clouds with lightning
are on either side of the face of
Tawa, the sun. The cloud‹ and
rainbow‹crowned figure of Pahliko
Mana is surrounded by rain
clouds and the face of the Katsina
Mother, Hahay'iwuuti. Images of
rain on these robes illustrate
Clifford Lomahaftewa's statement
that "everything we do is for rain."

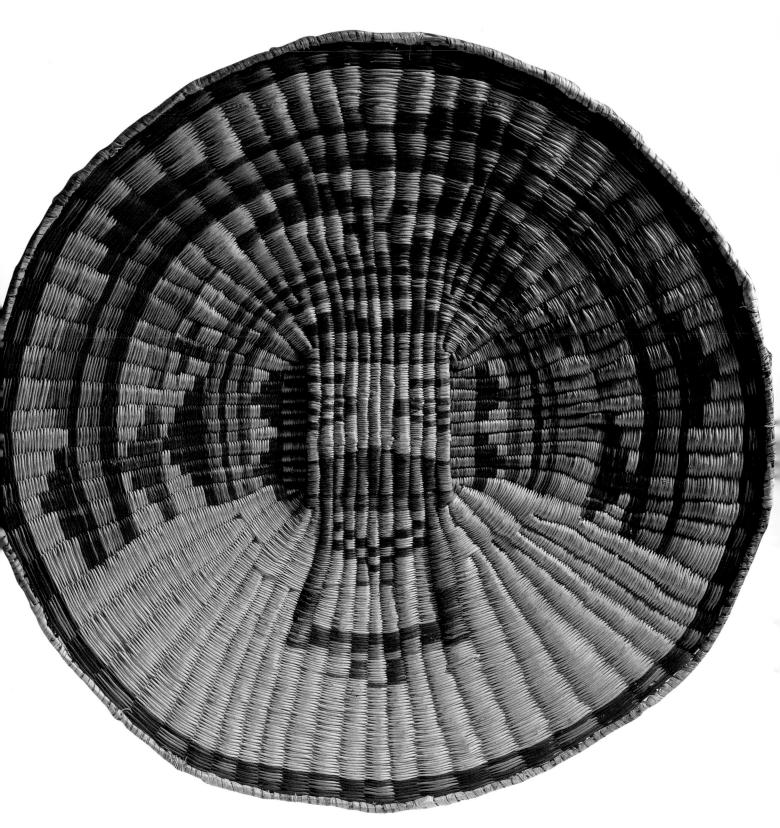

PLAQUE, EARLY 1900s
Hopi
Rabbitbrush, sumac, yucca,
kaolin, dye
23 1/2 INCHES IN DIAMETER

Four rows of clouds and rainbows
surround the head of this
katsinmana.

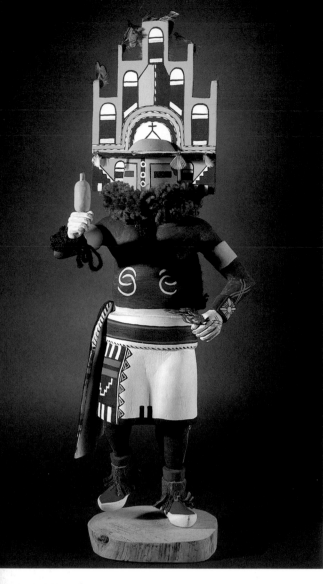

ABOVE LEFT

HEMIS KATSINA DOLL, C. 1983
Tino Youvella, Hopi
Cottonwood root, paint, chicken feathers, pigeon feathers, yarn
20 1/2 x 7 1/2 x 8

This doll depicts the Hemis Katsina, who is part of the Niman Ceremony held in July. Its headdress is in the shape of a cloud, and feathers representing clouds are along the top. Cloud designs can also be seen on the embroidered kilt. All katsinam are associated with rain. These dolls were selected by Clifford Lomahaftewa to illustrate some of the ways in which rain is expressed through katsina dolls.

RIGHT

TWO-HORN KATSINA DOLL, 1970s
Hopi
Cottonwood root, thread, turkey feathers, rabbit fur, plastic
15 INCHES IN HEIGHT

Rain clouds are painted on the face of this katsina doll.

BELOW LEFT

SNOW KATSINA DOLL, 1970s
Hopi
Cottonwood root, paint, yarn, pigeon feathers, cowhide, cotton string, turkey feathers
18 x 9 3/4 x 6 1/2

This doll depicts the Snow Katsina, who is responsible for bringing the cold and essential winter moisture to the Hopi mesas. Lightning bolts and rainbows surround his head, and snow clouds surround his eyes.

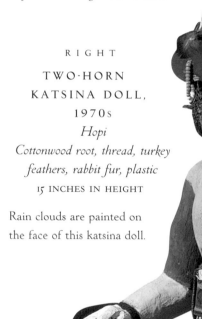

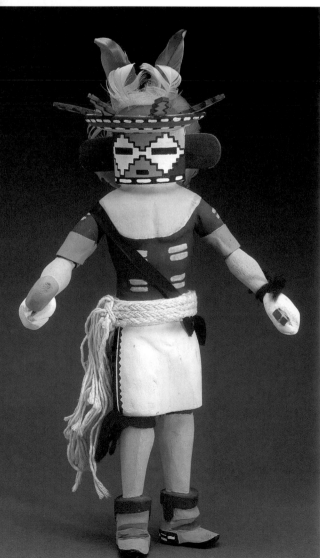

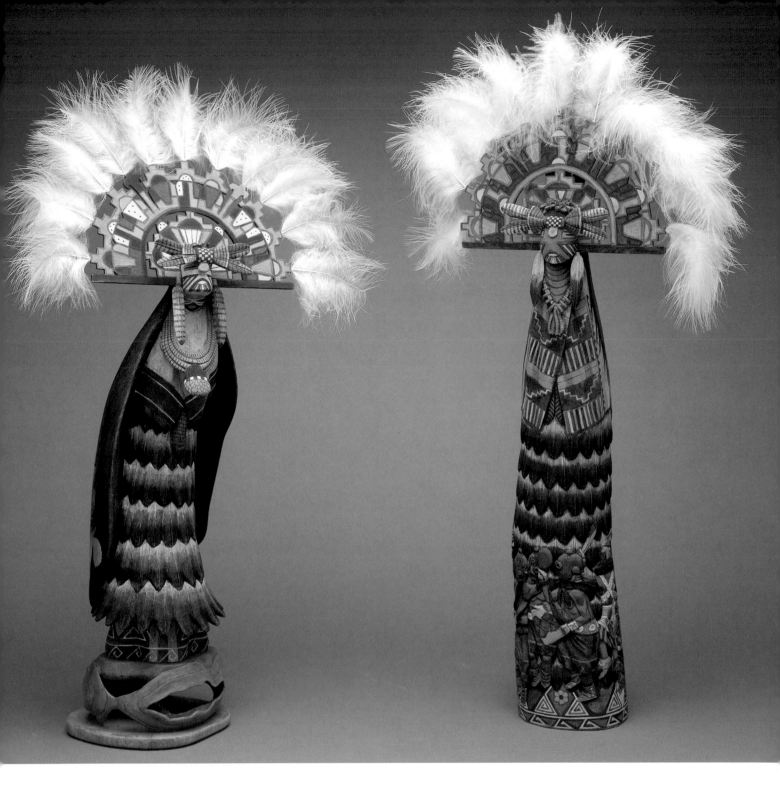

SALAKO TAKA AND SALAKO MANA, C. 1992
Brian Honyouti, Hopi
Cottonwood root, paint, unidentified down feathers
26 x 14 x 8 (MALE), 26 x 15 x 8 (FEMALE)

The male Salako Taka (pink face) and his female companion
appear together when an initiation is part of the final Niman
ceremony before the katsinam return to their homes. These are the
tallest of the katsinam. Their headdresses of clouds and rain reach
into the sky, rain falls from their eyes, and rainbows flow from their
mouths. The male wears the kilt with cloud symbols as a cape.
Brian Honyouti carved on these figures scenes from the ceremony
in which they appear.

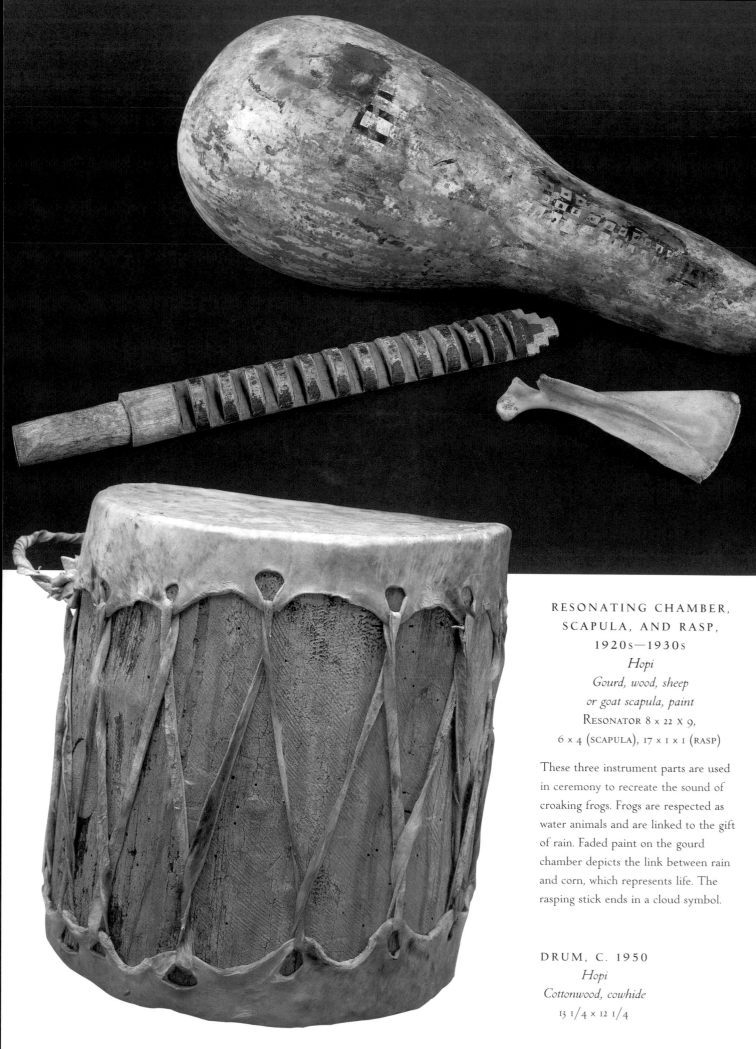

RESONATING CHAMBER, SCAPULA, AND RASP, 1920s—1930s
Hopi
Gourd, wood, sheep
or goat scapula, paint
RESONATOR 8 × 22 × 9,
6 × 4 (SCAPULA), 17 × 1 × 1 (RASP)

These three instrument parts are used in ceremony to recreate the sound of croaking frogs. Frogs are respected as water animals and are linked to the gift of rain. Faded paint on the gourd chamber depicts the link between rain and corn, which represents life. The rasping stick ends in a cloud symbol.

DRUM, C. 1950
Hopi
Cottonwood, cowhide
13 1/4 × 12 1/4

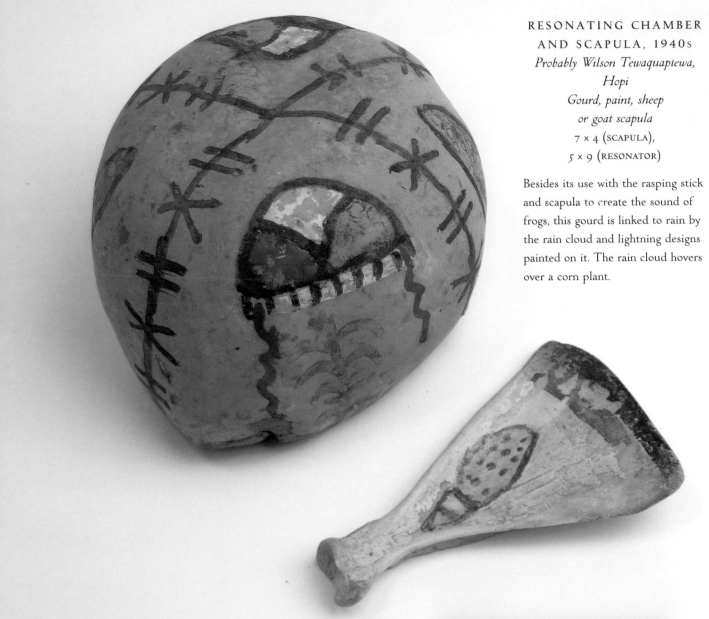

RESONATING CHAMBER AND SCAPULA, 1940s
Probably Wilson Tewaquaptewa, Hopi
Gourd, paint, sheep or goat scapula
7 × 4 (SCAPULA), 5 × 9 (RESONATOR)

Besides its use with the rasping stick and scapula to create the sound of frogs, this gourd is linked to rain by the rain cloud and lightning designs painted on it. The rain cloud hovers over a corn plant.

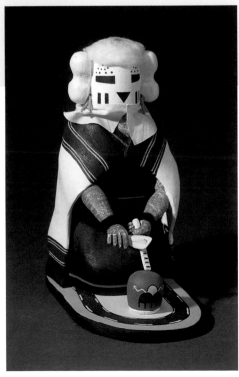

SNOW MAIDEN KATSINA DOLL, 1973
Hopi
Cottonwood root, cotton, paint, glass beads, plastic
9 × 4 1/2

Like rain, snow is a blessing to the earth. This katsina appears at the Niman ceremonies as a prayer for the upcoming cold weather that will cover the Earth with moisture in the form of snow. The gourd resonator and rasp are used to make the sounds of frogs, water animals. Rain clouds are depicted on the gourd resonator.

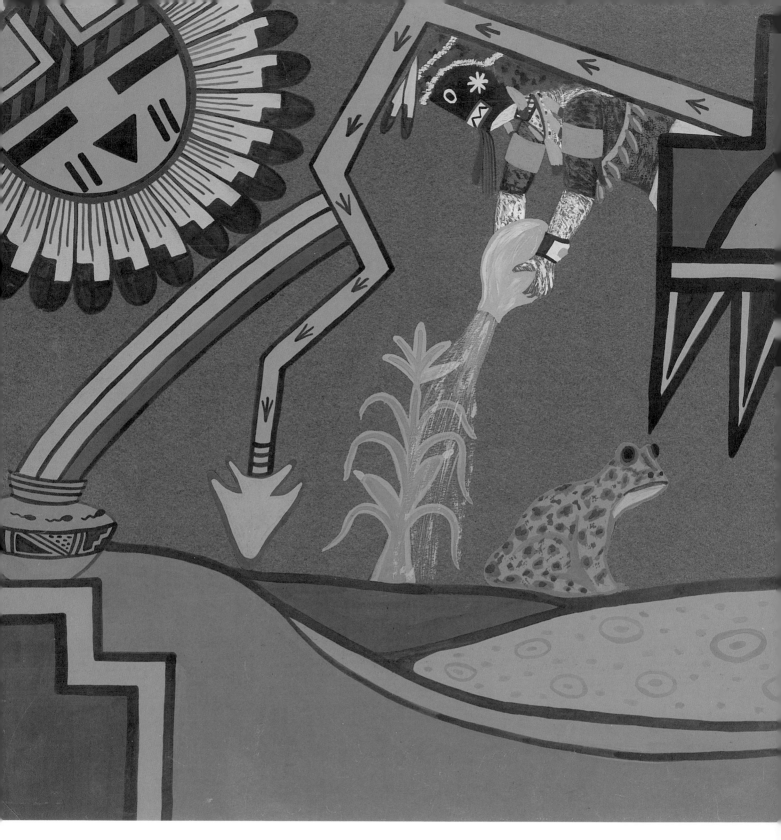

SUMMER RESULTS
Dawakema/Milland Lomakema, Hopi
Tempera paint on green posterboard
19 × 23 3/4

A Chakwaina katsina waters a corn plant as
he leans out of a bank of rain clouds.
Lightning shoots out around his body and a
rainbow ends in a water jar that is decorated
with clouds and tadpoles. The frog, a symbol
of water and growth, sits at the edge of a pool.

TWO WARRIOR KATSINAM, 1967
Dawakema/Milland Lomakema,
Hopi
Tempera on paper
14 1/2 x 12

All of the links between rain and the growth of plant (corn) and animal life (tadpoles) are evident in this painting. Watching over it all are Warrior Katsinam.

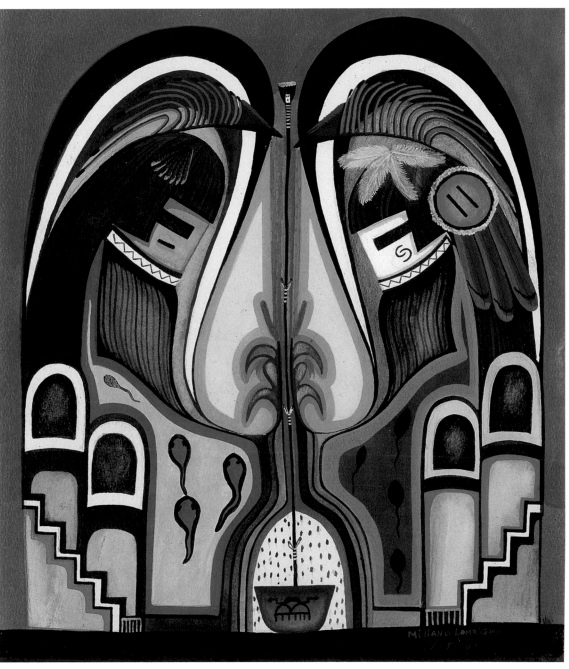

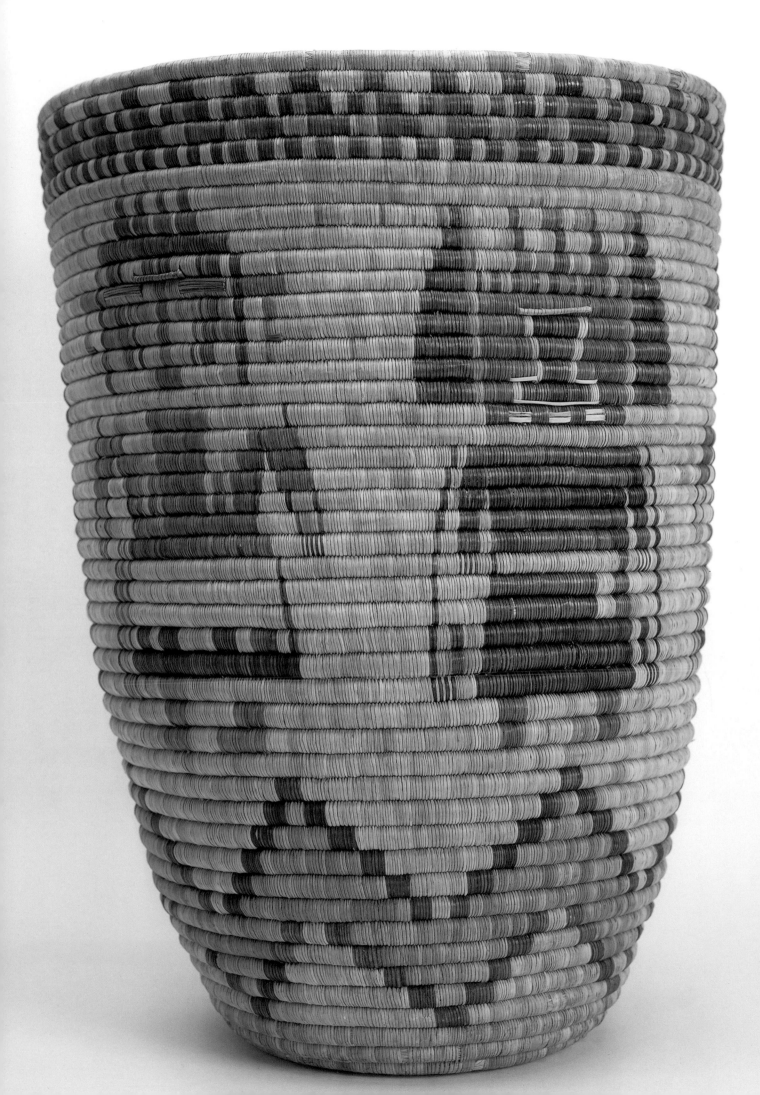

BASKET, 1920s
Hopi
Galleta grass, yucca, dyes
25 x 18 1/2

A row of rain clouds is above the heads of the Supai, Heheya, and Crow Mother Katsinam.

HOPI BASKETS CONTAIN MANY CLOUD AND RAIN CLOUD MOTIFS, BOTH STYLIZED AND ABSTRACT. BASKETRY TECHNIQUES ARE SPECIALIZED ACCORDING TO THE MESA ON WHICH THE WEAVER LIVES. BASKET WEAVERS FROM SECOND MESA VILLAGES MAKE COILED BASKETS, AND WEAVERS FROM THIRD MESA MAKE WICKER PLAQUES. DESPITE DIFFERENCES IN TECHNIQUE, DESIGNS INVOLVING CLOUDS, RAIN, AND WATER ANIMALS ARE USED BY WEAVERS OF BOTH MESAS.

BASKET, 1920s—1940s
Hopi
Galleta grass, yucca, dyes
13 1/4 x 11 1/4

Rain clouds form a row on the bottom of this basket and also crown the headpieces of the Sio Hemis Katsinam.

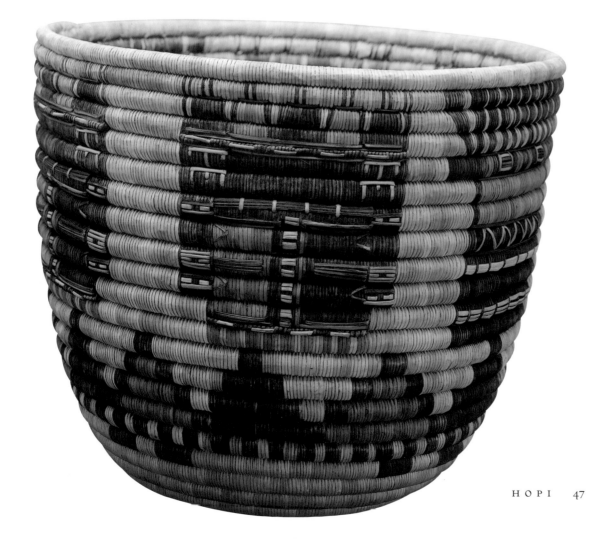

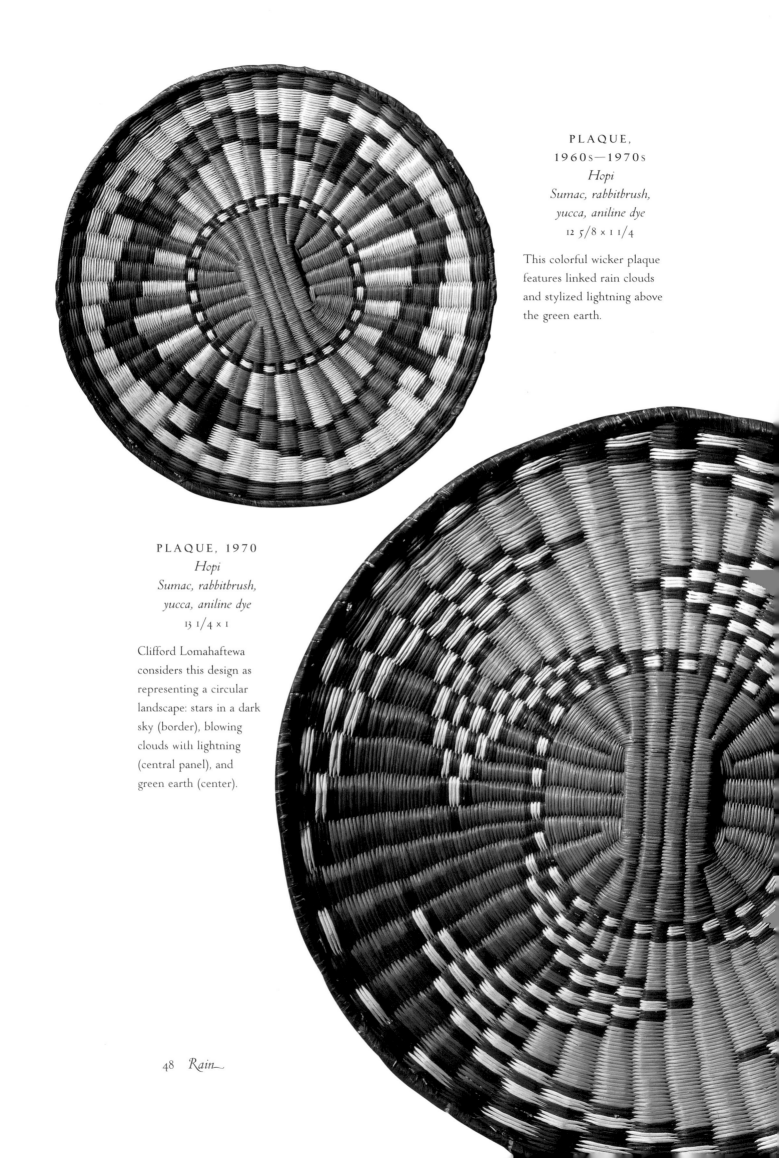

PLAQUE,
1960s—1970s
Hopi
Sumac, rabbitbrush,
yucca, aniline dye
12 5/8 × 1 1/4

This colorful wicker plaque
features linked rain clouds
and stylized lightning above
the green earth.

PLAQUE, 1970
Hopi
Sumac, rabbitbrush,
yucca, aniline dye
13 1/4 × 1

Clifford Lomahaftewa
considers this design as
representing a circular
landscape: stars in a dark
sky (border), blowing
clouds with lightning
(central panel), and
green earth (center).

PLAQUE, 1969
Beth Luke, Hopi
Galleta grass,
Yucca, dye
13 x 1 5/8

This coiled plaque features
stylized rain clouds and lightning.

PLAQUE, C. 1968
Hopi
Sumac, rabbitbrush,
yucca, aniline dye
15 x 1

Rain clouds, lightning, and
rain above the earth decorate
this plaque.

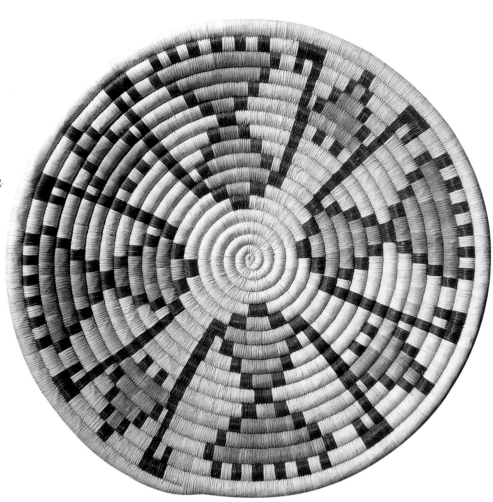

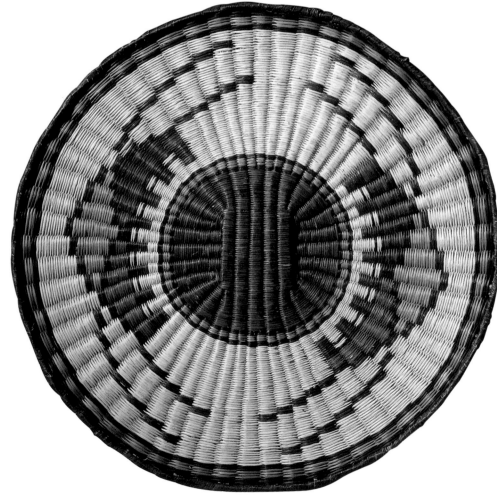

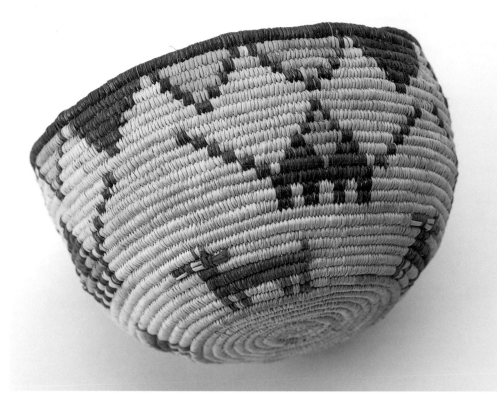

BASKET, C. 1964
Edith Addington, Hopi
Galleta grass, yucca,
aniline dye
5 1/2 × 3 1/2

This basket depicts a
landscape with rain clouds
hovering over antelopes.

BASKET,
1937
Hopi
Sumac,
rabbitbrush,
yucca, dye
10 1/2 × 13 1/2

On this basket,
lightning and rain
clouds hang over
antelope images.

PLAQUE, 1968
Vera Hyeoma,
Hopi
Galleta grass,
yucca, dye
12 × 2

Turtles as water
animals are popular
subject matter,
depicted on this
plaque with the shell
at the raised center.

CANTEEN,
LATE 1800s
Hopi
Clay, paint
8 × 13 × 12

Water serpents flank
a turtle on this water
carrier collected at
Polacca, Arizona.

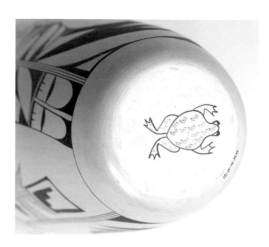

VASE, 1970s
Joy Navasie, Tewa/Hopi
Clay, paint
13 x 8 3/4

This accomplished potter who inherited her mother's pottery signature, a frog, is known as "Frog Woman." In this case, the symbol does not represent a clan linkage.

MANY HOPI CERAMICS ARE PAINTED WITH WATER- AND RAIN- RELATED MOTIFS.

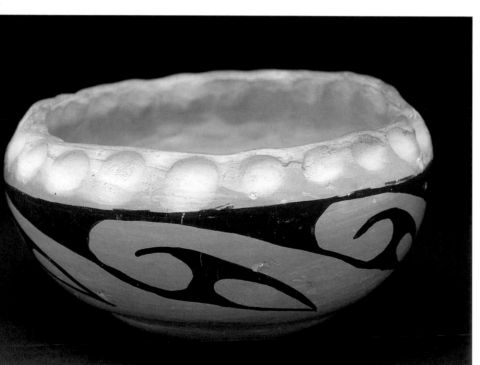

BOWL, C. 1970s
Elaine Poleahla, Hopi
Clay, paint
3 3/4 x 6 1/4

The corn and rain cloud symbols on this piece indicate a link between two clans in origin stories that involve water and the growing of corn. The potter belongs to the Corn Clan.

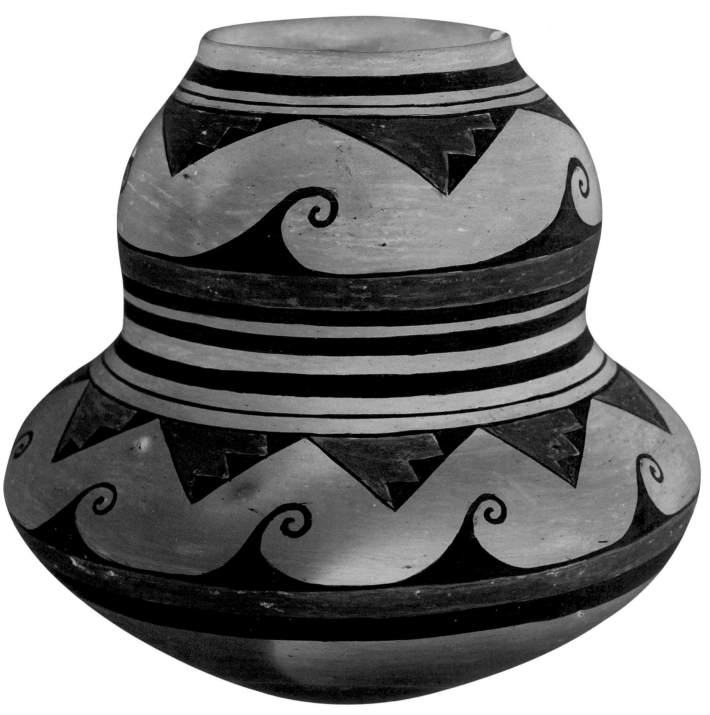

JAR, 1969
Dextra Q. Nampeyo, Tewa/Hopi
Clay, paint
7 x 7 1/4

Rows of waves surround this jar
formed in the shape of a water gourd.

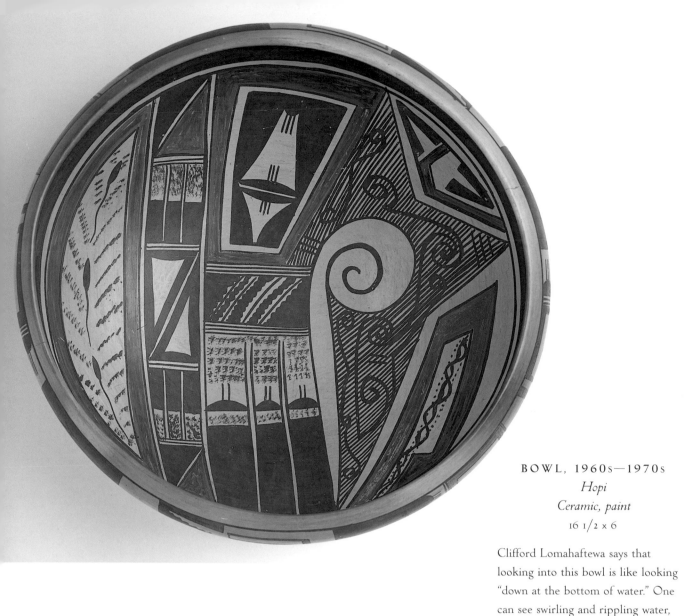

BOWL, 1960s—1970s
Hopi
Ceramic, paint
16 1/2 x 6

Clifford Lomahaftewa says that
looking into this bowl is like looking
"down at the bottom of water." One
can see swirling and rippling water,
water grasses, and either three
tadpoles or sprouting seeds.

BOWL, 1950s—1970s
Rena Leslie, Hopi
Ceramic, paint
4 x 5 1/2

The potter's Hopi name is translated
as "Yellow Cloud." On viewing this
design, one Hopi woman indicated
that the spiral design of swirling
water, coupled with feather motifs
suggesting prayer feather images,
makes the decorations on this bowl a
prayer for rain.

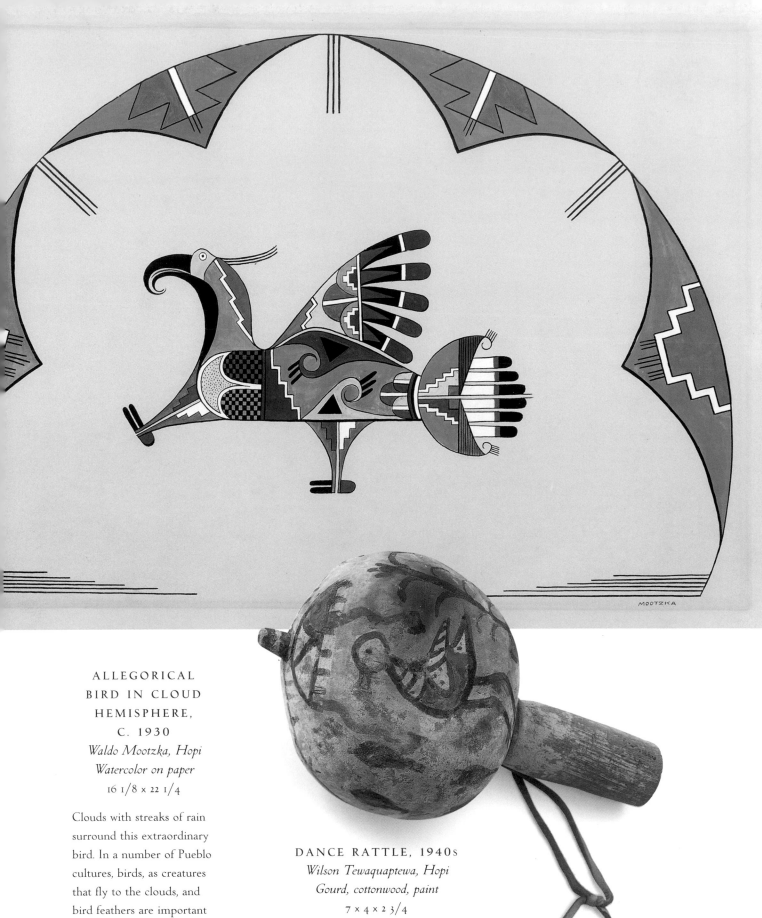

**ALLEGORICAL
BIRD IN CLOUD
HEMISPHERE,
C. 1930**
Waldo Mootzka, Hopi
Watercolor on paper
16 1/8 x 22 1/4

Clouds with streaks of rain
surround this extraordinary
bird. In a number of Pueblo
cultures, birds, as creatures
that fly to the clouds, and
bird feathers are important
in prayers for rain.

DANCE RATTLE, 1940s
Wilson Tewaquaptewa, Hopi
Gourd, cottonwood, paint
7 x 4 x 2 3/4

The rain cloud designs above the bird image and
the tadpoles on this dance rattle underscore rain's
importance for life. The sound of the rattle is
associated with the sound of rain falling. The
rattle noise can be varied to express rain falling
softly, or falling hard as in a storm.

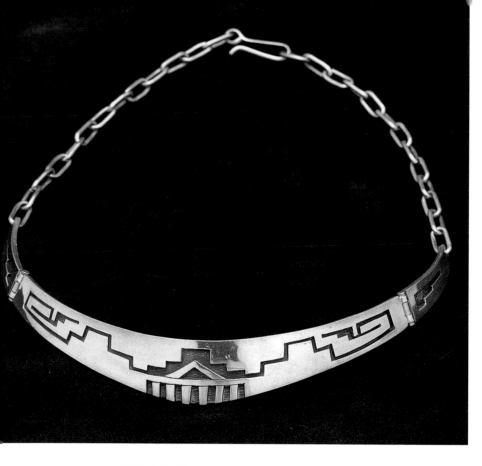

HOPI SILVERSMITHS
FREQUENTLY PLACE RAIN,
CLOUD, AND WATER ANIMAL
DESIGNS ON THEIR JEWELRY.
IN MANY CASES THESE
DESIGNS ARE ARRANGED IN A
MANNER THAT EXPRESSES THE
RELATIONSHIP AMONG RAIN,
RAIN-BRINGING SPIRITS, AND
GROWTH AND FERTILITY.

NECKLACE,
1970s
Victor Coochwytewa,
Hopi
Silver
15 × 5/8

This necklace features
stylized rain clouds.

PENDANT-
BROOCH,
1972
Hopi
Silver
3 INCHES
IN DIAMETER

This pendant displays
water serpent and rain
cloud designs. The
cornstalk in the center
denotes the importance
of rain to Hopi
agriculture and life.

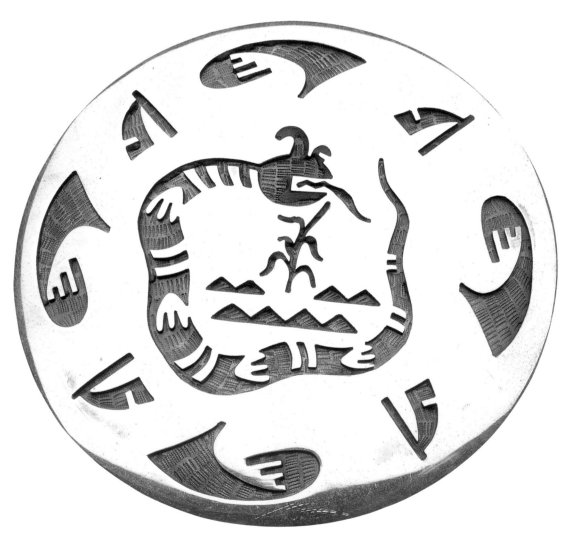

BELT BUCKLE, 1969
Patrick Lomawaima, Hopi
Silver
3 x 1 1/2 x 1/2

The water serpent is an important figure in rain-related ceremonies. The serpent's tongue is a lightning bolt, and there is a water design on its tail.

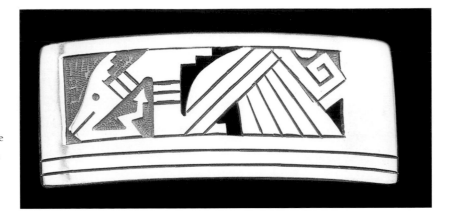

BELT BUCKLE, C. 1970
Victor Coochwytewa, Hopi
Silver
3 1/4 x 2 1/4

A deer dancer with rain clouds is the design on this buckle.

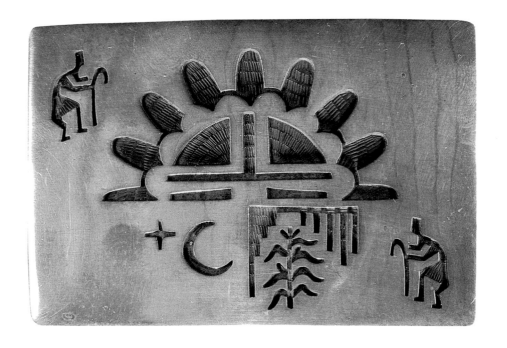

BELT BUCKLE, C. 1970
Hopi
Silver
3 1/2 x 2 1/2

The Sun Katsina, rain, and corn underscore those things necessary to a good life.

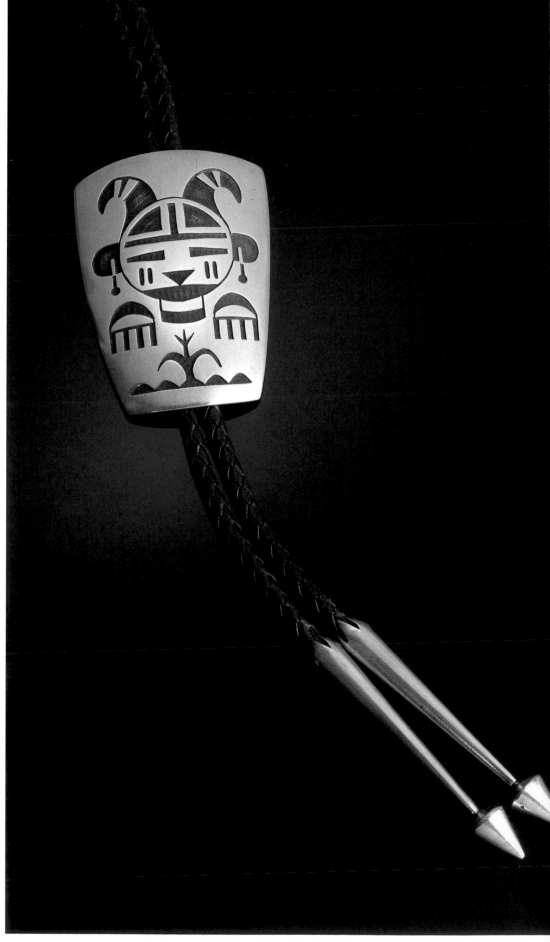

**BOLO TIE, C. 1970
[WITH DETAIL OF
BACK INSET
ABOVE]**
*Bernard Dawahoya, Hopi
Silver*
2 7/8 x 2 1/4

Bernard Dawahoya, who
became a silversmith in
1956, is of the Snow Clan
and uses a snow cloud as his
hallmark. He depicts the
links among katsinam, rain,
plant life, and Hopi life.

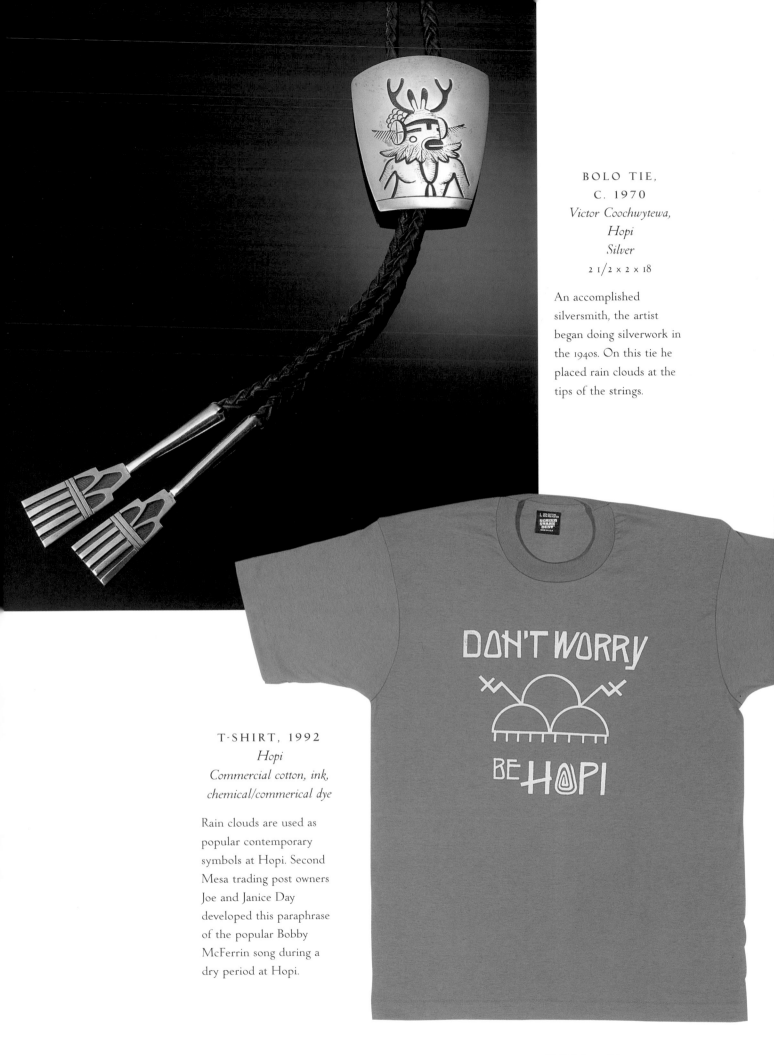

**BOLO TIE,
C. 1970**
*Victor Coochwytewa,
Hopi
Silver*
2 1/2 x 2 x 18

An accomplished
silversmith, the artist
began doing silverwork in
the 1940s. On this tie he
placed rain clouds at the
tips of the strings.

T-SHIRT, 1992
*Hopi
Commercial cotton, ink,
chemical/commerical dye*

Rain clouds are used as
popular contemporary
symbols at Hopi. Second
Mesa trading post owners
Joe and Janice Day
developed this paraphrase
of the popular Bobby
McFerrin song during a
dry period at Hopi.

DON'T WORRY
BE HOPI

LOOKING FOR RAIN IN NEW MEXICO PUEBLOS

Eileen Yatsattie, Zuni advisor

Eileen Yatsattie, a Zuni, is a potter and a teacher of pottery. She has also taught marketing at Twin Buttes High School at the Pueblo of Zuni. She learned the meaning of pottery designs from her teachers and her grandfather. Her grandfather also taught her the prayers that accompany the stages of pottery-making.

Gary Roybal, San Ildefonso advisor

Gary Roybal of San Ildefonso Pueblo is experienced in developing and consulting on museum exhibits. From 1985 to 1986, he was lieutenant governor of San Ildefonso. He works for the National Park Service at Bandelier National Monument. Because the pueblos of New Mexico are grouped together in this book, he needed to be aware of attitudes about the appropriateness of sharing cultural information; these attitudes vary from pueblo to pueblo. He is an award-winning moccasin maker; works by his father, J. D. Roybal, are included in this book. Initially, only Gary was asked to be a consultant on the Rain project. As discussions evolved, Gary's wife Laura Roybal, who is from the Keresan-speaking Pueblo of San Felipe, contributed important ideas to the discussions.

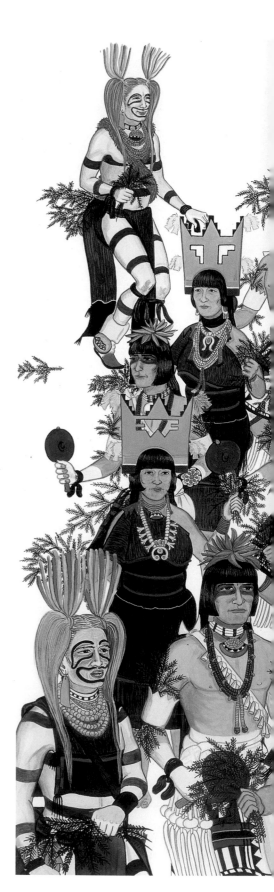

CORN DANCE, 1970s
Wah Peen/Gilbert Benjamin Atencio,
San Ildefonso
Watercolor on paper

23 x 29

Striped Kossa flank the procession of Corn Dancers. Gary Roybal notes that the Corn Dance expresses women's roles as connectors from this world to the world above. Only women dance barefoot, emphasizing their connection to the earth. On their heads they wear tablitas with images of mountains, clouds, moon, and stars. Rain sashes encircles the waists of male dancers.

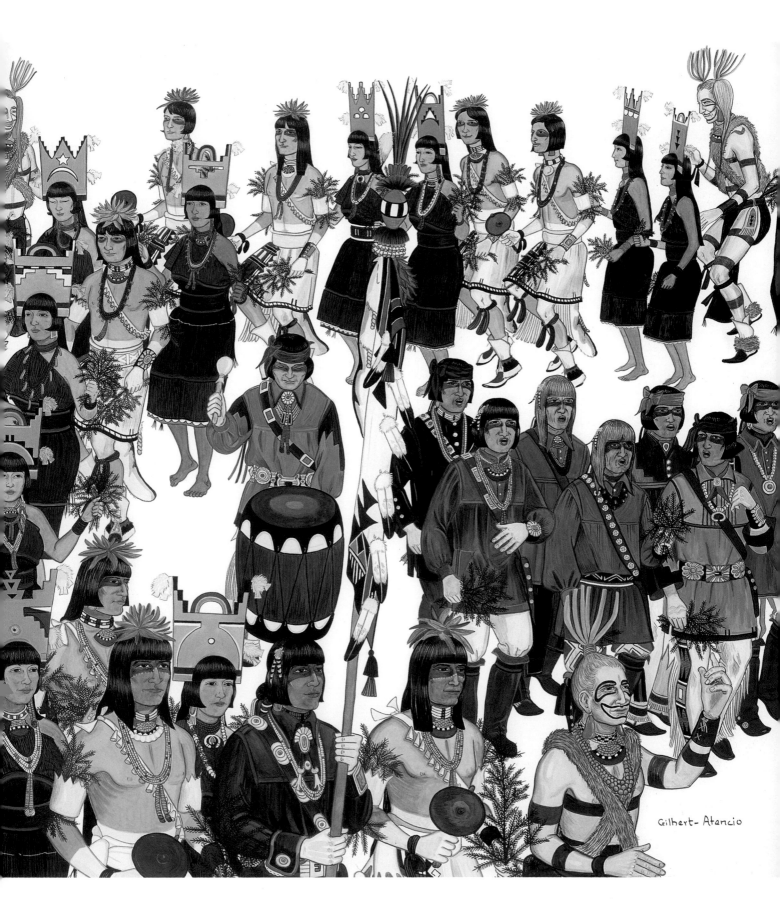

Gilbert-Atencio

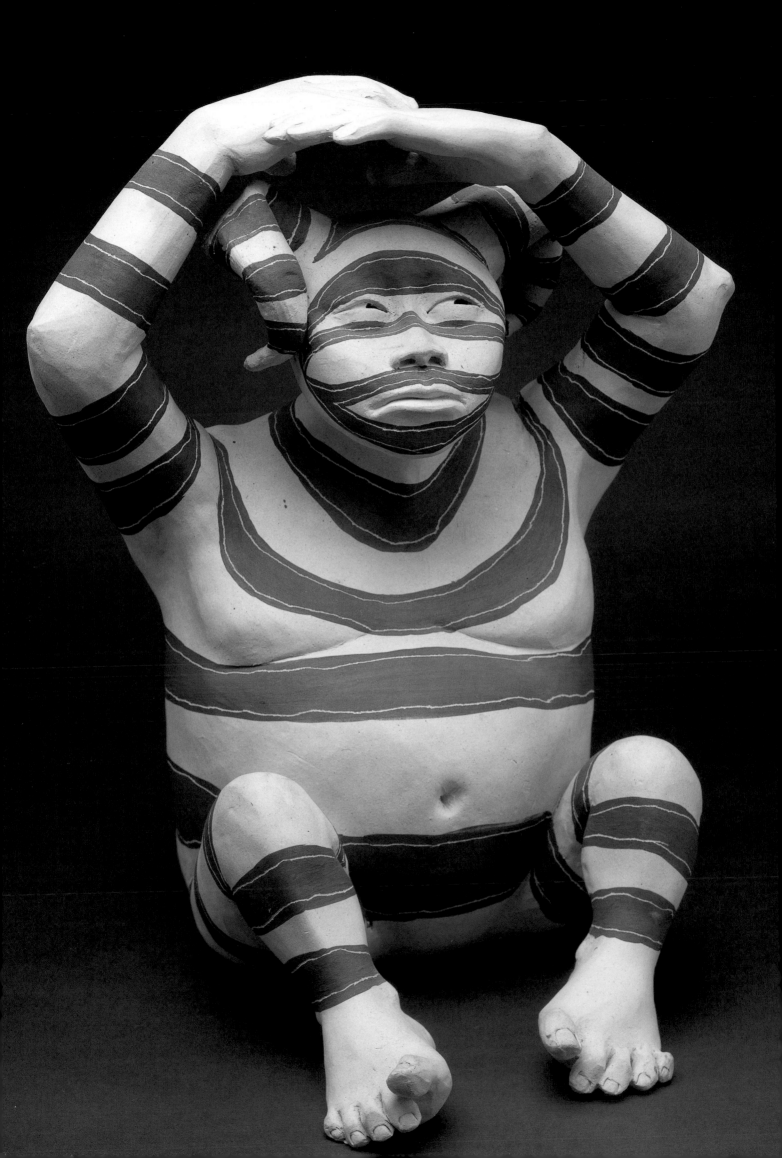

IT'S RAINING, C. 1984
*Roxanne Swentzell,
Santa Clara
Clay, paint*
17 1/2 × 14 × 14

This is a figure of a sacred clown. In the Tewa language of Santa Clara, he is a kossa. In certain ceremonies such as the Corn Dance, the kossa accompany songs with appropriate descriptive gestures of such things as rain, clouds, and rivers. Gary Roybal comments, "They represent the underworld or other side, the spirit world. They represent the dead. The faces represent the skull. You can see rings around their eyes and mouth. In many ways they are very strict. They always talk backwards, they say just the opposite. They never speak English, they speak the native language...They are contrary. They are always humorous. They can do anything they want to do because that is their way. When they talk they talk to you backwards. They say the opposite of what they mean, for example, 'Don't have a good day.'" This clown is sheltering from the rain, a very opposite thing to do in a place where the rain is welcomed as a blessing, what Laura Roybal calls a "grace."

Traveling from Albuquerque to Santa Fe in the summer, it is not unusual to see a "sky loom." This is the poetic name for virga, rain that falls but never reaches the ground because it is met by dry air rising from a baking earth. Sometimes the sun shines through virga, sometimes there is a rainbow, and the falling rain is the warp of the loom. Even though this rain doesn't touch the ground, the promise of rain is very close. In New Mexico, rainfall is lightest in the south and west and increases as the land rises to mountains in the north. The state's annual rainfall is about fifteen inches, and as in the rest of the Southwest, most of it occurs during fierce summer storms. But the winter snows that fall in the mountains are critical to feed all the rivers and streams, especially the Rio Grande.

West of the Rio Grande, on land that becomes increasingly dry as it approaches Arizona, is the Pueblo of Zuni, located along the Zuni River near the Arizona border. Although the river is a permanent stream, its flow is very limited in dry seasons. Rainfall at Zuni, which can be erratic from year to year, increases with elevation. Most Zuni people live at the 6,000- to 7,000-foot level, which receives eleven to sixteen inches of annual rainfall. Fierce summer storms account for up to half of the precipitation at Zuni. Water from these sudden storms runs off quickly, causing occasional flash floods. By contrast, the slow drizzle of winter storms and the gradual melting of the snowpack allow moisture to soak into the ground.

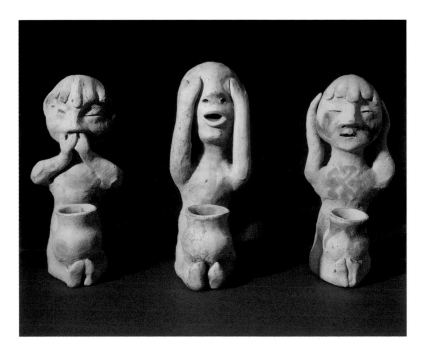

RAIN GOD FIGURINE SET, C. 1900
*Tesuque
Clay, paint*
EACH
APPROXIMATELY
6 1/2 INCHES IN
HEIGHT

This set of figurines is posed in a manner that evokes the 17th-century Japanese fable "Hear no evil; speak no evil; see no evil." The figure on the chest of one, popularly called "whirling logs," is a symbol frequently applied to tourist items, but with no relation to Diné.

BUFFALO DANCERS,
PRE—1942
Tonita Peña, Cochiti
Watercolor on paper
11 x 14

These buffalo dancers from Cochiti
Pueblo wear kilts with water serpents
similar to those of Jemez. Only one
drummer is shown, indicative of the pared-
down representation of ceremony in
Pueblo painting. According to the artist's
son, Joe Herrera, a Buffalo Dance at
Cochiti would includ six to eight
drummers from the drum society, and
forty to fifty singers. Gary Roybal
comments, "Historically, the buffalo in the
Rio Grande is before the coming of the
horses. Many of the Pueblo hunters and
war captains that protected the villages
would go to their brothers on the Plains
and hunt for buffalo. The Pueblo people
were farmers. They would use their crops
to trade with the Sioux, Cheyenne, and
Comanche. Buffalo were very important to
the Pueblo people. They ate the meat and
used the buffalo heads in the dances. The
deer and deer antlers were also important
to them. They still do the Buffalo Dance
exactly like in the painting. It is very
colorful."

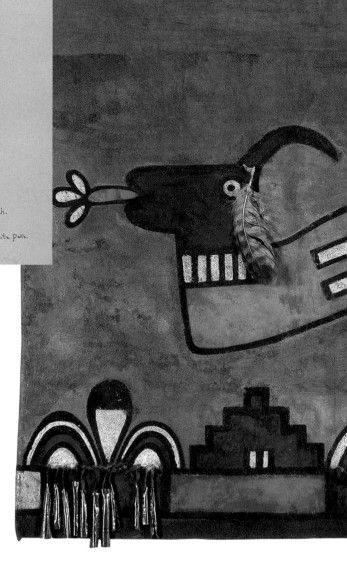

KILT, PRE—1979
Jemez
Cotton, paint, muledeer hide,
gray hawk feather, metal tinklers
25 1/4 x 47 1/2

According to Gary Roybal, many
kilts are handed down from
generation to generation. This
one is worn in a public dance at
Jemez, the Buffalo Dance. Even
at winter dances, more directly
associated with hunting, the
water serpent is present. This
kilt has a border of rain clouds
below the horned water serpent,
avanyu. Tinklers make a sound
resembling the patter of rain.

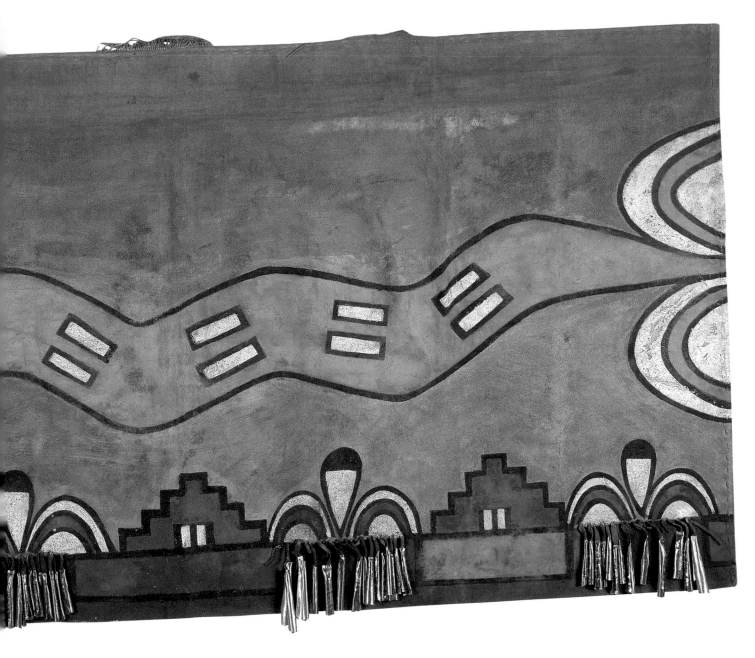

RAIN IN LIFE

Sixteen of the nineteen pueblos in New Mexico are located along the Rio Grande or on its tributaries. Jemez Pueblo educator and historian Joe Sando describes this area as the "heart" of New Mexico (Sando, 1992, 106). Gary Roybal says, "We say rain *is* life because without rain, many of the crops, the animals, the insects, and what have you, won't survive in this world. We are one of them. We have to have rain in order to survive and in order to grow corn.... The cycle is there; that is how we relate the use of corn and rain together." The Rio Grande, the river at the heart of that life, is thought of as an avanyu, or water serpent.

Laura Roybal, Gary's wife, is from the Pueblo of San Felipe, where the water serpent also represents this very important river. Laura says, "San Felipe is located along a mesa with a very narrow land base against the mesa, and the river runs through the land base. Many years ago there was a threat of flooding. You could see the water—it was above the pueblo but behind a bank. My brother was governor of the pueblo that year. He had many visits from the Corps of Engineers, Bureau of Indian Affairs, and Indian Health Services

officials because of the concern about flooding. We call it 'high waters'. Through our legends and prayers we believe that we are at peace with the water serpent, that is something that has been promised. Hopefully we are still carrying out our part of the bargain, and he will never come over the bank. It is sort of a dike, a mound that was built. I grew up along that river. The dike has never been reinforced. Many times I have walked along the road and have seen the river above me. It never has broken through. I believe in what my grandparents and my mother have shared with me in terms of peace with the water."

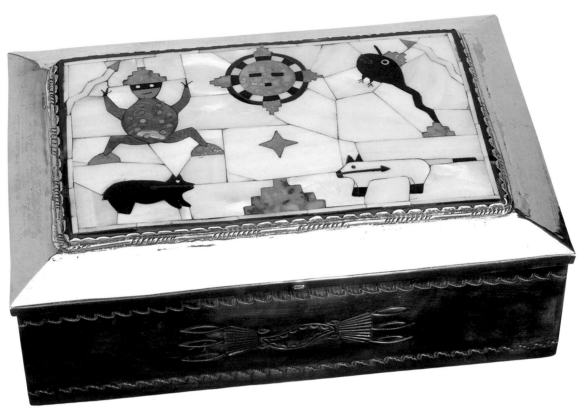

BOX, 1948
John Hoxie or Roger Skeet, Diné;
Mary Kallestewa, Zuni
Silver, jet, Arizona turquoise, Sicilian red
coral, red abalone shell, gold lip mother-of-
pearl oyster, golden conch shell
3 x 6 1/2 x 8 1/4

Mary Kallestewa used a shell inlay technique to create motifs—a tadpole and frog—related to water and rain on the lid of this box. Both the frog and the tadpole are capped with clouds, and lightning bolts flash overhead. According to Cal Seciwa of Zuni, the placement of the stepped element at the bottom edge relative to the other figures suggests this is emerging land rather than a cloud. This piece was made for trader C. G. Wallace, and the Navajo silversmith probably worked separately from Mary Kallestewa instead of in collaboration.

CEREMONIAL BOWL, C. 1968
Myra Eriacho, Zuni
Clay, paint, slip
7 x 11

According to Eileen Yatsattie, there are clouds at the four directions on the edge of the bowl with dragonflies, which represent summer rains. Kolowisi encircle the bowl.

JAR, 1921—1943
*Maria and Julian
Martinez, San Ildefonso*
Clay, paint, slip
7 × 9

In 1919, Julian Martinez began painting the avanyu (horned water serpent) on blackware jars made by his wife, noted potter Maria Martinez. He added cloud banks to the design above the serpent beginning in 1921. The serpentlike shape of the Rio Grande is linked in legend to the avanyu.

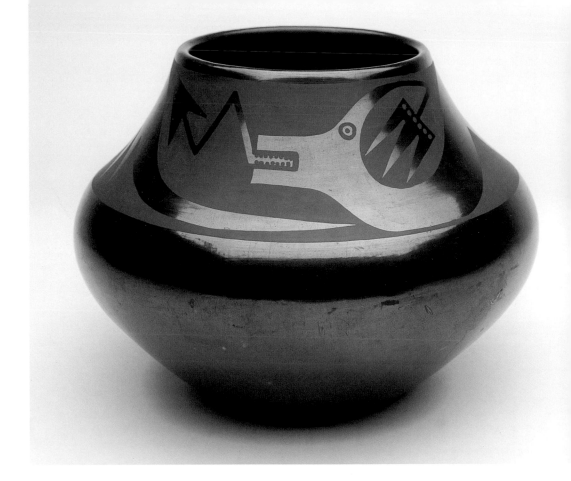

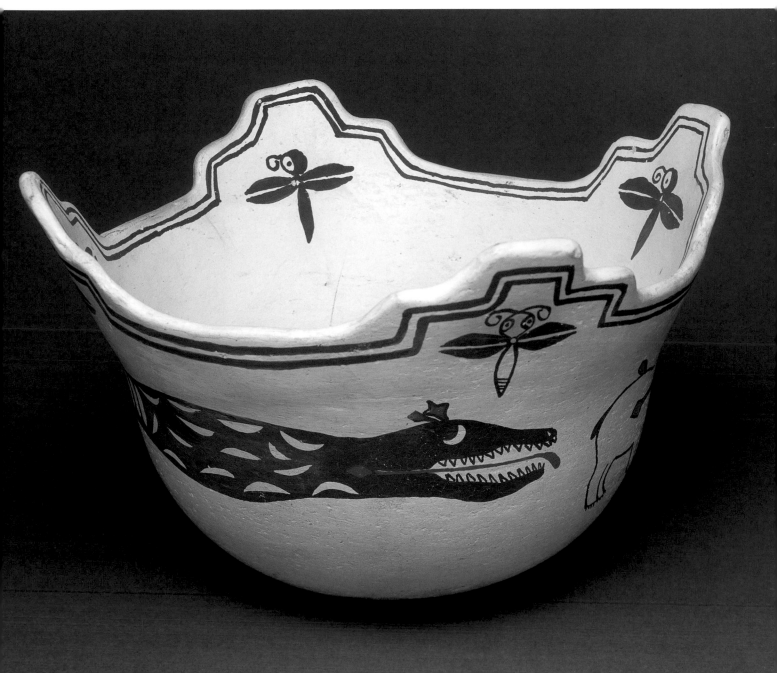

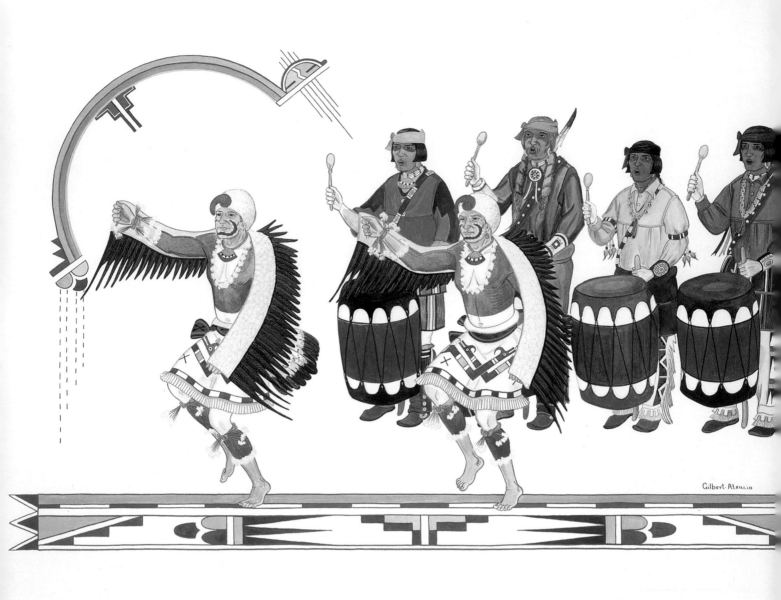

Gilbert-Atencio

RAIN IN CEREMONY

Knowledge of many of the summer ceremonies related to rain is restricted. Even in the more public ceremonies, however, themes of rain, clouds, rainbows, and water serpents are evident. Bob Chavez of Cochiti Pueblo says, ". . . clouds are always employed in the ceremonial songs. And the formations of the earth, the mountains, the hills, the rivers, the vegetation—all that is employed in the songs, the ceremonial songs" (Seymour, 1988, 147). Gary Roybal indicates that "when songs are made, all the elements of rain and how they relate to rain are part of that song. North, south, east, and west is always how they relate. You talk about animals and you talk about mountains. When the choir is singing they point to the directions. They are talking about the land bringing the rain down for the people. They pray for a good life not only for the Pueblo people but for the world."

Sometimes during a dance, the weather changes. Laura Roybal speaks of a dance at San Felipe. "The weather had been so nice. On this Saturday we saw big clouds and we said it is going to be a little cool. We are not going to get burnt. But we danced through hail. It didn't stop us. The hail hurt our bare shoulders and faces.

EAGLE DANCERS,
1969
*Wah Peen/Gilbert
Atencio, San Ildefonso*
Watercolor on paper
20 3/4 × 29 1/2

The Eagle Dance is a sacred dance. Speaking of his Cochiti Pueblo home, artist Joe Herrera states, "We sometimes refer to the eagle as the thunderbird" (Seymour, 1988, 190). The eagle is considered to be the highest-flying bird and a communicator with the deities of the sky. Many paintings of ceremonies at Rio Grande Pueblos include a drummer. Drums, which make the sound of thunder, are the primary instrument for accompanying song prayers in ceremony. Gary Roybal is part of the Drumming Clan at San Ildefonso and is a third-generation drummer. He says, "You are in it for life, until the day you die. Those kinds of traditions are a part of our way of life. If a person dies, family members carry on the tradition. Since the drummer is by himself, he has to know all the songs forward and backward. He doesn't know which songs he will be drumming on that day. He has to know the motion, the beats, and the pauses."

"The four painted tablitas were 'bleeding' because the water was making the paint come off. It was painful when we first went around and felt the hail. We were in kind of a shock. My feet were frozen— we were barefoot. We were literally dancing not just on ice but on. . . ice that sticks and burns. We kept going. As the song went around and the drum was turned over, the chorus picked up. We took off and finished. We did a double dance. . . . Because rain and hail came, we can't run for protection or shelter. We had to finish it. We all came off that dance feeling excitement. My sister and the kids said at first it was a shock. But we pushed forward and then all of us felt good about it." Gary Roybal adds, "That is what happens. You ask for rain and you get it. At Cochiti Pueblo one year, it rained all day and the whole plaza was flooded with a foot or two of standing water. We danced all day in front of the church. It rained before we started and all day until we finished. You don't think about it. Everything got wet and we were drenched. The rain is what we dance and pray for. We don't get very much rain in the summer, nine or ten inches a year, with most of it in a three- or four-month period. The clouds on pots, kilts, and paintings represent the rain we ask for."

In Zuni religion, each of the six directions is represented by one of six U'wanami (rain priests or water spirits), who live along the ocean shores and in springs. When the U'wanami leave their houses of cumulus clouds, they may take the form of clouds, rainstorms, fog, or dew. They have six "spokesmen," who are water-bringing birds. Thunder and lightning are made by their Bow Priests. Frogs are their children.

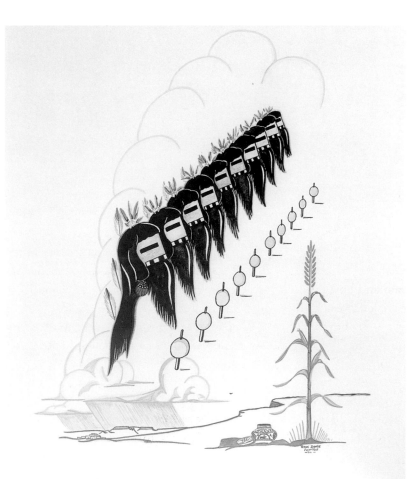

RAIN
DANCE, 1960
Red Robin, Zuni
*Watercolor on
paper*
16 × 20 1/8

The Downy Feather Hanging Kokokshe are part of the series of summer rain ceremonies at Zuni. Their name comes from the feather hanging down on their beards. The artist has depicted a line of these spirits leading up to mounds of cumulus clouds and overlooking a corn plant.

Zuni people offer song-prayers for rain, the growth of crops, and good health to spirit beings who live at the confluence of the Zuni and Little Colorado Rivers, near St. John's, Arizona. When a Zuni person dies, his or her soul travels to this place to join the ancestors. These ancestor spirits return to Zuni Pueblo, traveling up the Zuni River in the form of ducks, rain, or snow to bring life and guidance to the living. Six important ceremonies occur after the summer solstice and are associated with the need for the summer rainy season.

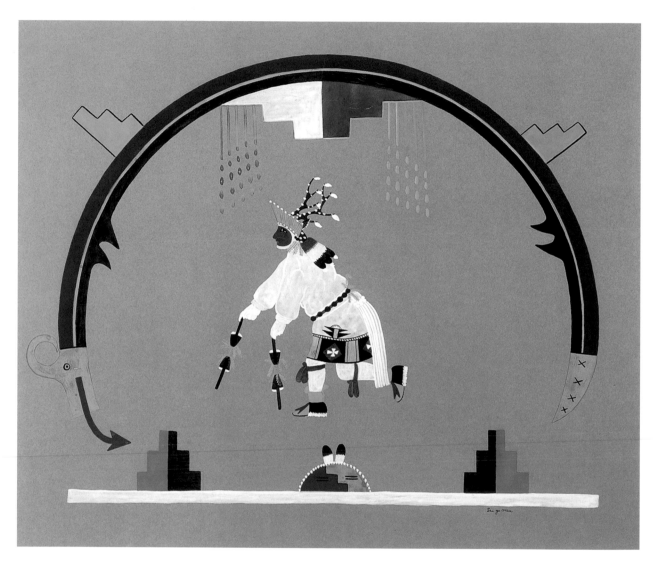

DEER DANCER,
C. 1945
Tse Ye Mu/Romando Vigil,
San Ildefonso
Watercolor on paper
15 3/4 x 20 1/4

This animal dancer is surrounded by the blessings of rain. The water serpent's body forms a rainbow, and clouds are carried on the serpent's back while rain falls on the dancer.

FACING

BIGHORN SHEEP
DANCER, 1968
Jose Rey Toledo, Jemez
Watercolor on paper
18 1/8 x 12

This dancer's head is crowned with a rainbow.

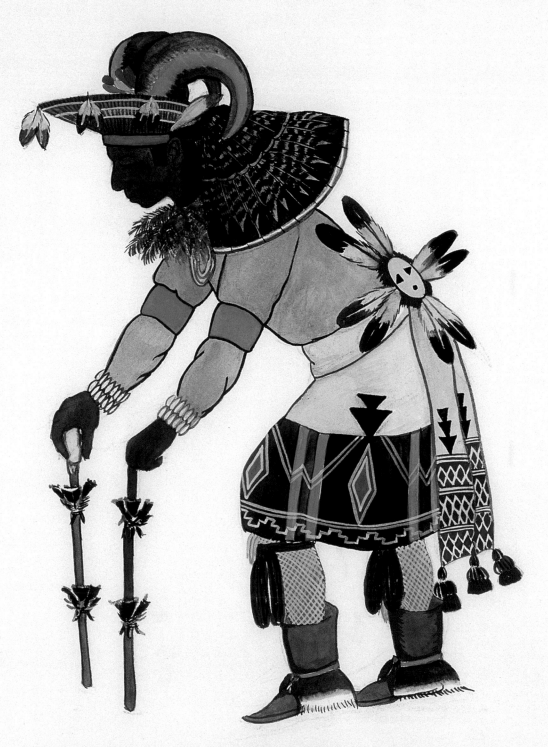

BIGHORN SHEEP DANCER
BY JOSE REY TOLEDO
2/3/68

CLOUD DANCE,
C. 1960
Soqueen/Encarnacion Pena,
San Ildefonso
Watercolor on paper
13 1/8 x 19 1/2

The Cloud Dance is a sacred
ceremony that asks for moisture.
At San Ildefonso, it takes place
every other year at Eastertime.
The dancers wear white rain
sashes and stepped cloud
headpieces.

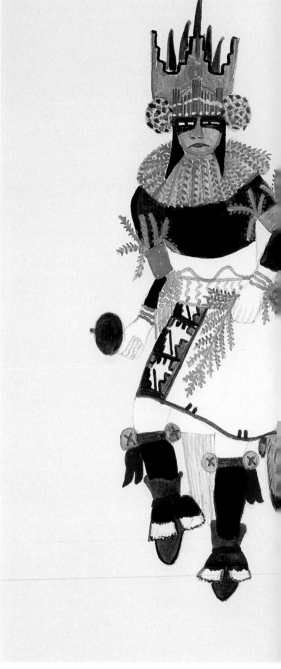

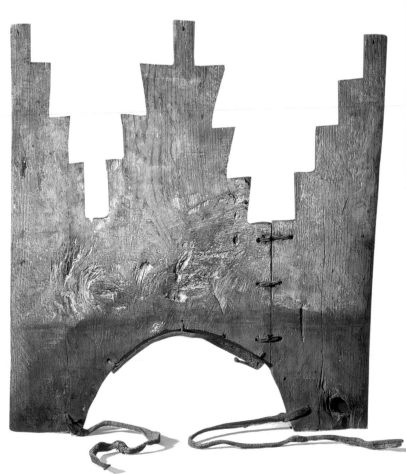

HEADPIECE,
EARLY 1900s
Acoma
Pine, paint, elk hide
11 3/4 x 10

Headpieces like this one,
sometimes referred to by the
Spanish word "tablitas," are
worn by women in ceremonial
dances. This headpiece with its
very simple cloud shape is
similar to those often seen in
paintings depicting New
Mexico ceremonies.

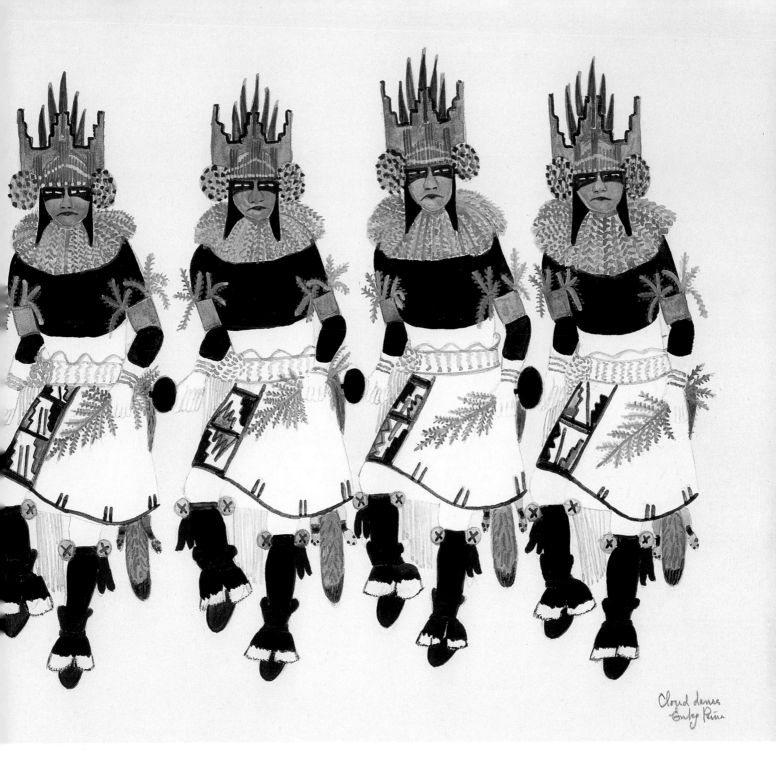

Cloud Dance
Encarnación Peña

According to Jose Rey Toledo of Jemez Pueblo, "Since the Pueblo world was based upon the rain culture, items expressive of rain and moisture were painted on the vessels: dragonflies or toads or frogs or butterflies or tadpoles and the like; or clouds themselves in their various shapes and forms, windblown clouds, or clouds pouring a lot of water, symbolically painted" (Seymour, 1988, 141).

Expressions of rain are also found in ceremonial clothing. Kilts have cloud designs and sometimes symbols for water animals. The white sash, which has a long, flowing fringe that moves like liquid, is generally referred to as a "rain" sash. In some ceremonies, dancers' heads are crowned with clouds in the form of stepped headpieces.

Birds, as messengers to cloud spirits and animals who dwell in or around water, are a part of many rain-related beliefs in the Southwest. Birds and water animals are the creatures most frequently depicted on items made in Pueblo societies. Sometimes they are very abstract, such as the rain bird designs on Zuni pottery.

One of the most important figures in Pueblo cultures is a horned and feathered serpent with a tongue of lightning. In the Tewa language, he is called "avanyu." He frequently has clouds on his back. The avanyu is represented in many ways: as a central figure in ritual dramas, on kilts worn in ceremonies, and on ceramics and paintings. His name and attributes vary among Pueblo cultures. Gary Roybal says, "It is a very important element not only in our mythology or where we come from, but also today as a symbol on much of the pottery. . . . I have been told stories about the water serpent. When you see a pond that has dried up, it means that the water serpent left to go to another pond." At Zuni, his name is Kolowisi, a horned water serpent who inhabits springs and underground waters. He can be an individual or a multiple being. As a guardian of sacred springs, he punishes trespassers, especially women.

Rainbows are also commonly a depicted link to rain in the Pueblo world. They wreathe the head and even flow from the mouth of certain Pueblo ceremonial figures. Jemez historian Joe Sando refers to the stone trees of the Petrified Forest (in Arizona) as "rainbows resting on earth." Cal Seciwa of Zuni says, "The rainbow has different meanings, one of which is, it represents the bow of the Bow Priests. It is also the bridge that our sacred mudheads often play on. . . . It has different meanings, but all good."

RAIN GOD
FIGURINE,
1890
Tesuque
Micaceous clay,
paint, fabric
12 1/2 x 6 x 6

This very early figurine was made more striking by pressing micaceous clay into the surface.

RAIN GOD
FIGURINE,
1930—1935
Tesuque
Clay, poster paint
10 1/2 x 5 x 6 1/4

Some rain gods were decorated with poster paints, as were other pieces of pottery made for tourists.

RAIN GOD
FIGURINE,
C. 1970
Tesuque
Micaceous clay, glass
beads, cotton string, silver,
button
12 1/4 x 4 1/2 x 3 3/4

This modern version of a "rain god" has the same pose as those produced sixty years earlier.

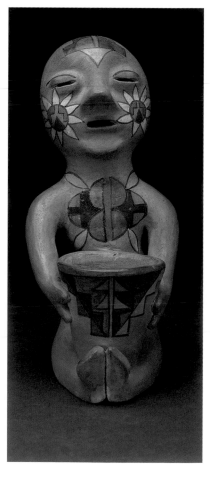

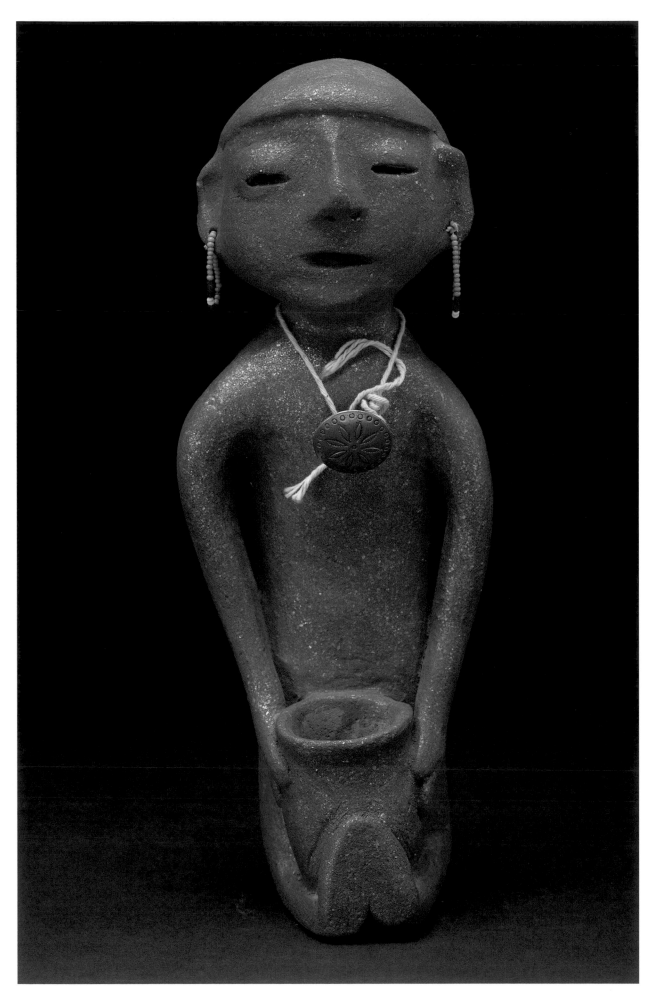

RAIN SASH, 1970
Lucy Lowden, Jemez
7 3/4 × 122

The fringe hanging from this sash represents rain. When it is worn in a ceremony, the fringe moves as falling rain would.

Talking with author Tryntje Seymour, artist Joe Herrera (Cochiti) said, "As the sun is still visible and there is rain in the distance, it creates this beautiful rainbow with all its colors.... The rainbow depicts all of the colors that exist on earth, and it plays an integral part in the manner in which we live: from this we have gathered all of these colors to use on the bodies of the dancers, on the costumes, the paraphernalia, the altars. And seeing the rainbow at times when it rains, we know that it is a good omen.... The rainbow is very peaceful... it shows us that there is beauty in this world" (Seymour, 1988, 188).

But a common warning is voiced by Joe Herrera and Gary Roybal. "We do not point at the rainbow, because it is believed that something bad might occur," Joe Herrera says. We might have an accident or we could fall." And Gary Roybal agrees. "Don't point at a rainbow! It is a bad sign. You might have your finger cut off."

At Zuni, expressions of rain are seen most frequently on ceramics and jewelry. Eileen Yatsattie comments, "These crafts that we make are part of prayers for moisture. So these images represent life in Zuni. Without the water we wouldn't be alive." Ceramics used in ceremonies have terraced edges that represent clouds and are painted in a distinctive style featuring animals associated with water. On water jars made for sale or everyday use, abstract designs of rain take meaning from connections to adjoining designs that represent vegetation, thus linking rain to growth, nourishment, and a good life.

Zuni lapidary work as a commercial art form often uses water animal designs and occasionally symbols associated with the Zuni gods of war, including rainbow bows and lightning arrows. Historically, another commercial object made in the Rio Grande area was the "rain god." The "rain gods" of Tesuque and other pueblos were marketed nationally through various commercial promotions. Although figurative ceramics with designs of rain, clouds, and lightning were collected as early as the 1870s and 1880s, "rain god" figures were mass-marketed by Santa Fe merchant Jake Gold, who sold them to stores across the country. Between 1900 and 1940, they were sold in bulk for $6.50 per 100 and were also included in boxes of Gunther Candy (Babcock, 1986, 14).

KILT, 1965—1975
*Alyda Delonio, Zuni
Cotton, commercial wool yarn*
24 × 29

This ceremonial kilt is linked to rain by the images of clouds and rain embroidered on the edges. The stepped cloud design of this type of kilt is generally the same one used at the pueblos, but differs in detail.

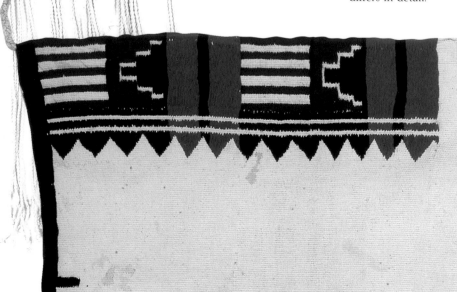

KILT, 1985
Ramoncita Sandoval, San Juan
Cotton, commercial wool yarn
26 1/2 x 48

This kilt has a terraced cloud design similar to that on the kilts at Hopi and Zuni. Some view the entire kilt as representing a cloud, with the stitches at the hem representing rain. Gary Roybal says that the kilt and rain sash go together. "Kilts represent rain. White sashes send rain falling."

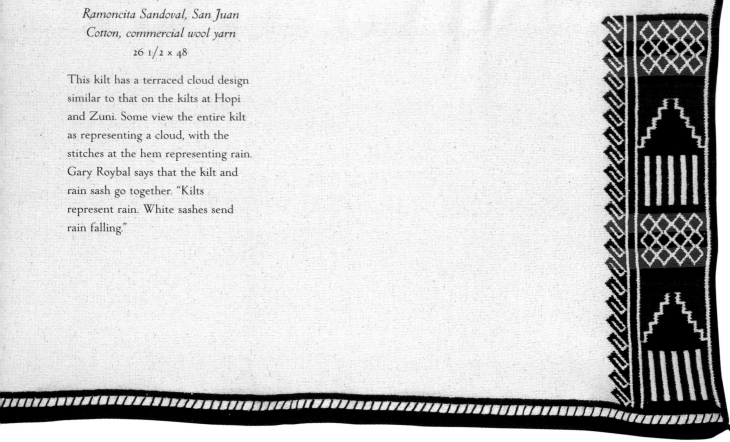

From wherever you abide permanently
You will make your roads come forth.
Your little wind blown clouds,
Your thin wisps of clouds,
Your great masses of clouds
Replete with living waters,
You will send forth to stay with us.
Your fine rain caressing the earth,
Your heavy rain caressing the earth,
Here at Itiwana,
The abiding place of our fathers,
Our mothers,
The ones who first had being,
With your great pile of waters
You will come together.
When you have come together

Our mothers,
Our children,
All the different kinds of corn,
Nourishing themselves with their
father's waters
Tenderly will bring forth their young.
Clasping their children
All will finish their roads.

From a prayer to the U'wanami made by a rain priest to begin a series of prayer retreats. Anthropologist Ruth Bunzel developed this interpretation of the prayer which was told to her at Zuni Pueblo in 1928 (Bunzel, 1929,1930, 645).

JAR, 1983
Jennie Laate, Acoma/Zuni
Clay, paint
9 3/4 × 14

Water animals are the
theme of this Zuni jar.
Tadpoles, butterflies, and
frogs represent spring,
summer, and late summer
or fall rains, respectively.
Kolowisi (water serpents)
surround the top of the jar.
Jennie Laate is from Acoma
Pueblo. Her husband is
from Zuni, and she began
teaching pottery to Zuni
high school students in 1974.

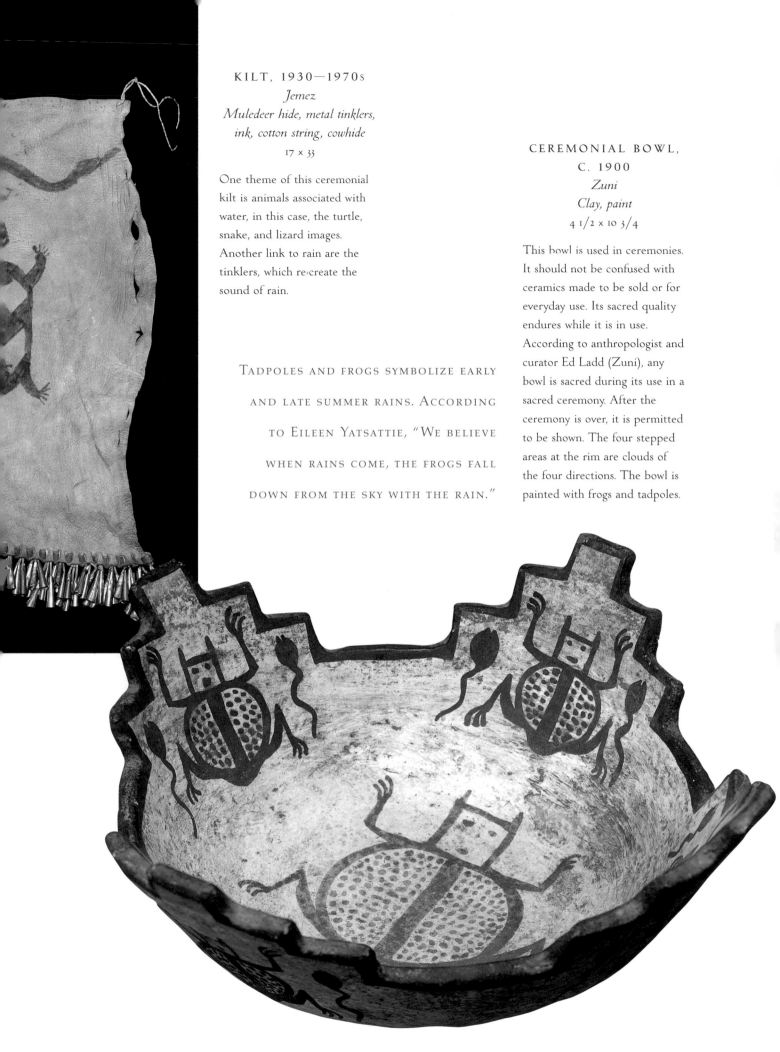

KILT, 1930—1970s
Jemez
Muledeer hide, metal tinklers,
ink, cotton string, cowhide
17 × 33

One theme of this ceremonial kilt is animals associated with water, in this case, the turtle, snake, and lizard images. Another link to rain are the tinklers, which re-create the sound of rain.

TADPOLES AND FROGS SYMBOLIZE EARLY AND LATE SUMMER RAINS. ACCORDING TO EILEEN YATSATTIE, "WE BELIEVE WHEN RAINS COME, THE FROGS FALL DOWN FROM THE SKY WITH THE RAIN."

CEREMONIAL BOWL, C. 1900
Zuni
Clay, paint
4 1/2 × 10 3/4

This bowl is used in ceremonies. It should not be confused with ceramics made to be sold or for everyday use. Its sacred quality endures while it is in use. According to anthropologist and curator Ed Ladd (Zuni), any bowl is sacred during its use in a sacred ceremony. After the ceremony is over, it is permitted to be shown. The four stepped areas at the rim are clouds of the four directions. The bowl is painted with frogs and tadpoles.

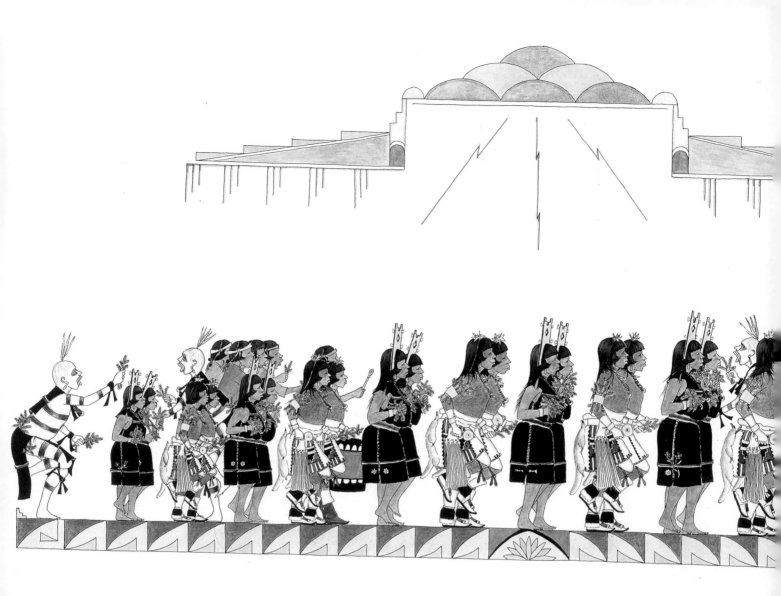

PUEBLO CORN DANCE, 1968
Oquwa/J.D. Roybal, San Ildefonso
Watercolor on paper
14 5/8 x 23 1/8

A sacred clown leads this procession of
Corn Dancers. Clouds, rain, and lightning
hover overhead. The staff carried in front of
the procession represents a rainbow. In the
ceremony, the staff is lowered and waved
over the heads of people as a blessing, just
as the rainbow is a blessing. Many paintings
of ceremony at Rio Grande Pueblos include
a drummer. Drums, as the sound of
thunder, are primary instruments for
accompanying song prayers in ceremony.

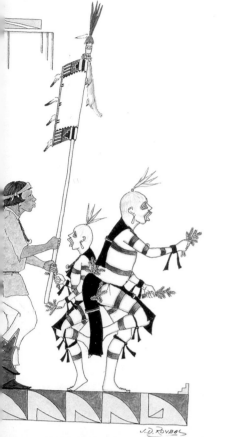

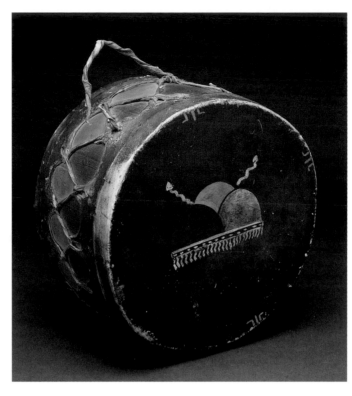

**DRUM,
1940—1950s**
*Probably New Mexico
Pueblo
Wood, paint, cowhide*
7 1/2 x 12

Made of lumber instead
of a tree trunk, this
drum is unusual for the
painted rain symbol on
its head. Despite its
Hopi-style rain cloud
representation, Clifford
Lomahaftewa does not
believe this is a Hopi
drum, because Hopi
drums are unpainted.

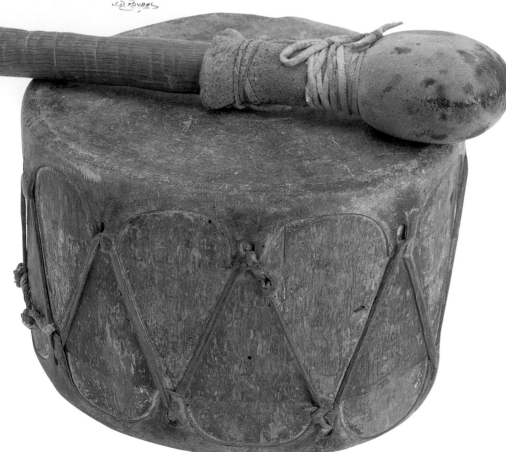

DRUM, 1930s
*Cochiti
Wood, paint, rawhide*
6 1/4 x 8 1/4

Painted and unpainted drums
of all sizes are used in Pueblo
ceremonies. The drum
suggests the thunder that
comes with rain. Gary Roybal
comments that, "The drum
has two sides. To a certain
extent songs are set up like
the song "Bolero" that goes
slowly and then to a
climax.... At a certain part of
the song, you flip the drum
over. You may be tired when
you turn the drum over to a
higher beat. But you get your
second wind and go. This lifts
the dancers and gives them
their second wind."

AFTER A RAIN, 1961
Po Tsunu/Geronima Cruz
Montoya, San Juan
Watercolor on paper
12 × 16

The rainbow and plant and
animal life are themes
conveyed in this painting.

WATER JAR, 1983
Josephine Nahohai,
Randy Nahohai,
Milford Nahohai, Zuni
Commercial clay, commercial
and mineral paint
8 × 9

The traditional abstract
design of a rain bird is
depicted on this jar.

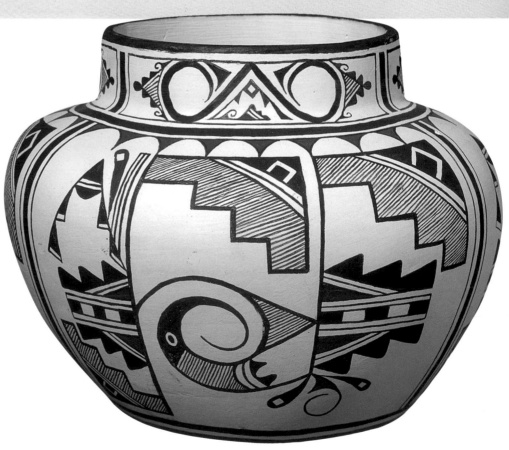

JAR, 1910
Zia
Clay, paint
10 x 13

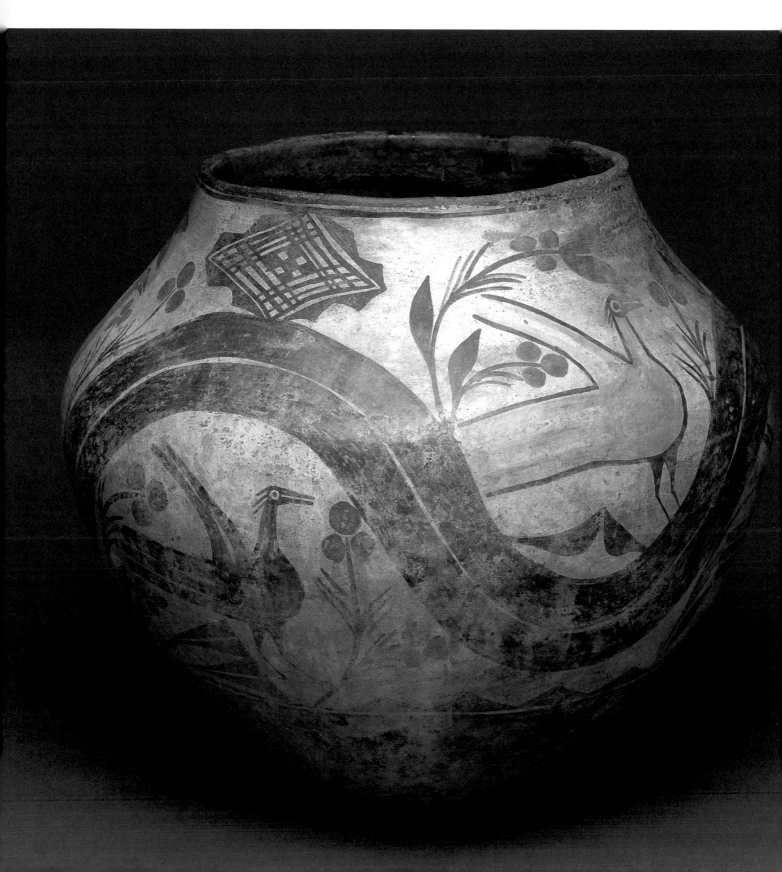

O our Mother the earth, O our Father the Sky,
Your Children are we, and with tired backs
We bring you the gifts you love.
Then weave for us a garment of rightness;
May the warp be the white light of morning,
May the weft be the red light of evening,
May the fringes be the falling rain,
May the border be the standing rainbow.
Thus weave for us a garment of brightness,
That we may walk fittingly where birds sing,
That we may walk fittingly where grass is green,
O our Mother the Earth, O our Father the Sky.

—Herbert J. Spinden, from *Songs of Tewa,* a volume of songs
Spinden collected between 1909 and 1912 while doing research
for the American Museum of Natural History.

WATER JAR, 1905
Santa Clara
Clay, slip
10 x 7 3/4

Noted Santa Clara potter
Margaret Tafoya referred
to the raised band on the
shoulders of water jars as
a rainbow.

JAR, 1900
Zuni
Clay, paint
11 x 15

Water jars often have wear
at the neck from the handle
of the dipper.

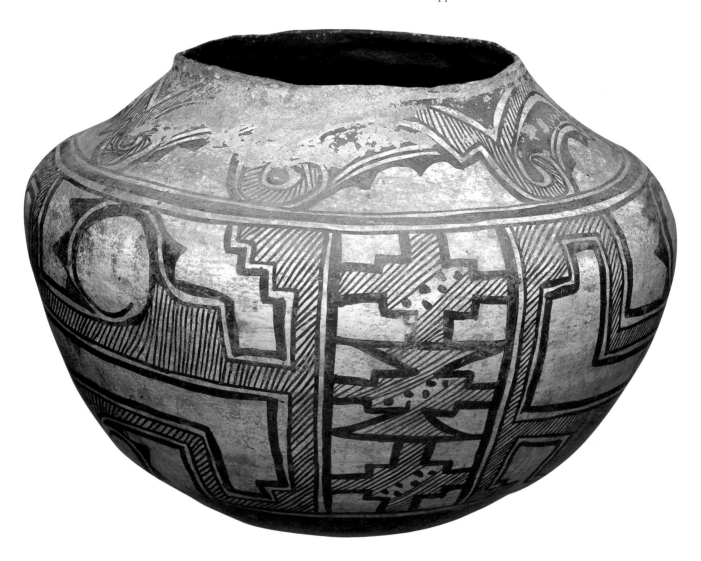

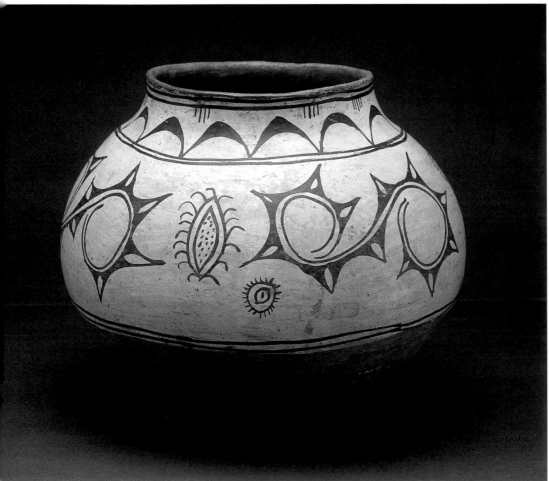

WATER JAR, 1910
San Ildefonso
Clay, paint
11 × 13

Distant clouds, rain clouds, and bands of clouds are among the several rain-associated designs on the rim of this water jar. To Gary Roybal, the older water jars, with their stylized and abstract depictions of rain falling on vegetation, are a fundamental expression of rain and its importance in making life possible.

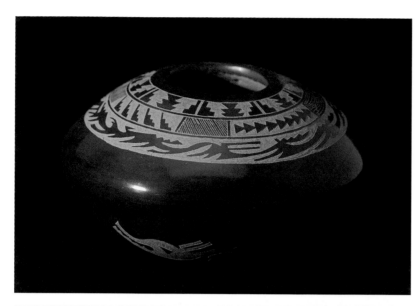

**SGRAFFITO JAR,
1970s**
*Grace Medicine Flower,
Santa Clara
Clay, slip*
2 1/2 x 4 1/2

A horned water serpent is ornately represented on this small jar by a carving technique known as sgraffito. Avanyus are frequently depicted on contemporary ceramics from Santa Clara and San Ildefonso Pueblos. Older ceramics not used for ceremony do not have this serpent.

JAR, C. 1972
*Maria Martinez
and Tony Da, San
Ildefonso
Clay, heishi,
turquoise, olivella
shell*
13 x 9

This beautiful contemporary piece depicts the avanyu, guardian of water.

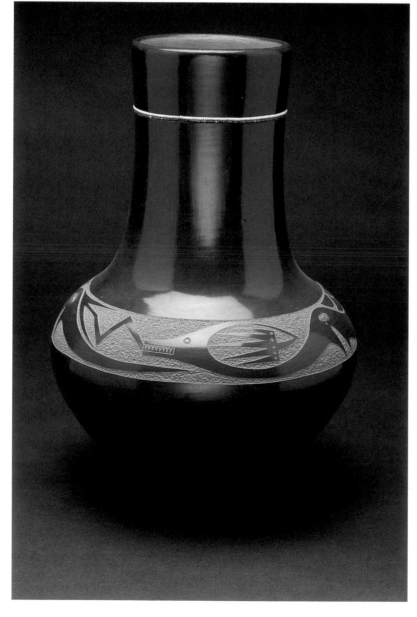

FACING

JAR, C. 1973
*Margaret Tafoya,
Santa Clara
Clay, slip*
15 x 13

The bear paw above the band on this jar refers to the origin story of Santa Clara Pueblo, in which a bear leads the people to water.

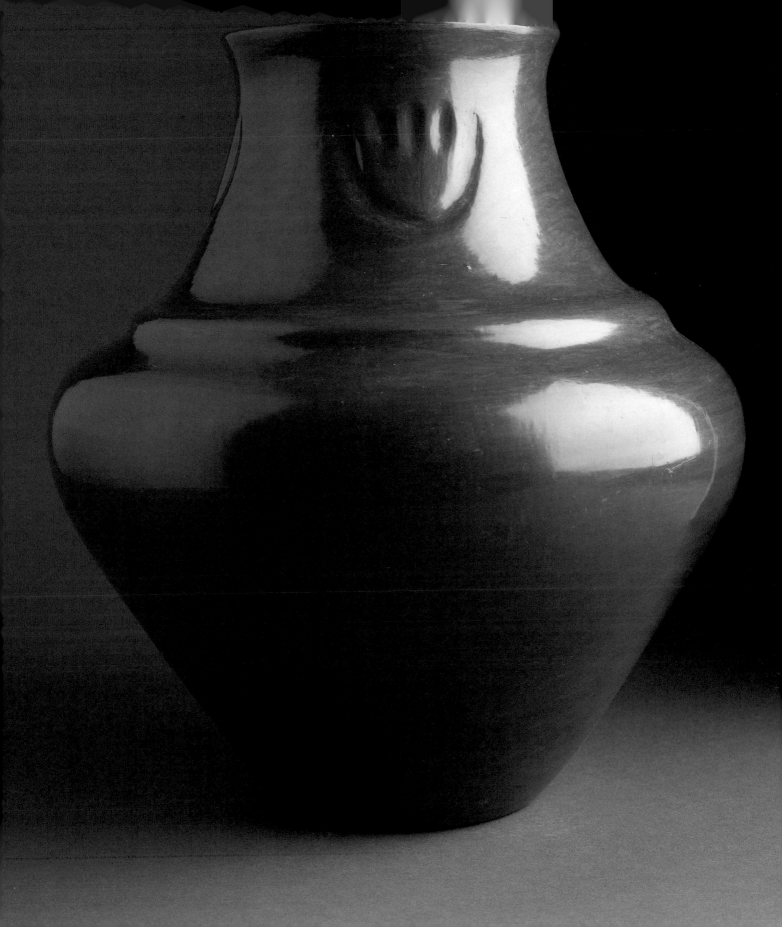

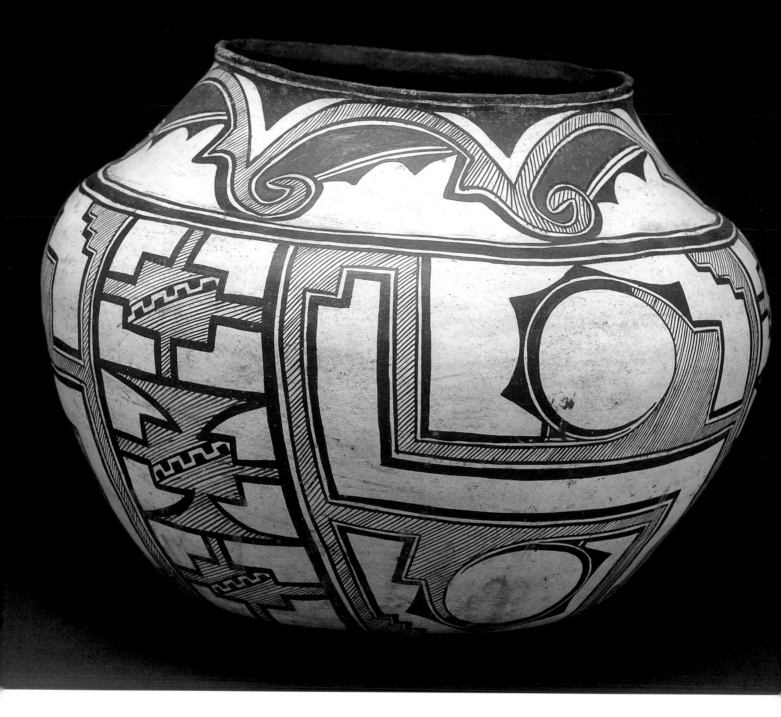

FACING, BOTTOM

WATER JAR, 1930s
Zuni
Clay, paint
12 x 8 1/4

The rectangles with
hatched lines and diagonal
bands on this jar represent
snow clouds.

WATER JAR,
LATE 1800s
Zuni
Clay, paint
11 x 7 3/4

Eileen Yatsattie linked water
jars to rain and was taught
that hatching, or lines, within
a variety of shapes represents
rain falling. This water jar has
rain bird designs on its body
and neck. According to Eileen
Yatsattie the addition of an
eye "personified" the motif.

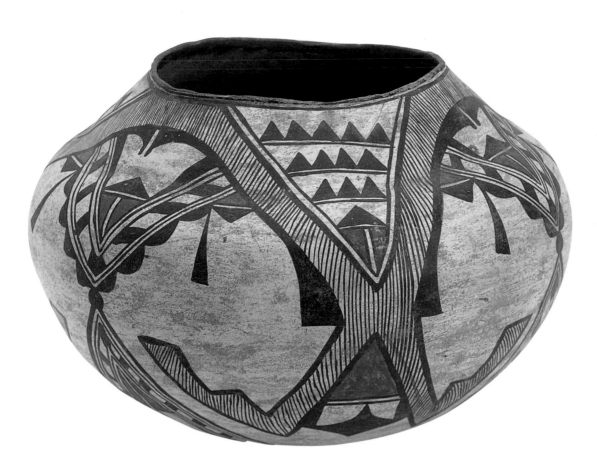

WATER JAR,
C. 1900
Zuni
Clay, paint
10 1/2 x 7 1/2

Eileen Yatsattie
interpreted the
large, V-shaped areas
of this jar as
lightning shooting
down with rain.

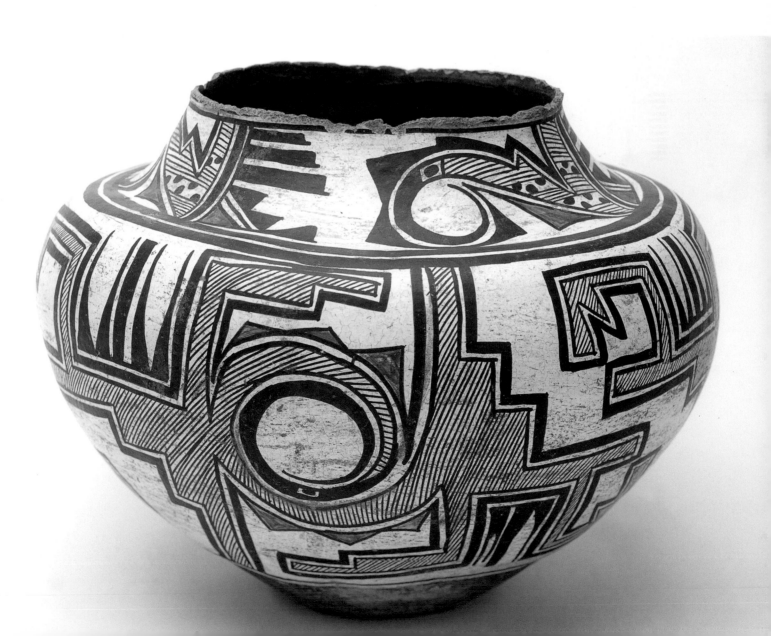

PLATE, EARLY 1970s
Blue Corn, San Ildefonso
Clay, paint
8 3/4 × 1

Cloud symbols are an enduring design motif at San Ildefonso Pueblo. On this plate, feathers associated with prayer arch over a bank of clouds, with streaks of rain falling below. The cloud design is very similar to those painted in the early 1900s.

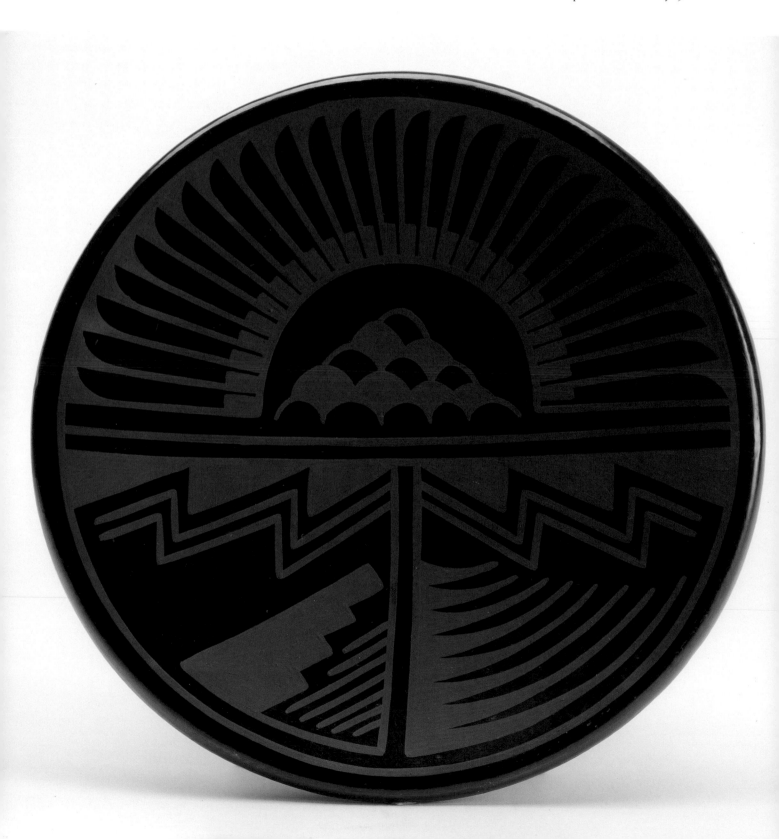

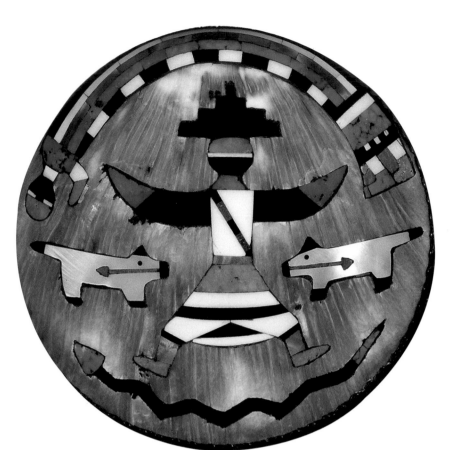

BOX, EARLY 20TH
CENTURY
Leo Poblano, Zuni
Silver, spondylus shell, jet,
turquoise, coral, abalone
shell, clam shell
3 1/2 × 3 3/4

Leo Poblano designed and created the shell inlay for this box lid using the shield of the Bow Priests as his subject matter. The principal figure wears a cloud hat. The bow is a rainbow that shoots lightning arrows. The box was made for C. G. Wallace, a trader in the Zuni area. It is believed that he asked silversmith Wilson Skeet (Diné) to make the box and the setting for the shell.

JAR, C. 1900
Marianita Roybal,
San Ildefonso
Clay, paint
10 × 11

Billowing cloud banks above distant rain are the focus of this San Ildefonso jar, which also has tadpoles on its lid.

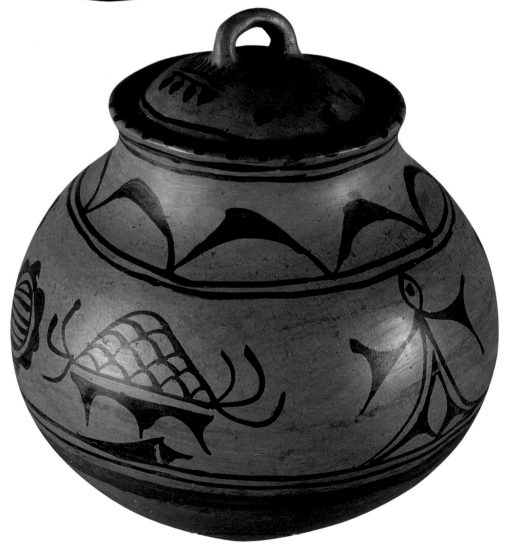

"The rainbow has many meanings, one of which is, it represents the bow of the Bow Priests. It is also the bridge that our sacred mudheads play on. . . . It has different meanings, but all good."

—Cal Seciwa, Zuni

JAR, 1875—1925
Acoma
Clay, paint
10 1/2 x 12

A rainbow seems an appropriate motif to decorate a water jar. Author and ceramicist Rick Dillingham traced the origins of the rainbow on ceramics from Acoma, Laguna, and Zia pueblos to ancestral Pueblo ceramics and designs on Hispanic textiles (Dillingham, 1992, 97).

FACING

NECKLACE, 1931
Merle Edaakie, Zuni
Turquoise, jet, white shell,
mother-of-pearl, clam shell
28 x 3

Zuni lapidary artists often feature Rainbow Gods on a wide range of jewelry.

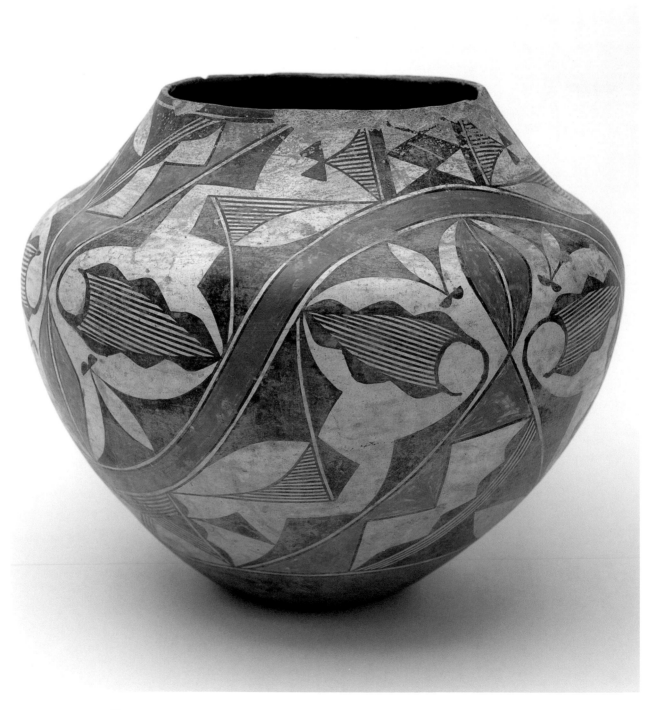

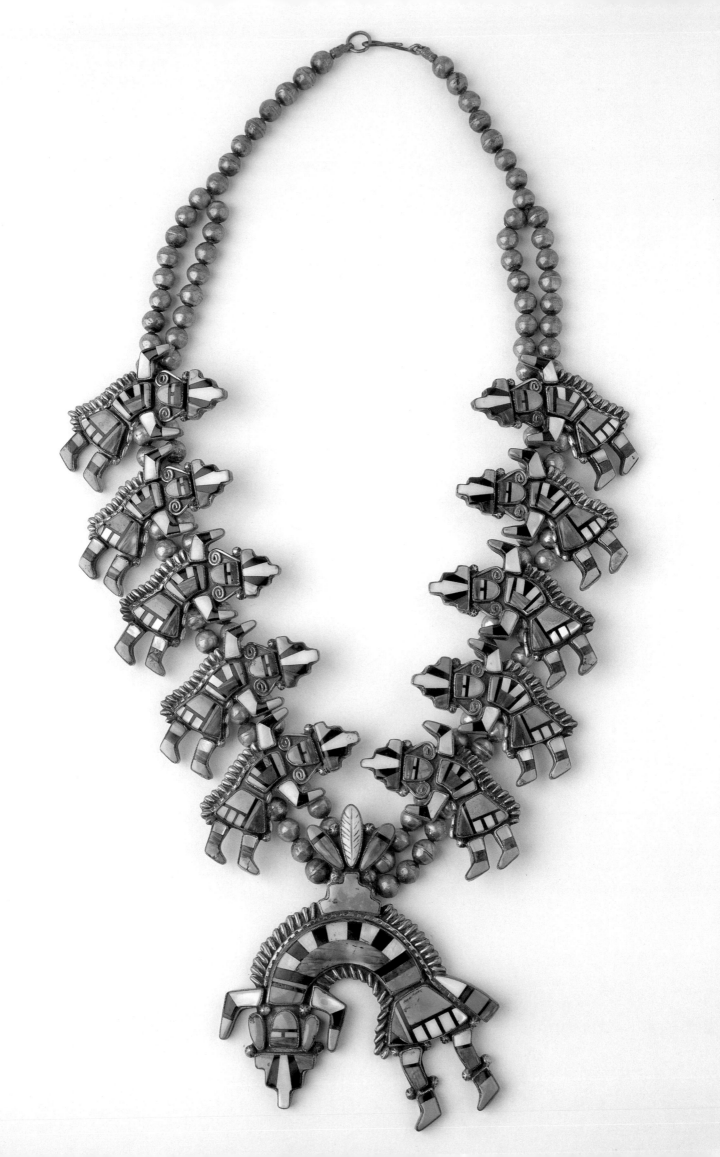

RAINHOUSE/
SAGUARO FRUIT
WINE FESTIVAL,
1993
*Michael Chiago,
Tohono O'odham/ Akimel
O'odham/
Pee Posh
Watercolor on paper*
20 x 30

Michael Chiago experienced
the saguaro fruit harvesting
and ceremonies with his
grandparents, who lived in
the desert on the reservation.
The ceremony depicted in
this painting is the wine
festival, taught to the people
by I'itoi. It takes place in late
June, when the fruit of the
giant saguaro ripens.

LOOKING FOR RAIN IN
THE DESERT

Michael Chiago, O'odham/Pee Posh advisor

Michael Chiago, an illustrator and painter, is Tohono O'odham,
Akimel O'odham (Pima), and Pee Posh (Maricopa). He was born at
Kohatk on the Tohono O'odham reservation. His participation in
Native dance and his desire to capture the spirit of the dance led him
to art. His depiction of O'odham ceremony and dance have been
widely exhibited and has illustrated several books.

94

O'ODHAM

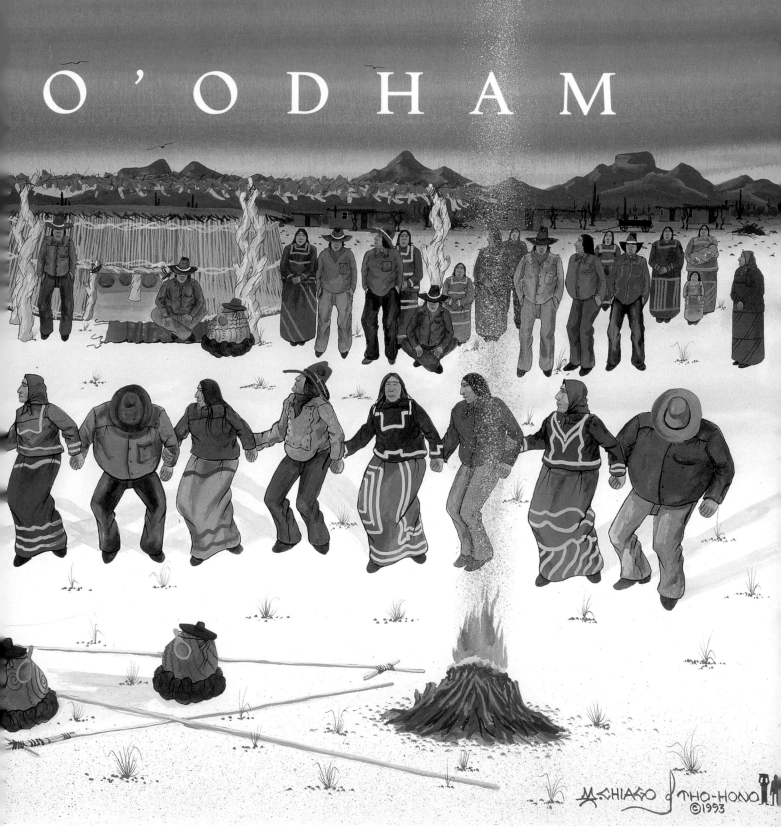

"In the old days . . . the saguaro provided the people with fresh fruit, syrup, and a cake made from the seeds. The syrup-making process produces a juice which ferments for three days in the rain house under the care of the Keeper of the Smoke, the village headman and ceremonial leader. Rain songs are sung, and men and women dance at night. At noon of the third day, the headmen gather to recite poems over the baskets of wine. The men of the village sit in a circle and pass the baskets until they are drained. The planting of crops takes place after the wine festival to make use of the rains that are bound to follow. Today, many families still prepare the saguaro wine for their own use, and the custom to cover the wine with song continues; anyone who accepts a drink of the wine recites a poem which invariably relates to clouds or rain." — Michael Chiago

SAGUARO FRUIT PICKING STICK, C. 1974
Baptisto Lopez, Tohono O'odham Saguaro cactus rib, wire
73 × 6

In the Tohono O'odham language, this is a kui'pad. It is more than six feet tall and made of saguaro ribs. Baptisto Lopez of Santa Rosa Village kept several of these sticks at his saguaro camp ready for each year's picking.

The rainshadow cast by coastal mountains falls heavily across the Sonoran desert, where annual precipitation is about eight inches. Despite such low rainfall, many plants and animals have adapted to the land. It is anything but barren and desolate, yet it is a place of extremes. The effects of flash floods and droughts mark the surface of the land. In the winter some of the stronger storms from the Pacific reach the desert. In fact the Sonoran desert is actually not the driest part of the Southwest during the winter; parts of the high Colorado Plateau in northeastern Arizona are even drier. If there is rain in the winter, spring can be the most beautiful of seasons, with brilliantly colored wildflowers. May, June, October, and November are very dry as the desert climate makes its transition from summer to winter and back again. In these months "very dry" can mean no precipitation or less than a tenth of an inch.

In the summer, monsoon storms form over the mountains of the Mogollon Rim and boil down into the desert in late afternoon and into the evening. If the winds are strong enough (such as those of Pacific hurricanes), other storms sweep up from the south—from the Gulf of California—and even from the southeast—from the Gulf of Mexico. Dust storms usually precede the rain, but sometimes dust is all that comes. When rain does arrive, however, it is dramatic, with lightning flashing all around and sheets of water that quickly flow into arroyos. If the conditions are right, this drama will play out for several afternoons in succession. Flash floods are common in some arroyos, which are untouched by falling rain but receive runoff from sudden storms at higher elevations.

PICTORIAL BASKET, C. 1965
Tohono O'odham Beargrass, bleached and unbleached yucca, martynia
12 1/2 × 14 1/2

A woman is picking fruit from a saguaro cactus on this modern basket that is made as an item of cultural art. Basketry depictions of this important cultural activity called "pulling down the clouds" are fairly common.

AFTER SAGUARO FRUIT IS PICKED, IT IS MIXED WITH WATER, KNEADED INTO A PULP, AND STRAINED. SEEDLESS PULP CAN BE ADDED TO SAGUARO SYRUP TO MAKE JAM. THE SEEDS CAN ALSO BE SEPARATED OUT AND GROUND INTO FLOUR.

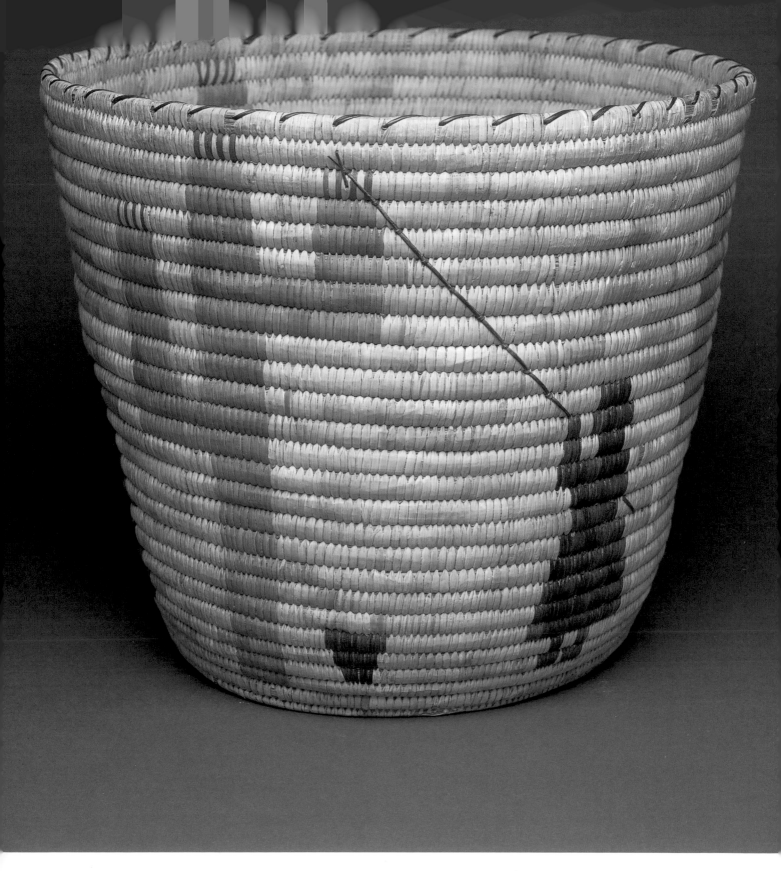

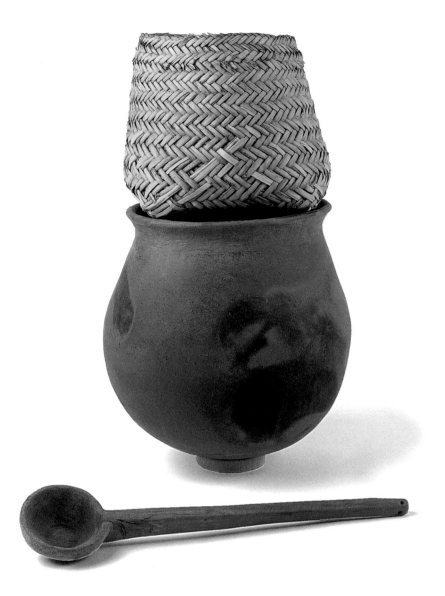

FRUIT
STRAINER, C.
1971
Tohono O'odham
Palm leaves
11 x 8

COOKING JAR,
C. 1890
Tohono O'odham
Clay
14 x 14 2/3

LADLE, C. 1950
Tohono O'odham
Wood
20 3/4 x 4 x 2

RAIN IN LIFE

For nearly two thousand years, people of the desert have based their residential patterns, agriculture, and food gathering on an in-depth knowledge of the seasons. The importance of rain in Tohono O'odham life is reflected in their traditional calendar. The new year, roughly equivalent to late June and early July, begins with Ha:saû Bak masad, the "saguaro moon." This is followed by Jukiabig masad (July), or "rainy moon," at the beginning of summer thunderstorms and the planting of crops. All of the O'odham months have descriptive names like these to refer to rain and plant growth. As summer rains end, the Wasai Gak masad, "dry grass moon," and the Wi'ihanig masad, "moon of persisting," initiate the wait for winter rains. The winter rains bring Ce:dagi masad, "green moon," in the spring, when plants and trees begin to bloom.

For the Tohono O'odham, life in the desert means adapting to cycles of rainfall and water flow. In the past, some of the people lived year-round along the perennial streams, and some lived in seasonal locations, wintering near permanent springs in the foothills and summering in alluvial areas where summer rains wash down from higher ground.

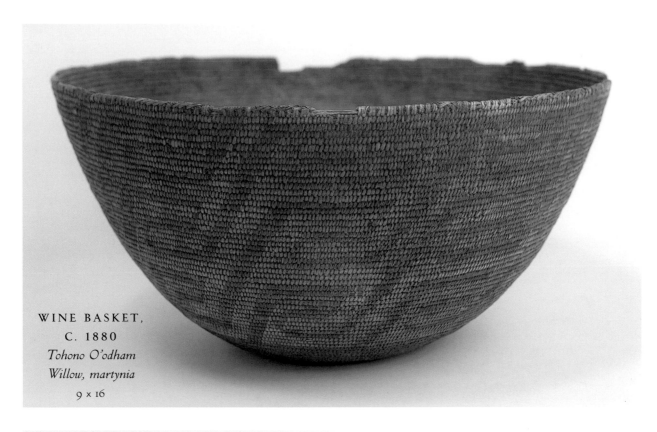

**WINE BASKET,
C. 1880**
*Tohono O'odham
Willow, martynia*
9 x 16

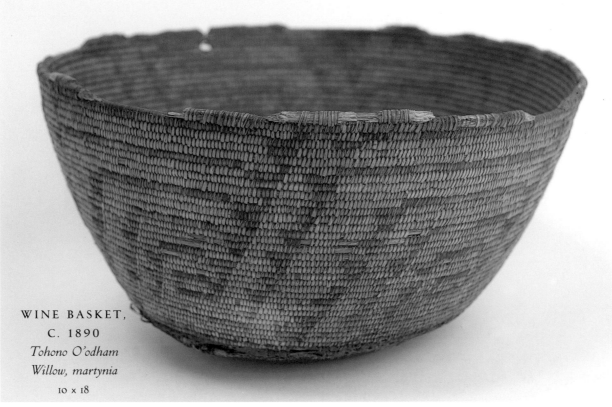

**WINE BASKET,
C. 1890**
*Tohono O'odham
Willow, martynia*
10 x 18

During the rain ceremony,
baskets are used to hold
saguaro wine. Poems of rain
are recited over the wine.
The men of the village sit in
a circle and take turns
drinking from the baskets
until they are empty.

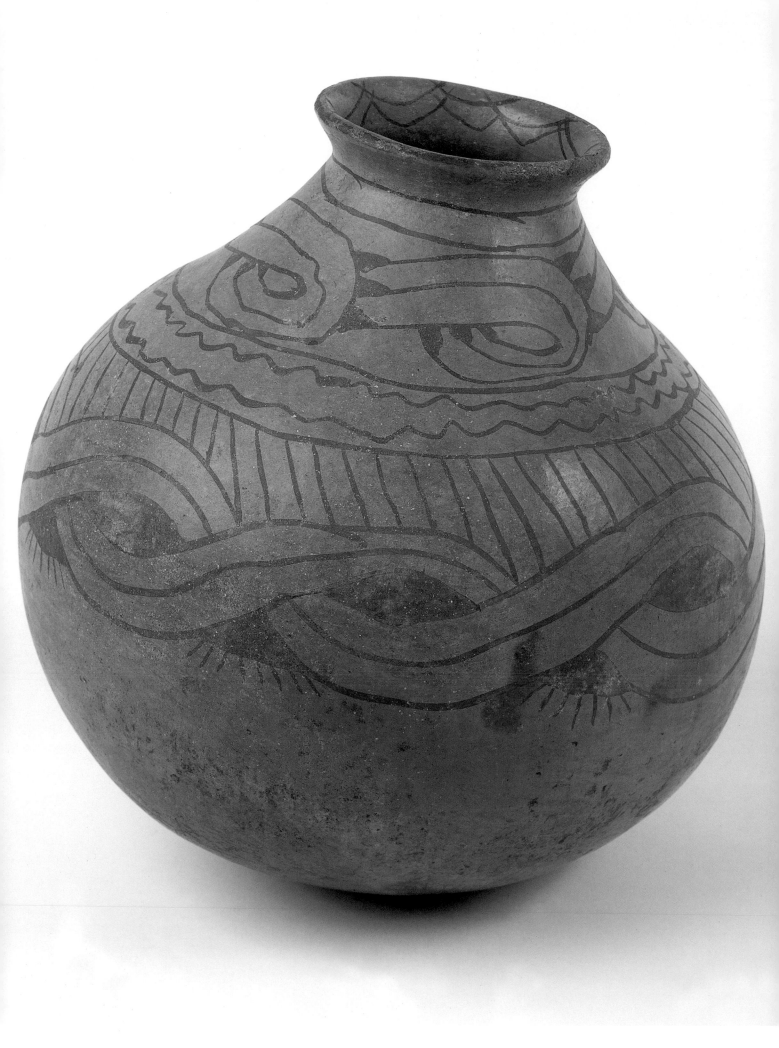

100 *Rain*

In the 1830s, when Anglo fur trappers discovered ever-flowing streams like the Gila River with huge beaver populations, life changed dramatically for the people of the desert. Within ten years, trappers had killed the beaver and moved on. But changes to the river's flow occurred in the years following the Civil War, when Anglo farmers diverted the river water for their crops. Almost no water could reach the Pima, which led to starvation. In 1872, Pima leader Antonio Azul led a delegation to Washington, D.C., to seek redress. President Ulysses S. Grant offered no relief; he suggested they move to Indian Territory (now Oklahoma).

A terrific winter flood was followed by a multi-year drought in 1892. In fact, Arizona experienced a lengthy drought that lasted into the twentieth century. But adapting to the desert was not the way of the Anglo settlers. Instead, they adapted the desert rivers to their needs; the early twentieth century saw the building of dams that destroyed rivers and changed the desert way of life forever (McNamee, 1993, C-1 and 2).

Still, the O'odham live in the desert, appreciating its beauty and celebrating the saguaro and the fruit harvest that precedes the summer rains and the start of a new year.

. . . You look at my rainhouse that here stands.
In it many winds here lay, many clouds
here lay, many seeds here lay

And I set them down and sat on them
You joined with them and touched me.

And so I moved
[I] Breathed my wind, my cloud started

With it I was doing things
And these [doings] I drop on your land
From that your land is wetly put and finished.

—Jose Pancho (Santa Rosa)
from *Rainhouse and Ocean: Speeches for the Papago Year*

RAIN IN CEREMONY

On the last day of the school year, teacher and Tohono O'odham elder Danny Lopez explained some of the rain ceremonies to his second grade class. He punctuated his description with certain O'odham terms, for carrying on the culture is inextricably tied to carrying on the language. As his students looked up at the summer sky, he said, "We always want the rain to come to our desert. Everything is calling for the rain. So that's why we have the rain ceremonies at places like Big Fields, Santa Rosa, and all the places where they do that. But first we have to do the other important ceremony of going after the saguaro fruit. . . . We get the first one we knock down and we open it up . . . take a little bit and place it over your heart. It is like a little prayer. You ask for something good to help you live right on the earth and then you eat that. But also with the first peeling, you put it down on the ground with the red up to the sky, so that way it can call the clouds so they can bring the water to our land. . . . Come, come bring the water to our land," he called. "We need the water." Then he led his class in a circle dance that resembles a junior version of the ceremonies Michael Chiago has painted. As they walked in a circle, singing, Danny Lopez told them to stomp harder so they can "shake the earth" and "loosen the clouds so we can get some water."

His students are learning bits of a larger and complex rain ceremony, the wine feast. This ceremony is a gift to the Tohono O'odham people from I'itoi, the Elder Brother and Creator. It begins with "pulling down the clouds," or harvesting ripe fruit from the saguaro cactus. The harvest and production of saguaro syrup may take from one to three weeks. The public portion of the ceremony includes the preparation, drinking, and regurgitation of saguaro wine as well as ritual oratory and dancing. Men consume large quantities of wine, and the wine becomes the medium through which they pray for rain. The sacred intoxication and regurgitation are referred to as "throwing up the clouds." It is said that the saturation of the people with wine is like the earth that will soon be saturated with water. Through their songs, speeches, and sacred intoxication, the Tohono O'odham summon the rain.

EXPRESSIONS OF RAIN

In contrast to Pueblo cultures, in which rain images are pervasive in art and life, concrete expressions of rain in O'odham culture are rare. Instead, they are found in their rich oral traditions. The rain ceremony includes several examples of ritual oratory. Early in the ceremony, runners go to neighboring villages with speeches of invitation. These speeches are followed by others associated with being seated, sitting, and drinking at the ceremony, and finally the mockingbird speeches, which call for the release of the clouds.

SAGUARO WINE JAR, PRE—1955
Tohono O'odham
Clay, paint
14 × 11 1/4

An important element of the Tohono O'odham rain ceremony is the drinking of saguaro fruit wine. The wine is prepared and stored in redware jars like this one. Rain songs are sung over the jars while the liquid ferments. Drinking of the wine and dancing, together, bring rain. The geometric designs on these jars are traditional Tohono O'odham but are not specifically rain designs.

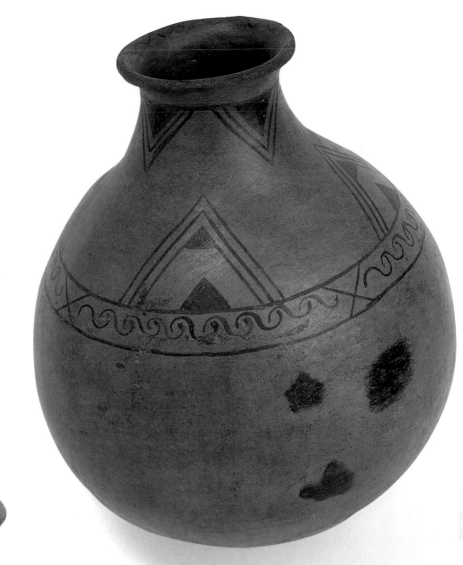

SAGUARO WINE JAR, PRE—1955
Attributed to Annie Thompson, Tohono O'odham
Clay, paint
15 × 13

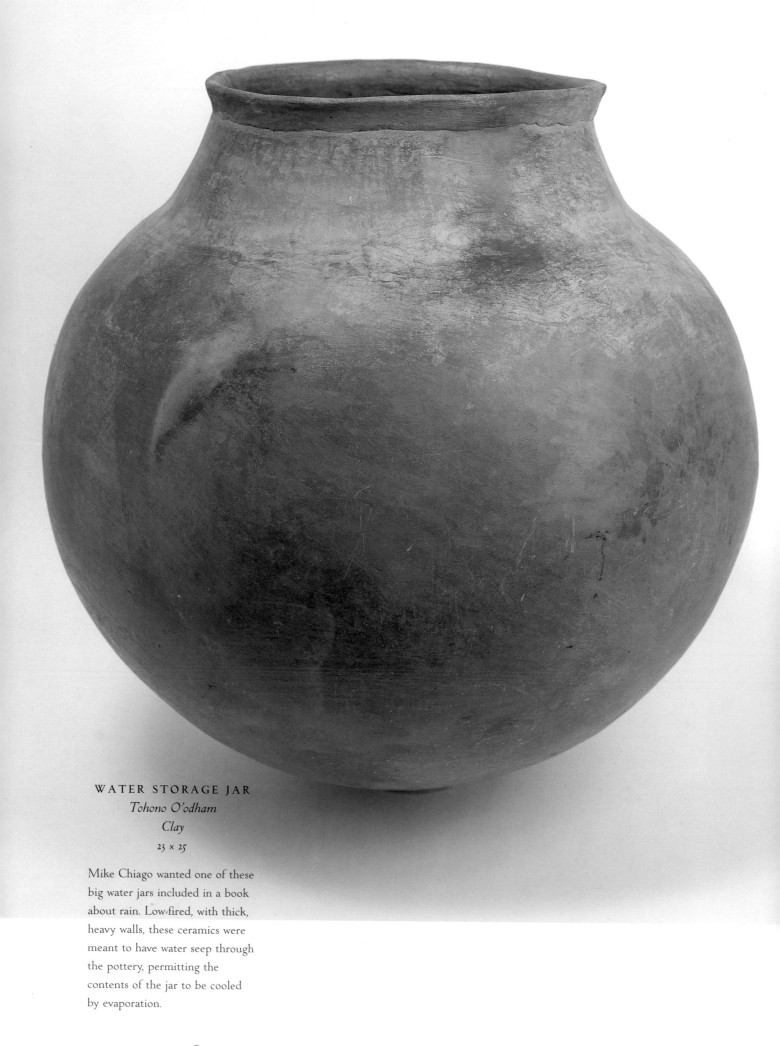

WATER STORAGE JAR
Tohono O'odham
Clay

23 x 25

Mike Chiago wanted one of these
big water jars included in a book
about rain. Low-fired, with thick,
heavy walls, these ceramics were
meant to have water seep through
the pottery, permitting the
contents of the jar to be cooled
by evaporation.

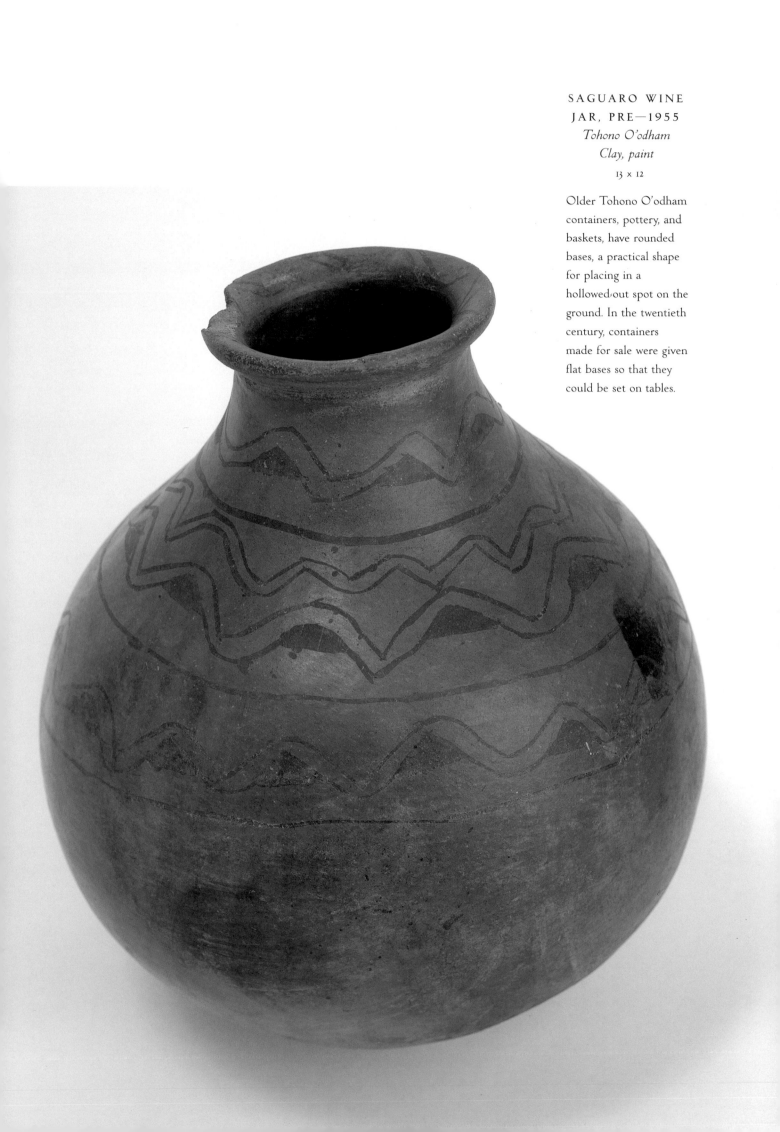

SAGUARO WINE
JAR, PRE—1955
Tohono O'odham
Clay, paint
13 × 12

Older Tohono O'odham
containers, pottery, and
baskets, have rounded
bases, a practical shape
for placing in a
hollowed-out spot on the
ground. In the twentieth
century, containers
made for sale were given
flat bases so that they
could be set on tables.

D I N É NAVAJO

LOOKING FOR RAIN

IN DINÉTAH

Joe Ben, Jr., Diné advisor

Joe Ben, Jr., a Diné, is originally from Shiprock, New Mexico. For more than twenty years, he has made incredibly fine, detailed sandpaintings and, most recently, compositions that express the universal nature of Navajo ideas. He has studied with healers and is most interested in sharing knowledge of the Navajo religion. He has taught at the Ecole des Beaux-Arts in Grenoble, France, and his sandpaintings have been exhibited at the Georges Pompidou National Center for Art and Culture in Paris.

RAIN IN THE LAND

On the Colorado Plateau, between the four sacred mountains, the Diné live in a land carved by water and wind into fantastic shapes. Dinétah has a variety of environments. Lower elevations at about 5,000 feet may receive eight inches of precipitation a year, while the Chuska Mountains, at 8,000 feet, may receive twenty to twenty-five inches. Although it snows here in the winter, the Rocky Mountains block Canadian air masses, which can make this region even drier than the desert in the winter.

RAIN IN LIFE

In the Navajo world, there is a duality, or pairing, expressed as male and female in nature and in life that leads to balance. So there is duality in rain. Rain accompanied by thunder, lightning, and wind is considered male rain. Steady, quiet rain is female rain. Within one storm, both kinds of rain may fall. Navajo healer Annie Kahn says, "This rain that comes together makes a union like getting married and producing children, and I belong to that family, the family of water." She was born to the Water Clan, her mother's clan. Just as for Pueblo peoples, rain or water can be part of a Navajo person's identity.

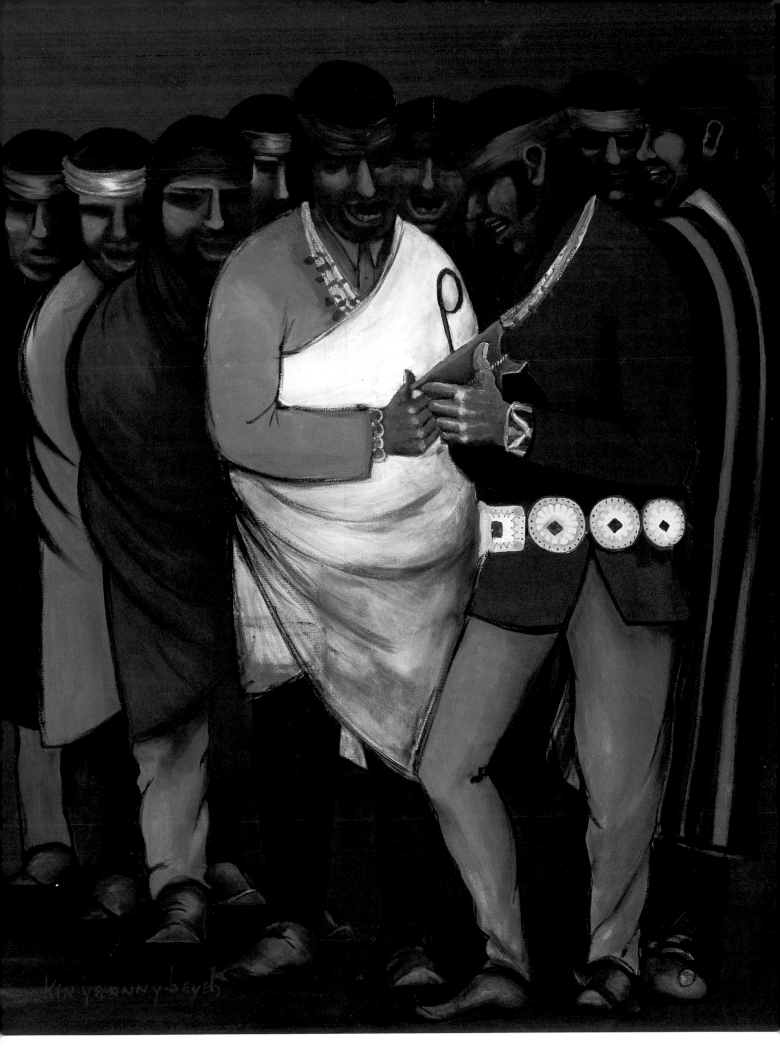

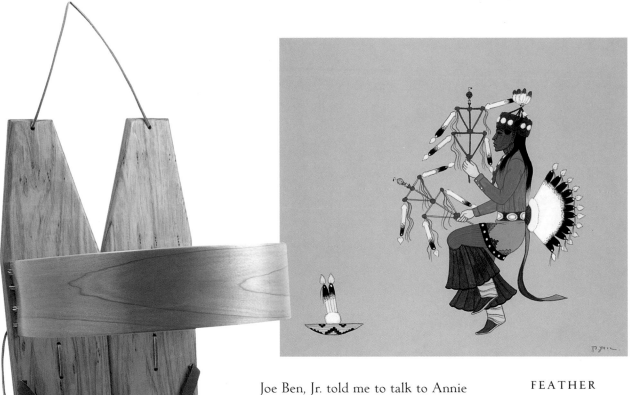

FEATHER
DANCER, 1959
Beatien Yazz, Diné
Watercolor on posterboard
17 × 22

Joe Ben, Jr. told me to talk to Annie Kahn about rain. She selected a place beside a stream just off a mountain road near her home in Lukachukai. Later in the summer, people would move sheep along this road, heading for green pastures and cooler weather. The road is surrounded by tall evergreen trees. "I look to the dark trees, the evergreen trees— trees that don't become old," she says. "These are the trees that are very close to the rain. When the rain comes these trees move, and when they move they are dancing. The trees, the tall trees, are holding up their hands and saying, " 'Water! Come down!'... This to me is happiness; it is the greatest happiness to have rain upon you. Let the rain fall on you; let the rain drop on you. It is life touching you." As she speaks, she looks upward, smiling as rain from a small cloud falls on her face.

Asked about images of rain in her life, elementary school teacher Arlene Old Elk mentions the cradleboard, making the point that even in infancy a Navajo baby is surrounded by references to rain and the land. The band that protects the baby's head is a rainbow; the laces that zigzag across to hold the baby in place are lightning bolts.

This painting suggests the fundamental role of the ceremonial basket beyond that of the wedding ceremony, for which the design on the basket is popularly named.

CRADLEBOARD,
1996
Lolita Curley, Diné
34 1/2 × 10 1/2 × 11

CEREMONIAL BASKET, LATE 1800S
Diné
Sumac, willow, vegetal dyes, charcoal dye
3 1/8 × 3

To Joe Ben, Jr., these ceremonial basket designs illustrate important concepts about rain and its connection to the creation of life. Such baskets are used to make prayers for rain. Joe Ben, Jr., interprets the meaning of the wedding or ceremonial basket design in this manner as shown in the diagram at right.

The concept of male and female rain reflects the duality and balance that are fundamental to the natural and spiritual world of the Diné—present in animals, people, and deities as well as in lightning, mountains, hogans, and rainbows.

Watersprinkler, a deity of celestial waters, makes rain and is the water carrier in the Nightway Ceremony, a healing ceremony that lasts nine days and includes Yeii Bicheii dances to which the public may come. It takes place at the end of the growing season in late autumn, when the thunder and lightning are over. Rain, essential to life's balance, is part of this ceremony. In the Nightway Ceremony, Watersprinkler re-creates and depicts the forces of rain in nature. His role is also that of a clown, one who makes people happy and who, by extension, represents the rain itself, a phenomenon that makes people happy.

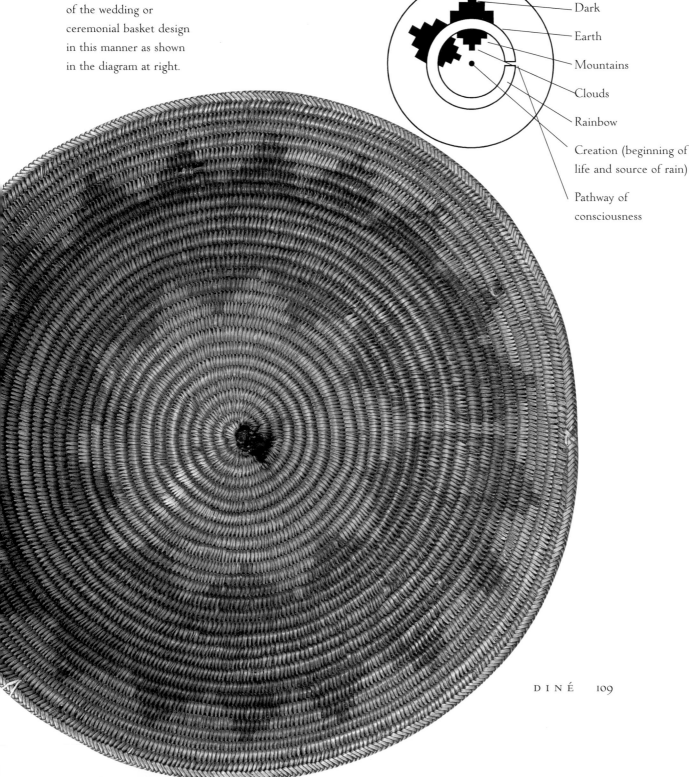

Daylight
Dark
Earth
Mountains
Clouds
Rainbow
Creation (beginning of life and source of rain)
Pathway of consciousness

Expressions of rain in Navajo ceremony are reconstructions of nature and the universe. For Diné artist Joe Ben, Jr., baskets of the "wedding basket" design, used in a marriage or healing ceremony, symbolically create a sense of time, place, and the environment with representations of dark clouds, mountains, and rainbows. These provide a foundation for the ceremony. Ceramic water drums are also part of the rain imagery of ceremony, as are shell beads on necklaces. Lightning and rainbow designs are painted on ceremonial rattles.

The Navajo homeland's Four Sacred Mountains are each associated with a different natural material. Sisnaajinii (Blanca Peak) is adorned with white shell, Tsoodzil (Mount Taylor) is adorned with turquoise, Dook'o'oosliid (the San Francisco Peaks) are adorned with abalone, and Dibe'Ntsaa (Hesperus Peak) is adorned with jet. Based on these associations, necklaces of turquoise, abalone, white shell, and jet contain stones that are used in many Diné rituals, with turquoise a central ingredient in prayer offerings for rain.

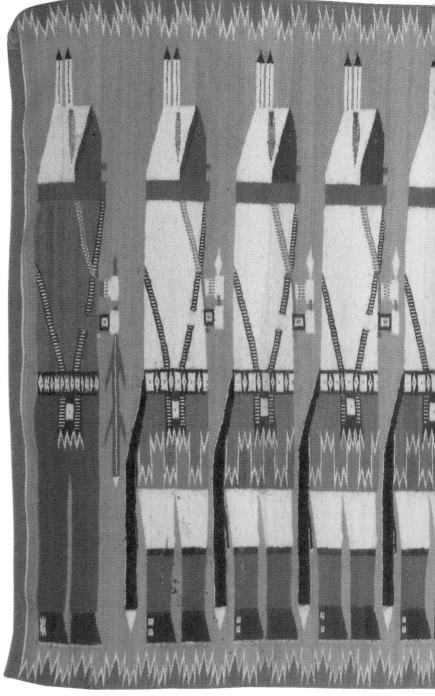

TEXTILE, 1968
Della Woody, Diné
Wool, vegetal dye, aniline dye
35 × 59

Joe Ben, Jr., selected a textile depicting a Yeii Bicheii ceremony that included the figure of Watersprinkler (on the left). Also referenced as the Rain God, or Deity of Celestial Waters, he is the water carrier for the gods and produces rain. Although not shown in this textile, the Watersprinkler wears white-tipped turkey feathers. The white represents water that touched the tail feathers of the turkey, the last to emerge from the rising waters of the fourth world.

Rain is tied into the origins of weaving, including the legends of Spider Woman. In Diné legend, three of the spindles used by Spider Woman to teach the people to spin were made of zigzag, flash, and sheet lightning; the fourth spindle was made of a rain streamer. Textiles with sandpainting designs, and depictions of Yeii Bicheii ceremonies, are linked to rain through the ceremonies they represent. Rain-related designs have also been incorporated in Navajo textiles made for sale. The origin of the Storm Pattern is debated, but the design is shown in mail-order leaflets used by trader J. B. Moore between 1903 and 1911. Moore's catalog text was written to tempt customers seeking rare rugs with powerful symbols.

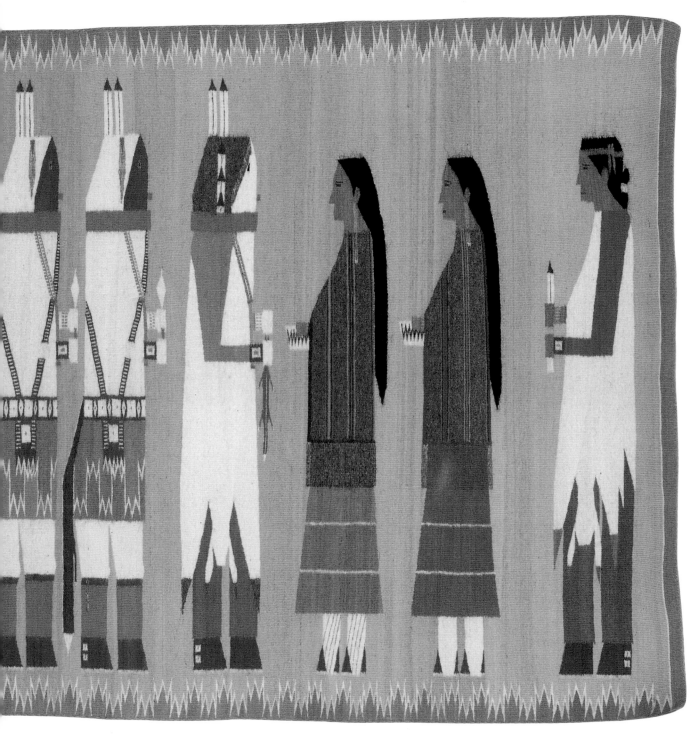

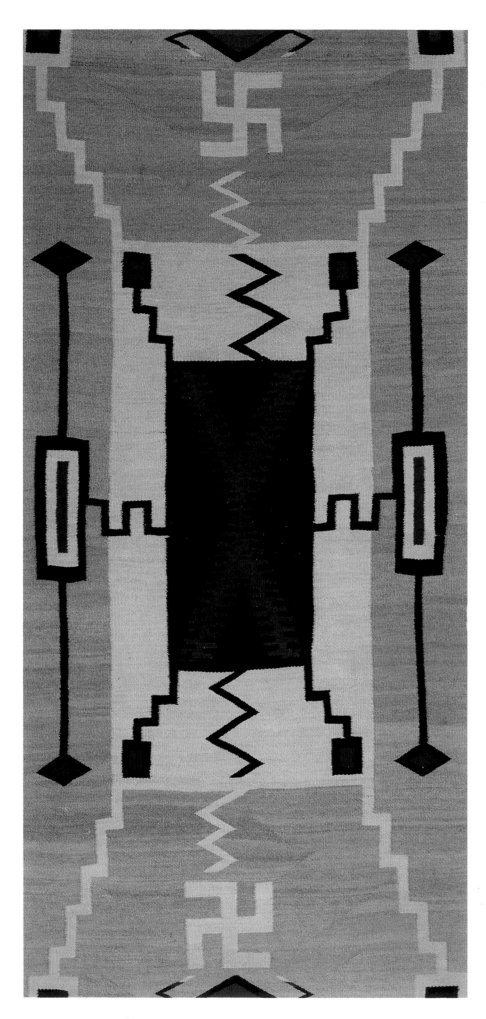

STORM PATTERN
TEXTILE,
1920s—1930s
Diné
Wool, aniline dye
69 x 32

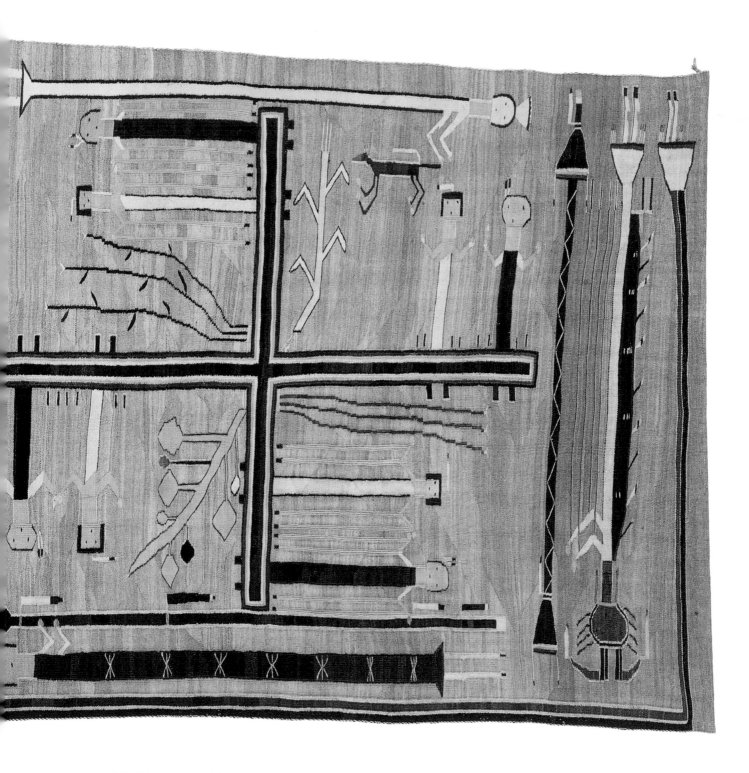

TEXTILE, C. 1920
Hosteen Klah, Diné
Wool, aniline dye
79 1/2 × 110

To Joe Ben, Jr., it was important to include a textile woven by the respected medicine man, Hosteen Klah. Klah's depiction of the Whirling Logs portion of the Night Chant contains numerous references to rain and rain-related phenomena. A rainbow guardian, open to the east, protects the figures in the textile. To the north and south are two large figures with horns, the Mountain Sheep gods, who carry on their backs sacks of black clouds filled with fruits and the harvest of the field. At the center of the whirling logs is the Water Meeting Place, a lake on whose shores grow the sacred plants of corn, beans, squash, and tobacco. It is the place of emergence for Diné from the fourth world to this world.

114 *Rain*

STORM PATTERN
TEXTILE,
C. 1970
Marie W. Begay, Diné
Wool, vegetal dye
48 x 72

Woven in the raised
outline style, this storm
pattern textile is a
modern version of the
design advertised by
trader J.B. Moore in the
early 1900s. Although its
origins are not known,
the design may have been
trader-inspired, either by
Moore or another trader.
Certainly, they do not
depict any version of a
dry painting used in
ceremony. The motifs do
represent some important
beliefs and concepts of
the Diné. Regardless of
its origins, the references
to some possible
symbolism have made the
"Storm Pattern" a design
that has lasted much of
the twentieth century.

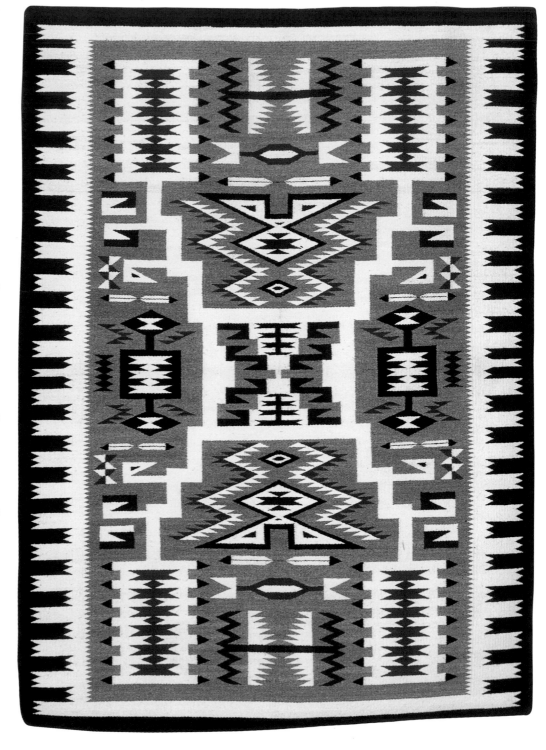

Zigzag connecting
lines = lightning
bolts

Center box = the
hogan dwelling

Squares at each of
the four corners =
the four sacred
mountains

STORM PATTERN
TEXTILE, 1961
Rose Maloney, Diné
Wool, aniline dye
69 x 49

This piece shows the
elaboration that has developed
from the basic early design.

RAIN IN THE LINE OF THE SKY, 1993
Joe Ben, Jr., Diné
Masonite, gesso, azurite, diamond,
gold, lapis, coal, hematite, chrysocolla,
gypsum sand, sandstone
28 1/4 x 32 x 1

Joe Ben, Jr., used azurite, chrysocolla, diamond dust, coal shale, gold dust, gypsum, hematite, lapis, sand, sandstones, and sulfuric materials in this work. He has these thoughts about his sandpainting: "I did not want to do the kind of sandpainting that a medicine man would have done fifty years ago. Instead, I wanted to address this as a contemporary work, just as Hosteen Klah did with his sandpainting symbols in textiles. I did not want to just reproduce ritualistic symbols, but, like Hosteen Klah, go further and explore the universalism of these symbols. This painting is about yçdihil [sky] and the female and male aspects. It is the sky where the rain comes from. And it is the sky that tells us how much rain and when. This painting deals with the line of the sky running from south to north and then back again, completing a circle. This is the home of the clouds—the white cloud, the yellow cloud, the blue cloud, and the black cloud—symbolized by the four triangles under the sun. The morning star on the left is a representation of Changing Woman. The evening star on the right is a representation of White Shell Woman, who is the carekeeper of the rain. Rain is represented in the bed of white clouds on the line of the sky. Female rain is on the left side and is colored white and yellow. The male rain on the right side is colored blue and black.

I hope that when people view this work, questions will be raised about their existence and their connectiveness. Where do they belong in the cosmos? Because we all belong. How?"

FATHER SKY AND
MOTHER EARTH,
C. 1970
Mary Morez, Diné
Acrylic on canvas
36 3/16 × 48 9/16

Rain drips from the horns of both
Father Sky and Mother Earth.
The two figures are linked by a
rainbow. The sky is the color of
dawn. Mary Morez painted this
shortly after the moon landing,
when she felt the earth and sky
were coming closer together.

TEXTILE/PREPARATION
OF NOAH'S ARK, 1992
Sadie Begay, Diné
Commercial wool and dye
40 × 43 1/2

Although there are no clouds,
people are building the ark. A
modern touch is added by the
people who are painting the vessel
using paint rollers. Other people
are preparing food for the voyage.

THE PICTORIAL TEXTILES OF SADIE BEGAY REFLECT CULTURAL CHANGE AND PERSONAL

BELIEFS. SHE HAS WOVEN A NUMBER OF TEXTILES DEPICTING EPISODES IN THE JUDEO-

CHRISTIAN FLOOD STORY OF NOAH AND THE ARK. MRS. BEGAY IS A MEMBER OF A

CHRISTIAN DENOMINATION. HER WEAVINGS DEPICT A STORY THAT IS FAMILIAR TO MANY.

TEXTILE/AFTER THE FLOOD, 1992
Sadie Begay, Diné
Commercial wool yarn
35 1/2 × 42

A rainbow has appeared and the land is drying off. A cow has been sacrificed as an offering to God. The surviving animals include giraffes and elephants, who will migrate to live in other parts of the world far from the Diné.

TEXTILE/THE FLOOD, 1992
Sadie Begay, Diné
Commercial wool yarn
44 1/2 × 38 1/2

The lights are on in the ark, and those inside are dry. Outside, the sky is full of storm clouds and people and animals are drowning. Some of the animals are fairly exotic, such as the alligator. Some people have climbed to the roof of a house or hogan in an attempt to save themselves.

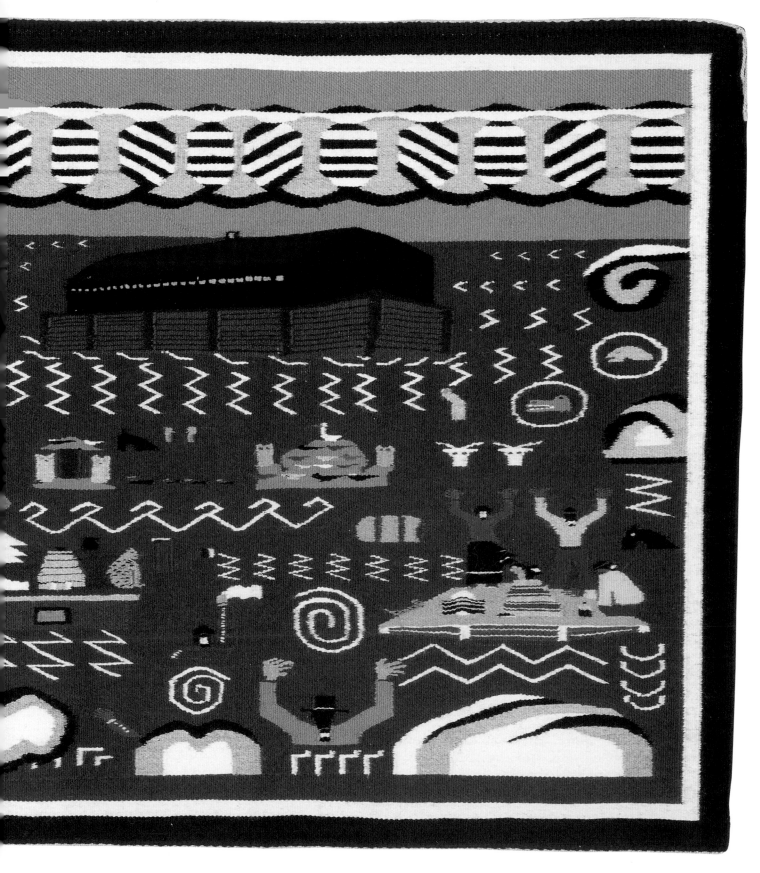

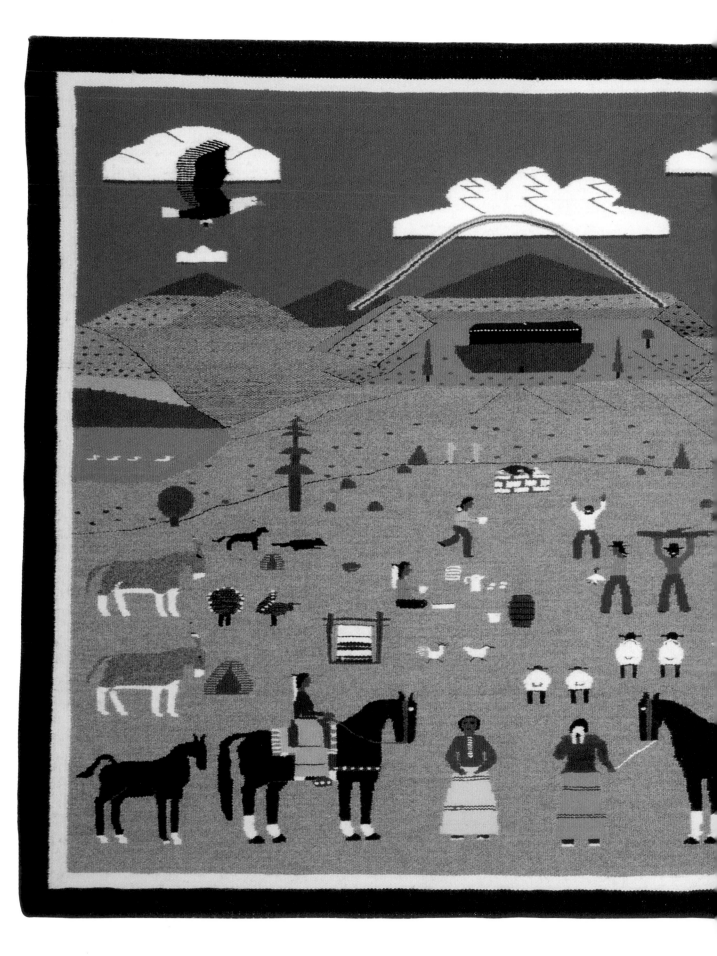

**TEXTILE/ANIMALS
DISPERSE AFTER
LEAVING THE ARK, 1992**
*Sadie Begay, Diné
Commercial wool yarn*
48 × 43

The animals in the foreground all live in the Diné lands. The giraffe and elephant are seen in the far distance, departing for their new homes.

male rain

*He comes
riding on the wind
kicking up dust
bending the trees
blowing flakes of rain
He flees past my window
to a distant rumble*

*In-laws beware of him
who mocks the braves
as his features are majestic illusions
his knife the cutting cold
and his soul a drifter*

female rain

*she pregnant with rain child
comes
quite
softly
and gently
in the night*

*At dawn she gives birth
to little droplets of rain
and for days on end*

awakening

*male rain has come and gone
female rain is fading in the distance
father sun is here
and mother earth is awakening*

—Agnes Tso (Diné),
from *The South Corner of Time*

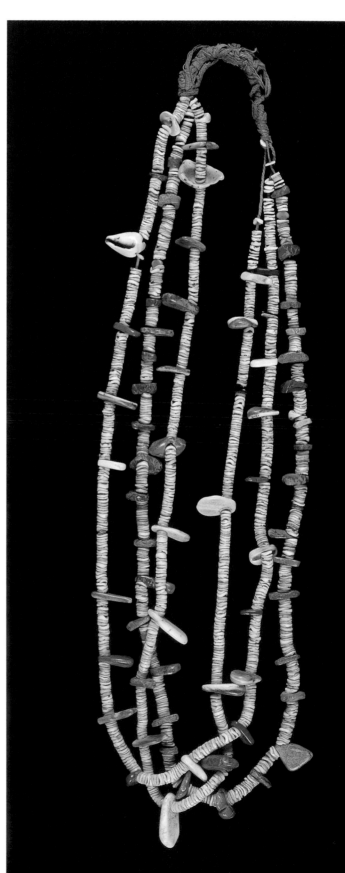

Diné
Spondylus shell, turquoise, glass beads,
cotton thread, metal
15 INCHES IN LENGTH

Although probably made at Santo Domingo Pueblo, this style of turquoise jewelry is appreciated by the Diné. Turquoise represents the color of water and is an important stone in Diné prayer offerings for rain.

NECKLACE, C. 1880
Diné
Turquoise, glass beads, jet beads, conus
Californicus, glycymeris shell, spiny
oyster, olivella
13 3/4 INCHES IN LENGTH

This necklace of jet, shell, coral, and turquoise has the colors of the four directions, which are associated with the four sacred mountains that surround, protect, and shelter the Diné. Joe Ben, Jr. saw the wearing of such a necklace as "surrounding" the wearer's neck, and so by wearing the necklace, one is symbolically surrounded by the four sacred mountains. Shell and turquoise have associations with water and rain, which are part of the blessings of life.

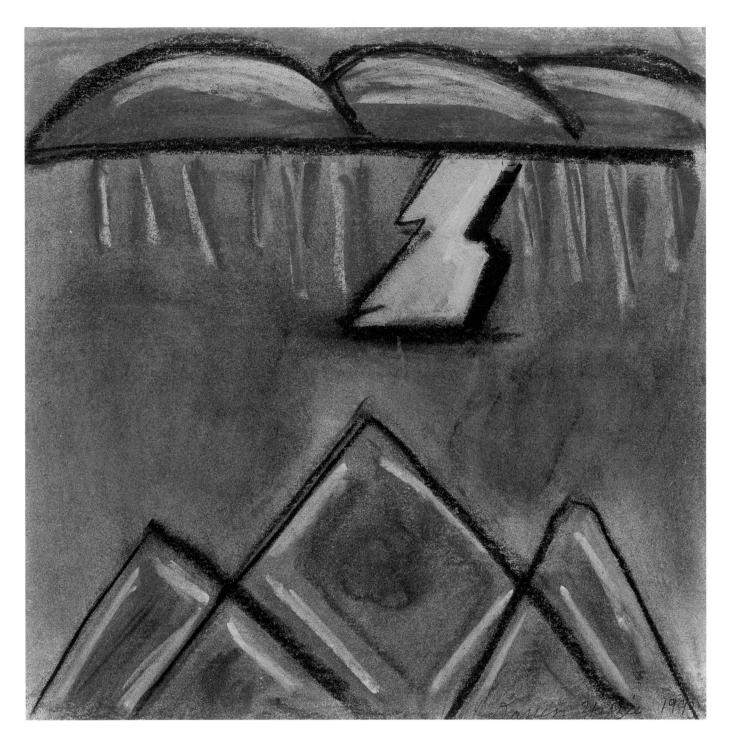

RAINSTORM, 1993
Darren Yazzie, Diné
Pastel on construction paper
10 x 10

In the context of culture-based
school arts programs, traditional
themes and motifs linked to rain
are frequently selected by
students. Darren Yazzie entered
this piece in the Heard Museum
Guild's Native American Student
Arts and Crafts Show.

NA IH ES
CANE, 1984
Indé
Wood, paint, eagle
feather, leather,
metal, ribbon
40 x 6

One account of the
four days following
a Na ih es (puberty)
ceremony indicated
the belief that by
sprinkling water over
her cane, a girl for
whom the ceremony
was conducted has
the power to cause
rain (Basso, 1964,
160).

LOOKING FOR RAIN
IN THE MOUNTAINS

Edgar Perry, Indé advisor

Edgar Perry, an Indé, has served as a curator of
many exhibits and is the former director of the
White Mountain Apache Cultural Center. He
has taught the Apache language for many years
and is on the Heard Museum's Native
American Advisory Committee.

RAIN IN THE LAND

Indé communities are located
in mountainous areas and thus are quite varied
in elevation and precipitation. There are deep
canyons, sheltered valleys, and streams and
rivers that flow down off the mountains and the
Mogollon Plateau to the spectacular dropoff
that is the Mogollon Rim. Elevations range from
3,000 to 11,000 feet. The most intense rains in
Arizona fall in this area, and the high elevations
mean snow is an important source of moisture.
About 75 percent of winter precipitation is
snow. As spring fades into summer and
vegetation dries out, forest fires, caused either
by humans or by lightning strikes, are of great
concern, especially before the monsoon season
begins. In the southern White Mountains, as
many as eighty or ninety thunderstorms may
occur throughout midsummer. On the White
Mountain Apache Reservation, the village of
Cibeque, at 5,000 feet, is in an exposed position
and receives the full force of dramatic summer
thunderstorms. These usually occur in the
afternoon and early evening. Including both rain
and snow, annual precipitation can be as high as
twenty-five inches.

NA II ES
(SUNRISE)
CEREMONY
PONCHO,
C. 1983
Mescalero Indé
Muledeer hide, glass
beads, metal tinklers,
yellow pigments, metal
bells
31 x 32

During the Sunrise
Ceremony, a young
woman embodies several
traditional Indé beliefs.
The most important is
her representation of the
cultural heroine, White
Shell Woman, who, it is
believed, was impregnated
by water and gave birth to
another hero, Water
Child.

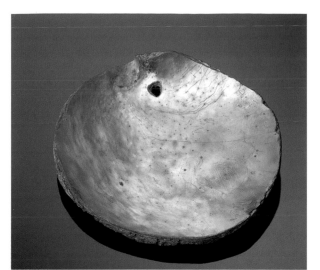

PENDANT, C. 1900
Hopi
Abalone shell
2 INCHES IN DIAMETER

A pendant of abalone shell is worn on the young woman's forehead as she participates in the Sunrise Ceremony and, for a time, becomes White Shell Woman. Indé origin stories tell of White Shell Woman sealing herself inside an abalone shell in order to survive a flood. This pendant was collected at Hopi but is similar to the Indé shell pendant.

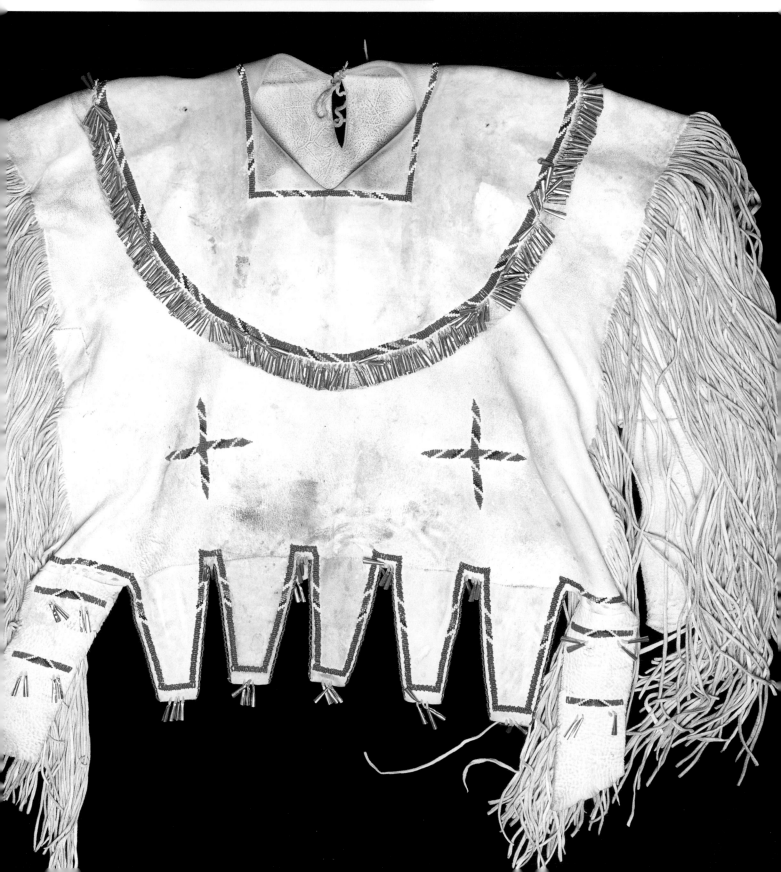

In a varied terrain many kinds of plants and animals flourish. Historically, the Indé moved in bands on a seasonal migration that followed the growing season and hunting opportunities. Before they were forced onto reservations in the 1870s, the Western Apache occupied 90,000 square miles in east-central Arizona. The need to gather food over such a wide area contributed to many conflicts as the land became increasingly populated by ranchers and settlers. Today the Western Apache occupy two major reservations in the mountains: White Mountain (Fort Apache) and San Carlos.

Indé artist Delmar Boni and the late Indé medicine man Philip Cassadore talked to author Tryntje Seymour. Delmar Boni told her, "We know that when their harvest is gone, that is not the end of it. Because with the natural elements of life, that rain will come over again, over that mountain, the lightning will bless it, the water will fall on the seedling. It will start growing again" (1988, 32). The late Philip Cassadore spoke of rain in relation to death. "When the rain drops on you, they [the dead] are touching you. So stand out there. Like if your mother passed away, and the rain drops, she is touching you with the rain. She changed into rain while she is traveling to that other world" (1988, 34).

BURDEN BASKET,
PRE—1950
Indé
Willow, martynia, metal tinklers, glass beads, leather, stone, glycymeris maculata, muledeer hide
13 × 13 1/4 × 13 3/4

Burden baskets were traditionally used by Indé women to carry various objects during travel and gathering. Following Indé contact with Anglo traders, the fluted metal tinklers became a traditional part of these baskets. Some Indé today say that the sound of the tinklers resembles rain hitting the earth.

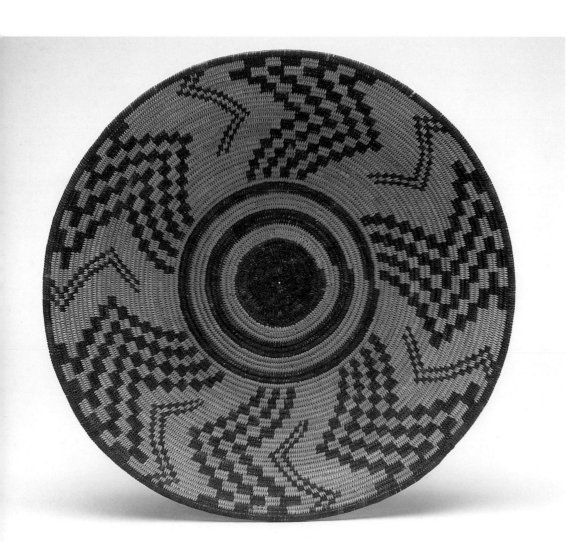

TRAY, PRE—1950
Indé
Willow, martynia
4 × 16 1/4

Zig-zag designs of this type refer to lightning.

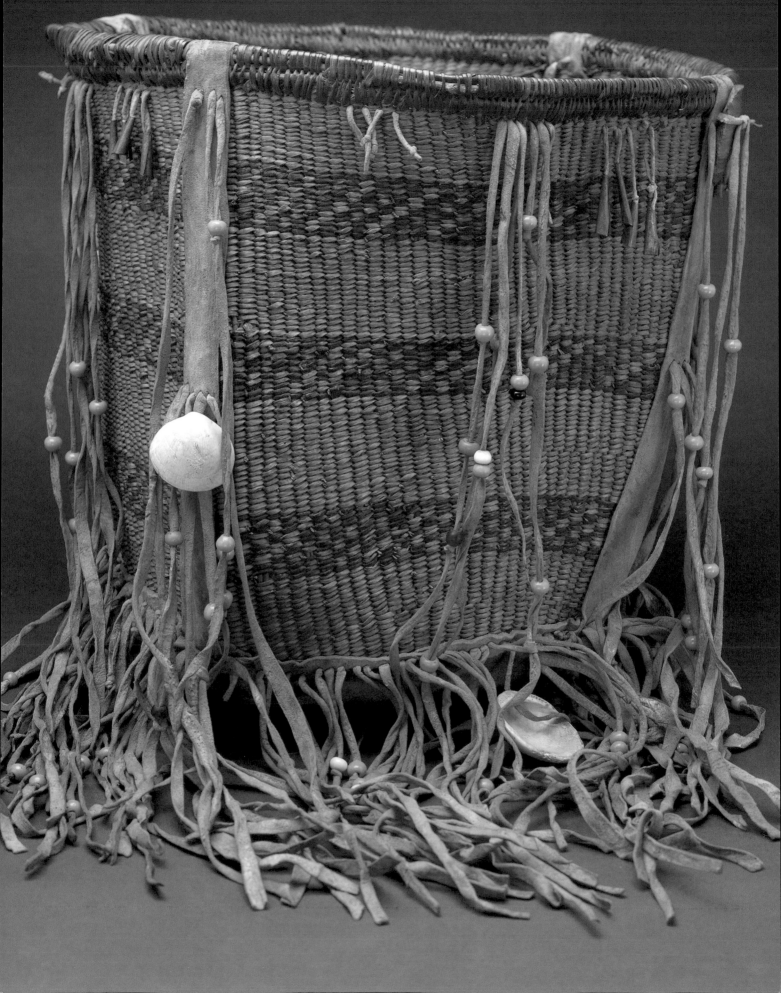

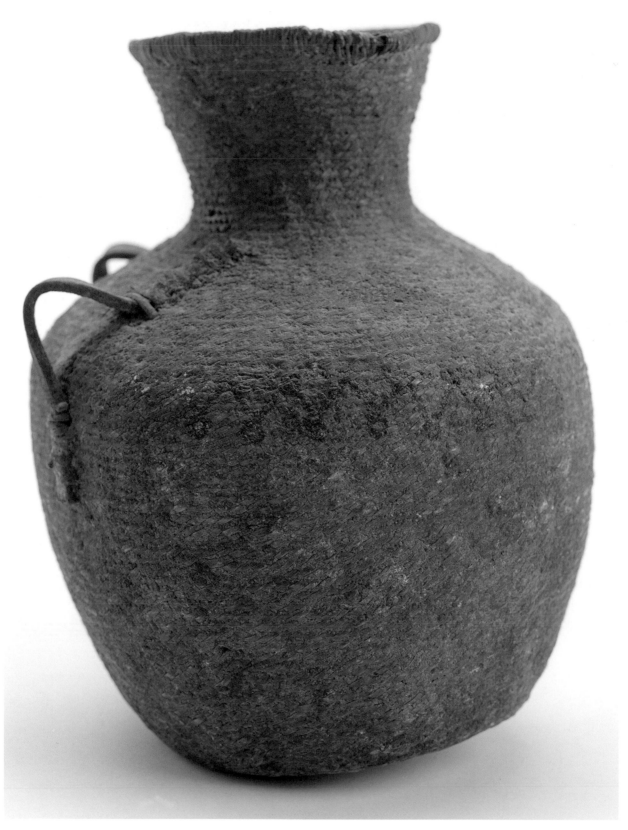

PITCHED WATER CARRIER, C. 1836
Indé
Sumac, martynia, red ochre, pitch
10 1/4 × 8 1/4

This is a pitch-covered basket used to carry water from the family of Warm Springs Apache leader John Loco. The triangle and dot symbol is seen upside down on this piece.

EDGAR PERRY LOOKS FOR LIGHTNING DESIGNS ON INDÉ BASKETS. HE SEES A TRIANGLE WITH A DOT JUST ABOVE ITS APEX OR AT EACH CORNER AS REPRESENTING RAINDROPS OVER A MOUNTAIN. THIS MOTIF IS SOMETIMES ALSO FOUND ON GAAN HEADDRESSES, VIOLINS, AND PITCHED WATER BOTTLES.

TRAY, PRE—1933
Indé
Willow, martynia
4 × 18 3/4

Traditionally, trays like this one had several uses: as dispensers of food and other items, and for winnowing and collecting seeds, grains, and plant fruits. Edgar Perry chose this basket because of the parallel zigzag designs that refer to lightning.

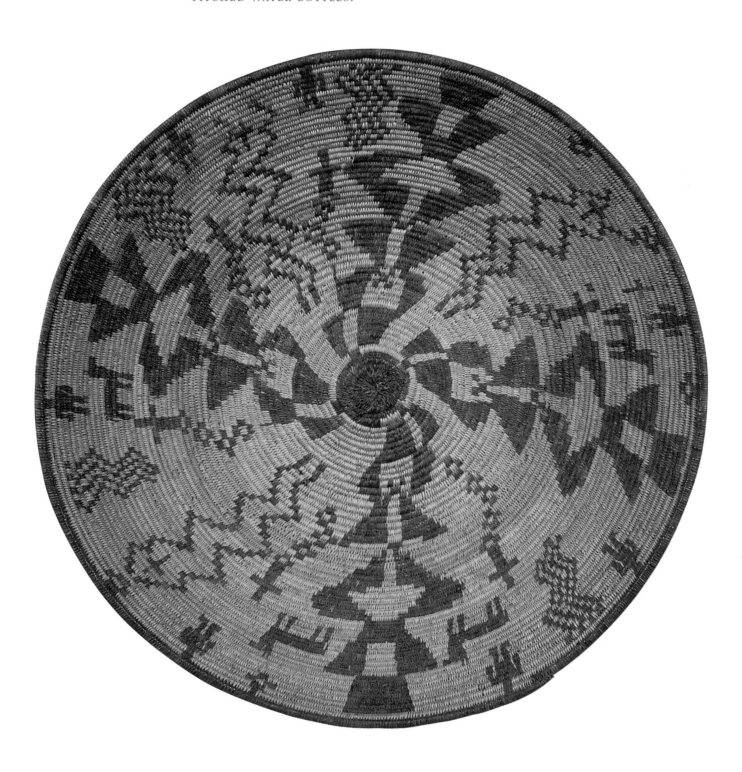

SECTION OF
GAAN
HEADPIECE,
C. 1940
Indé
Wood, paint, cord
54 × 44 (ENTIRE PIECE)
8 × 12 (SECTION SHOWN)

The Gaan appear during certain ceremonies, including the Sunrise Ceremony. They represent the many powers of the Indé universe, including the sun, moon, wind, lightning, thunder, and rain. Edgar Perry identified the dot and triangle design as one representing rain on the mountains. The entire headpiece is not shown at the request of Indé cultural leaders.

BULLROARER,
1979
*Lorenzo Baca,
Isleta/Mescalero Indé*
Oak, string
1 1/4 × 6 1/2

The sound of the bullroarer is the sound of wind and storm. It is whirled in ceremonies by L'ubaiye (the Gray One), who accompanies the Gaan.

Lightning, the voice of the wind in the mountains, and the mountains themselves are also entwined with people's lives and beliefs. The power of lightning is readily felt in this high country. The Inde people sometimes lose livestock to lightning strikes. Edgar Perry says his father was nearly killed by lightning while standing close to a tree when lightning struck it.

RAIN IN CEREMONY

In the Indé creation story, a flood killed all the people with the exception of White Shell Woman, who sealed herself inside an abalone shell. This story is presented in the girls' puberty ceremony known as Na ii es, which means "It is happening." For four days following the ceremony, the young woman can offer blessings to the community, including rain to relieve dry weather. The Na ii es, or Sunrise Ceremony, celebrates a girl's transition from childhood to womanhood. During this time, she is honored as a life-giver. The girl and all who witness the ceremony are blessed and are wished prosperity and long life.

The Gaan, four benevolent mountain spirits who keep the world in balance, add several elements associated with rain, wind, lightning, and thunder to the ceremony. Lightning, a focused power directed to earth, is regarded as a blessing. The swords of the Gaan are decorated with lightning symbols, and such symbols are also painted on their bodies. A fifth figure, L'ubaiye, the Gray One, whirls a bullroarer that makes the sound of thunder and stormy winds.

Philip Cassadore, who knew the songs of the na ii es ceremony, spoke to author Stephen Trimble about how power, in terms of thunder and lightning, found him as a medicine man.

You hear voices from another world if you become a medicine man. I am here, but when I look at the cloud, that's where I'm at. I'm up there with those medicine people. When the thunder and lightning come close, they're talking to me. When the thunder roll, it goes inside me. The closer it comes, the better I feel. I have a lightning shield—all around me (Trimble 1993, 225).

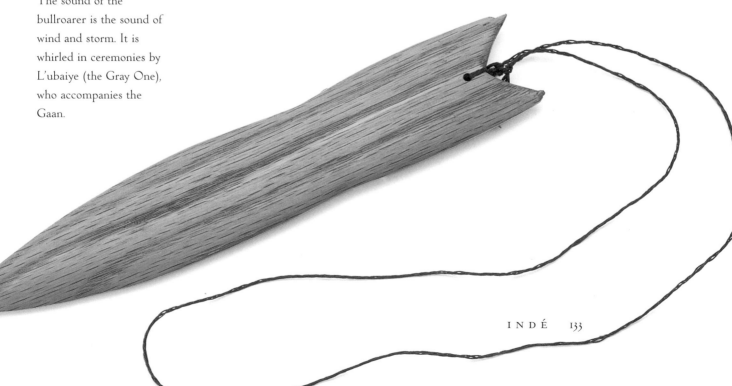

INDÉ 133

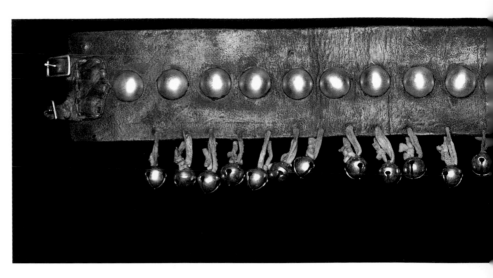

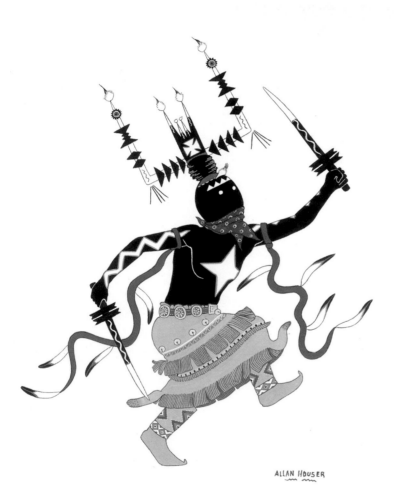

ALLAN HOUSER

GAAN DANCER BELT, PRE—1950
Indé
Cowhide, nickel, steel,
muledeer hide
6 x 38

This belt and its bells are often worn by the Gaan dancers during their ceremonial performances. Philip Cassadore explains that "the sound of the bells is like rain. . . when it hits the earth" (Seymour, 1988, 57).

MESCALERO GAAN DANCER, 1958
Allan Houser,
Chiricahua Indé
Watercolor on posterboard
13 1/8 x 11 1/8

A symbol of lightning is painted on the dancer's arm; the red strips of cloth hanging from his arms also represent lightning.

EXPRESSIONS OF RAIN

According to Philip Cassadore, the sounds of rain are expressed in the dancing of the Na ii eis ceremony. The young woman for whom the ceremony is given wears a buckskin dress with metal tinklers and carries a cane with bells attached. The Gaan also have tinklers and bells on their kilts and belts. As the Gaan dance, the sound of the bells and tinklers is likened to the sound of rain striking the ground during a hard rainstorm.

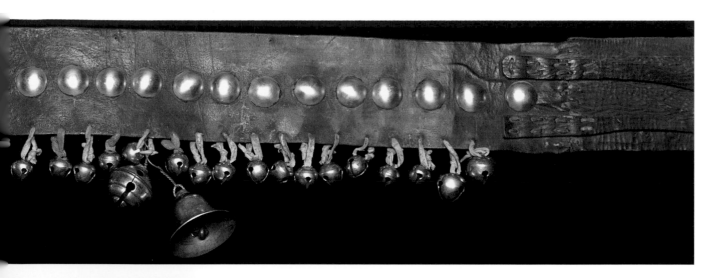

FIDDLE AND BOW, PRE—1970

Indé

Sotol, cottonwood, paint, willow, horsehair, string

19 1/2 × 7 1/8 × 3 5/8 (FIDDLE)

13 × 3/8 × 3 1/4 (BOW)

This fiddle, constructed from the center stalk of the maguey plant, is a traditional Indé instrument. Edgar Perry selected this piece because of the design element: dots at the corners of a triangle, which he considers an expression of raindrops on the mountains.

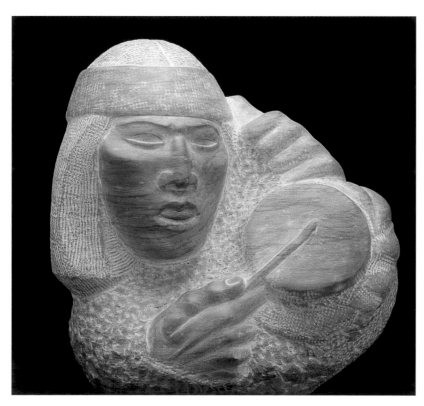

LEAD SINGER, 1970

Allan Houser

Chiricahua Indé

Gray marble

16 × 15 × 9

Painter and sculptor Allan Houser depicted a singer with a water drum and spoke of the importance of songs and stories told by his parents and elders for him as a young boy.

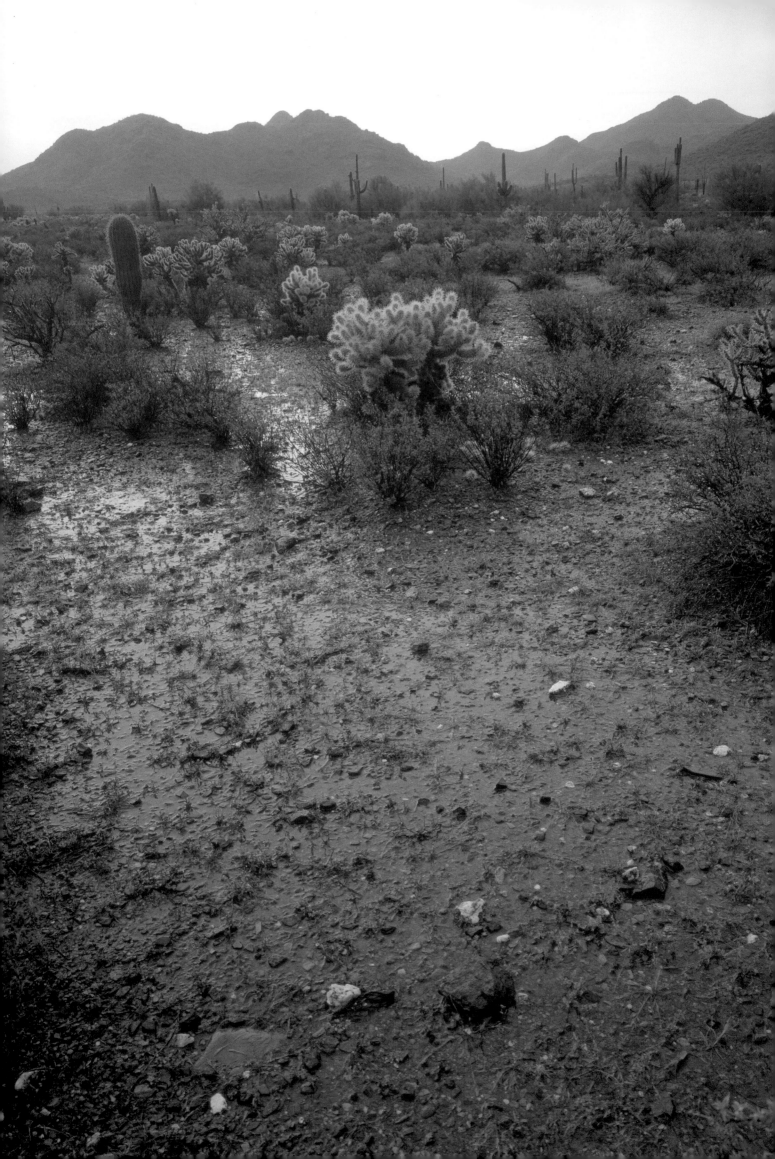

Babcock, Barbara A *The Pueblo Storyteller: Development of a Figurative Ceramic Tradition.* Tucson: University of Arizona, 1986.

Basso, Keith H. "Gift of Changing Woman." *Buraeu of American Ethnology Bulletin 196*, Anthropological Papers, No. 76, 1964, pp. 113-173.

Bunzel, Ruth L. "Introduction to Zuni Ceremonialism." *Bureau of American Ethnology Annual Report No. 47*, 1929-1930, pp. 467-544.

Bunzel, Ruth L. *The Pueblo Potter.* New York: Dover Publications, 1972. A republication of the original work published by Columbia University Press in 1929.

Dillingham, Rick. *Acoma and Laguna Pottery.* Santa Fe, New Mexico: School of American Research, 1992.

Fewkes, J. Walter. "Ancient Pueblo and Mexican Water Symbols." *American Anthropologist.* Vol.6, 1904, pp. 535-538.

Fontana, Bernard L. *Of Earth and Little Rain.* Tucson: University of Arizona Press, 1989.

Fox, Nancy. "Hopi Kachina Mantas" in *American Indian Art Magazine,* Winter 1988. pp. 61-67.

Goddard, Pliny E. *Gotal: A Mescalero Apache Ceremony.* Putman Anniversary Volume. New York: Stichert, 1909.

Hardin, Margaret A. *Gifts of Mother Earth: Ceramics in the Zuni Tradition.* Phoenix, Arizona: Heard Museum. 1983.

McNamee, Gregory. "Arizona Underwater." *Arizona Republic,* February 14, 1993, pp. C1-C2.

Mahoney, Thom. "Pablita Velarde." New Mexico, n.d. pp.18a-b. From a clipping in the Heard Museum Native American Fine Art Resource Files.

Mirocha, Paul. *Gathering the Desert.* Tucson: The University of Arizona Press, 1985.

Nabhan, Gary Paul. *The Desert Smells Like Rain.* San Francisco, California: North Point Press, 1987.

Sando, Joe S. *Pueblo Nations: Eight Centuries of Pueblo Indian History.* Santa Fe, New Mexico: Clear Light Publishers, 1992.

Seymour, Trintje VanNess. *When the Rainbow Touches Down.* Phoenix, Arizona: Heard Museum, 1988.

Slaney, Deborah. *Blue Gem, White Metal: Carvings and Jewelry from the C.G. Wallace Collection.* Phoenix, Arizona: Heard Museum, 1998.

Spinden, Herbert J. *Songs of the Tewa.* New York: Exposition of Indian Tribal Arts, 1933.

Trimble, Stephen. *The People: Indians of the American Southwest.* Santa Fe, New Mexico: School of American Research Press, 1993.

Tso, Agnes. "male rain, female rain, awakening" in *The South Corner of Time: Hopi, Navajo, Papago, and Yaqui Tribal Literature,* Larry Evers, ed. Tucson, Arizona: Sun Tracks, 1980.

Underhill, Ruth M.; Bahr, Donald M.; Lopez, Baptisto; Pancho, Jose and Lopez, David. *Rainhouse and Ocean: Speeches for the Papago Year.* Flagstaff, Arizona: Museum of Northern Arizona, 1979.

Underhill, Ruth M. *Singing for Power: The Song Magic of the Papago Indians of Southern Arizona.* Tucson: Sun Tracks and the University of Arizona Press, 1993. This is a republication of the 1938 University of California first edition with a forward by Ofelia Zepeda.

Zepeda, Ofelia, Ed. *Mat Hekid O Ju: 'O'odham Ha-Cegĭt.odag/ When It Rains: Papago and Pima Poetry.* Tucson: Sun Tracks and University of Arizona Press, 1982.

Quotes from advisors were taken from transcripts of discussions about the pieces to be illustrated for this project, from a video that was a part of the RAIN exhibit, and from classroom and gallery presentations to Heard Museum docents in preparation for the exhibit.

Sincere thanks to the many generous donors to the Heard Museum collection who made this book possible. (Art not listed below was purchased with general funds or acquired during the early years of the museum's collecting.) Numbers refer to page numbers of the objects. Items not listed were purchased with general funds or from early years of the museum's collecting.

ANCESTRAL PEOPLE

19 Purchased with funds donated by Mr. and Mrs. Byron Harvey III

27 Fred Harvey Fine Arts Collection

HOPI

30 Gift of Mr. and Mrs. Byron Harvey III

31 (bottom) Gift of Mr. Byron Hunter

32 Gift of Mr. and Mrs. Byron Harvey III

36 (third from top) Gift of Mr. William E. McGee

36 (bottom) Fred Harvey Fine Arts Collection

39 Fred Harvey Fine Arts Collection

40 (bottom left) Gift of Mr. and Mrs. Byron Harvey III

40 (bottom right) Gift of Mr. Byron Hunter, Jr.

41 Gift of the family of Adrienne and Jerome Harold Kay

42 (bottom) Gift of Mr. and Mrs. Byron Harvey III

43 (top) Gift of Mr. Byron Hunter, Jr.

43 (bottom) Gift of Mrs. D. L. Willetts

44 Gift of Mr. Byron Hunter, Jr.

45 Gift of Mr. and Mrs. Byron Harvey III

46 Gift of Bank One Arizona

48 (top and bottom) Gift of Mr. and Mrs. Byron Harvey III

49 (top and bottom) Gift of Mr. and Mrs. Byron Harvey III

50 (bottom) Gift of Mrs. Charles H. Maxwell

52 (top) Gift of Mr. Charles Benton

52 (bottom) Gift of Mr. and Mrs. Byron Harvey III

54 (bottom) Bequest of Nora K. Loerpabel

55 (top) Gift of Dr. and Mrs. Oscar Thoeny

55 (bottom) Gift of Mr. and Mrs. Byron Harvey III

57 (middle) Gift of Mr. and Mrs. Henry S. Galbraith

57 (bottom) Gift of Donna G. Rosenberg

58 Gift of Woodard's Indian Arts

59 (top) Gift of Mr. and Mrs. Henry S. Galbraith

NEW MEXICO PUEBLOS

60 Bequest of Herman and Claire Blum

62 Purchased with funds provided by the Goldsmith Foundation

66 Gift of Mr. C. G. Wallace

69 Gift of Mr. and Mrs. Byron Harvey III

70 Gift of Mr. and Mrs. Henry S. Galbraith

71 Gift of Mr. and Mrs. Henry S. Galbraith

74 (top) Gift of Giovanni Bolla

76 (top left) Gift of Ms. DeEtte Powers Buekers

76 (top right) Gift of Mr. C. G. Wallace

79 (bottom) Fred Harvey Fine Arts Collection

83 Fred Harvey Fine Arts Collection

84 Fred Harvey Fine Arts Collection

85 (top and bottom) Fred Harvey Fine Arts Collection

86 (top) Gift of Mr. Richard F. Chedester

86 (bottom) Gift of Mr. James T. Bialac

88 Gift of Woodard's Indian Arts

89 Fred Harvey Fine Arts Collection

90 Gift of Mary T. Berg

91 (top) Fred Harvey Fine Arts Collection

91 (bottom) Gift of Lorraine Mulberger

92 Fred Harvey Fine Arts Collection

93 Gift of Mr. C. G. Wallace

O'ODHAM

94 Commissioned with funds from the Lila Wallace Reader's Digest Fund

97 Gift of Mr. and Mrs. Byron Harvey III

98 (top and middle) Gift of Mr. and Mrs. Byron Harvey III

98 (bottom) Gift of Mr. and Mrs. Glenn E. Quick, Sr. (Cleo)

99 (top and bottom) Gift of Mr. and Mrs. Byron Harvey III

p.103 (top) Gift of Mr. Fred E. Warren

DINÉ

p.108 Gift of Dr. and Mrs. Oscar Thoeny

p.109 Fred Harvey Fine Arts Collection

p.110 Gift of Mr. Read Mullan

p.112 Gift of Mr. Reade Whitwell

p.113 Gift of Mr. Read Mullan

p.114 Gift of Mr. Read Mullan

p.115 Gift of Mr. Read Mullan

pp. 116-117 Commissioned with funds from the Lila Wallace/Reader's Digest Fund

p.120 Purchased with funds provided by the Goldsmith Foundation

p.124 (left) Bequest of Carolann Smurthwaite

p.124 (right) Gift of The Graham Foundation for Advanced Studies in the Fine Arts

INDÉ

p. 127 (top) Fred Harvey Fine Arts Collection

p.130 Gift of Ms. Juanita Marie Loco

p.131 Gift of Miss Marion R. Plummer and Mr. and Mrs. Stanley W. Plummer

p.134 Gift of Dr. and Mrs. Oscar Thoeny

p.135 Gift of Mrs. C. A. Upton (fiddle); Gift of Mr. Byron Hunter (bow)

Avanyu, the water serpent, is an ancient symbol of rain. For examples, see pages 64-65, 70, 78-79, 80, 86.

Bird and feather motifs as symbols of rain. For examples, see pages 54, 55, 82, 83.

Butterfly is associated particularly with spring rain. For an example, see page 78.

Cloud shapes as symbols of rain. For several examples, see pages 28-59, and pages 72-73, 76-77, 84.

The billowing cloudbank denotes rain for Rio Grande pueblos. See page 91.

Dragonfly as a symbol of rain. See page 27.

Lightning standing for rain. For examples, see pages 131, 112, 114, 115, 125, 128.

Prehistoric cloud forms symbolizing rain. For examples, see pages 20-24 and 121.

Dot and triangle, or triangle and dot, suggest rain on the mountain to Apaches. See pages 130, 133.

Rainbow as a rain symbol often adorns pots and other objects. See pages 82, 92.

Storm Blanket Pattern. This composite of rain symbols appears on Diné textiles. See pages 112, 114, 115.

Tadpole is one of the water animals that represent rain. For examples, see pages 66, 79, 78, 91.

The "whirling logs" is a rain symbol that acquired an unfortunate association with Nazi Germany, although the symbol is much more ancient and in fact, whirls in the opposite direction. For an example of its use in a textile, see page 112.

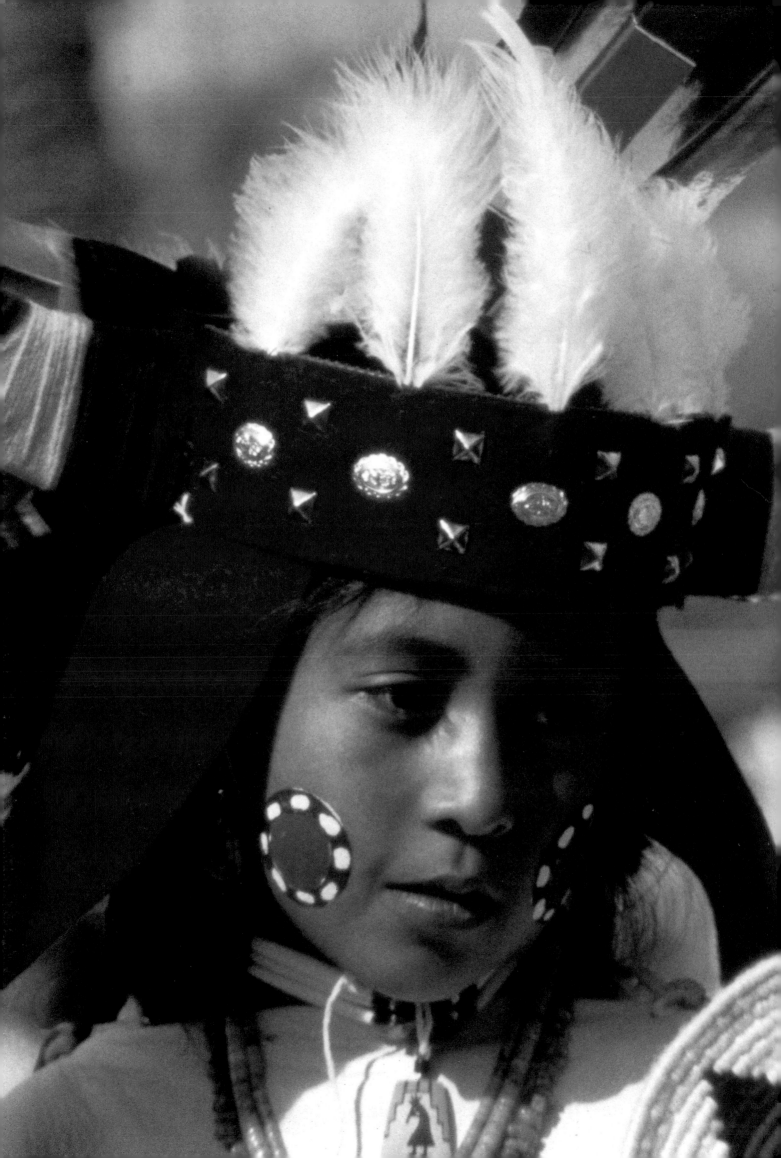